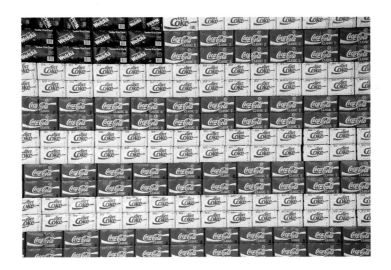

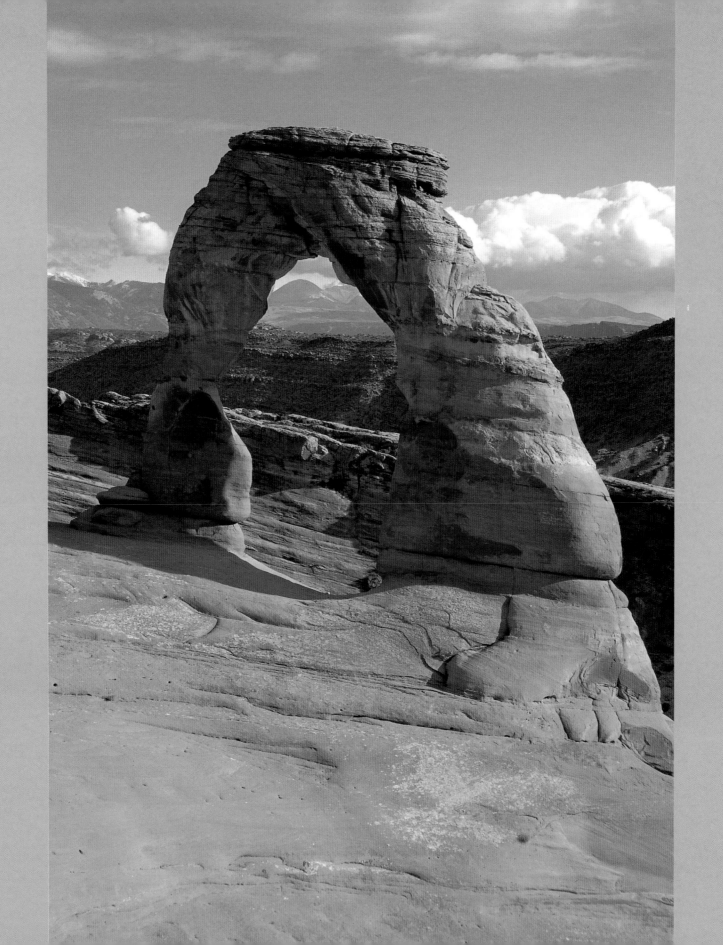

AMERICA
AMERICA

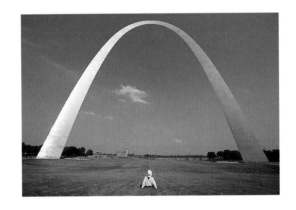

PHOTOGRAPHS BY
Sonja Bullaty & Angelo Lomeo
TEXT BY Robin Magowan

ABBEVILLE PRESS ❚ PUBLISHERS
NEW YORK ❚ LONDON

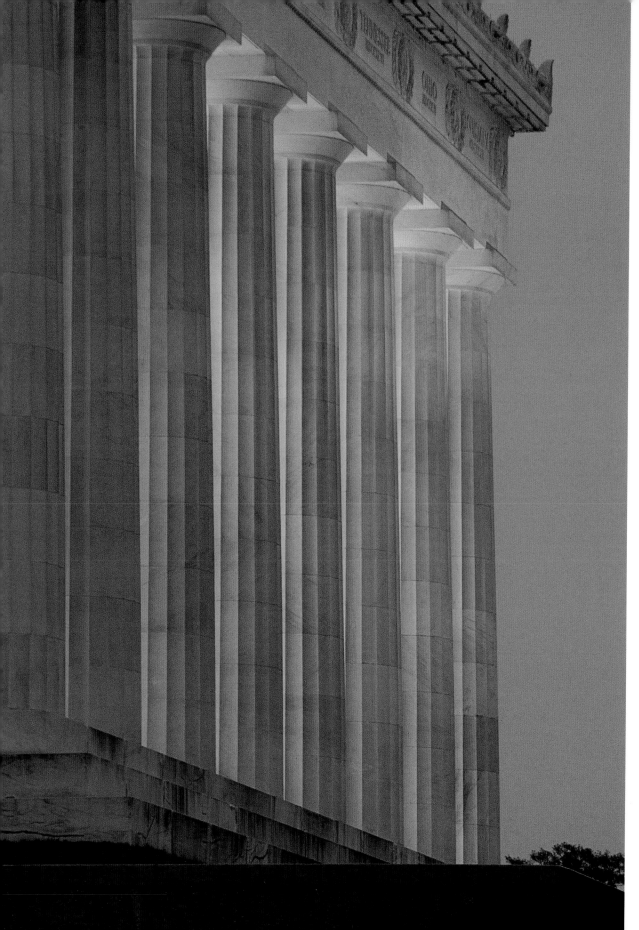

JACKET FRONT:

Navajo man and child, Monument Valley, Arizona

JACKET BACK:

The Empire State Building, New York, New York

P. 1: Coke flag, Charleston, South Carolina

P. 2: Delicate Arch, Arches National Park, Moab, Utah

P. 3: Gateway Arch, St. Louis, Missouri

P. 4: Lincoln Memorial at dusk, Washington, D.C.

EDITOR: Susan Costello

DESIGNER: Celia Fuller

PRODUCTION MANAGER: Louise Kurtz

"Noticed" from *New and Selected Poems, 1942-1997* (The
National Poetry Foundation, University of Maine, Orono,
1997) copyright © John Tagliabue. Reprinted with permission
of the poet. "May All Earth Be Clothed in Light" copyright ©
George Hitchcock. Reprinted with permission of the poet.
Quotations on pages 11 and 12 from *Sudek* by Sonja Bullaty.
Copyright © 1978 by Clarkson N. Potter, Inc. Reprinted with
permission of Clarkson N. Potter, Inc.

First edition

2 4 6 8 10 9 7 5 3 1

Library of Congress Cataloging-in-Publication Data
Bullaty, Sonja.
America, America / photographs by Sonja Bullaty & Angelo
Lomeo; text by Robin Magowan.
p. cm.
Includes index.
ISBN 0-7892-0530-0
1. United States—Pictorial works. 2. United States—Social
life and customs—20th century—Pictorial works. 3. United
States—Description and travel.
I. Lomeo, Angelo.
II. Magowan, Robin.
III. Title. E169.02 .B84 1999
973—dc21
99-14181
CIP

CONTENTS

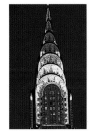
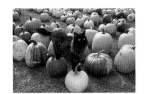
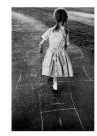

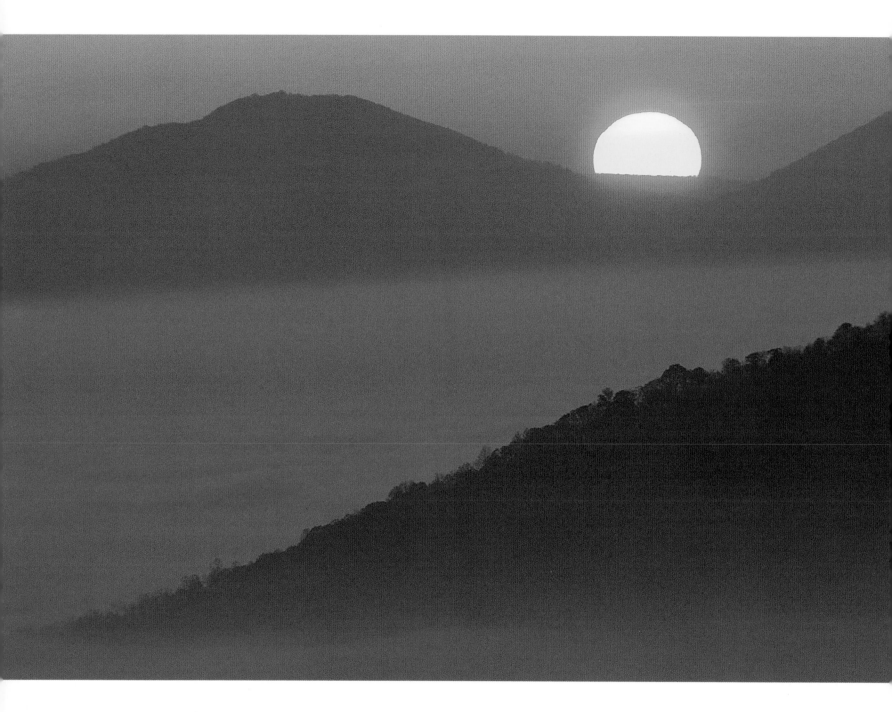

Sunrise | BLUE RIDGE MOUNTAINS, NORTH CAROLINA

PHOTOGRAPHERS' NOTE

by Sonja Bullaty and Angelo Lomeo

AMERICA, AMERICA IS AN ONGOING PROJECT WHICH WE FIRST started in the late 1940s. At the time we did not realize that our early photographs would be part of a lifelong project nor did we imagine that one day these pictures would become a book. We took them because photography is our life, and it is our joy.

Our portrait of America includes timeless landscapes—the deeply moving beauty of the land from the Atlantic coast at sunrise to the Pacific coast at sunset, from ocean to desert, field, and forest throughout the seasons and with the unique imprint of the American people.

We offer our celebration of America, which is an observation of its glory, its poetry, and its irreverence. The book is our journey;

this is my land *and* *my (adopted) land*

Angelo Lomeo Sonja Bullaty

7

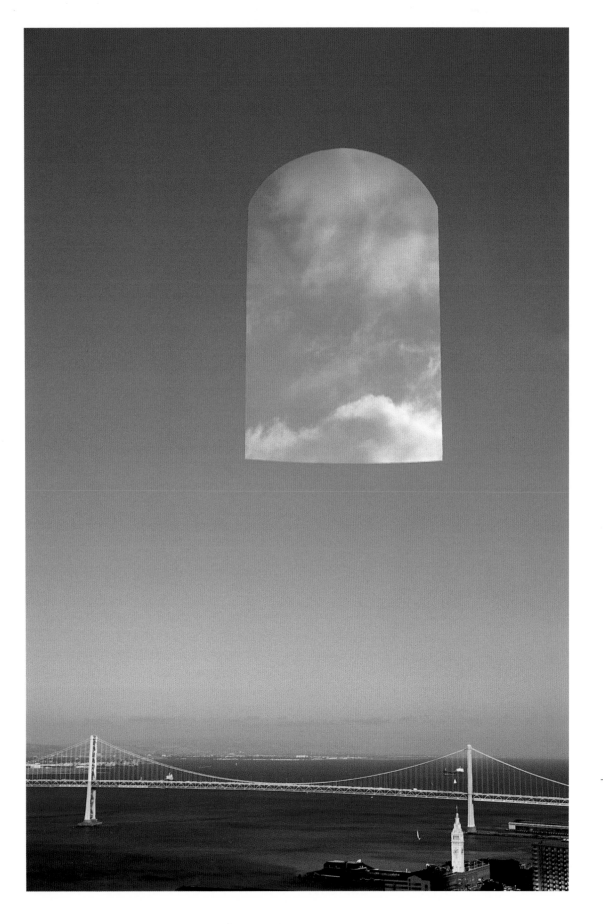

There

is

an

invisible

bridge

sometimes

you

want

to

call

it

light

sometimes

you

want

to

call

it

darkness

we

know

there

is

an

invisible

bridge.

—JOHN TAGLIABUE,
"Noticed," in *New and
Selected Poems, 1942–1997*
THE NATIONAL POETRY FOUNDATION,
UNIVERSITY OF MAINE, ORONO, 1997

Introduction

Who is the American, this new man?
—HECTOR ST. JOHN CRÈVECOEUR (1735–1813)

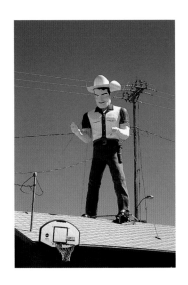

THE QUESTION THE FRENCH NOBLEMAN CRÈVECOEUR POSED IS NOT ONE WE CAN READILY ANSWER. WE MAY FEEL an instinctual identity. We may also recognize an obligation of sorts, a larger purpose that we try to live up to as best we can. The sense of a special dispensation dates back to the Pilgrims. America was to be that "shining city on a hill" of biblical yearnings, perched there for all the world to behold.

If this sense of a new start, a special destiny, was one our forefathers brought with them, it was the land, and the opportunities it offered, that made us different from other peoples. To be able to answer who we are, we must know the land that has shaped us.

Incentive enough, one would think, to hop into a car and hit the road. Alas, there is only so much of the passing blur we can take in through a car window. We have to stop, get out, and walk around. And we have to spend some time in the middle of it all: that city, that farm, those trees, that vast loneliness. Even then, we may still find ourselves wondering with Henry David Thoreau what all our gadding about has taught us. Couldn't we have learned as much by going into the nearby woods and building a cabin and spending a while looking into the lens of a pond?

Thoreau's solution may strike us, social animals that we are, as a bit extreme. But it does help explain why American literature has been, by and large, a first-person literature. Benjamin Franklin's *Autobiography*,

OPPOSITE San Francisco–Oakland Bay Bridge and reflection from the Coit Tower | CALIFORNIA

ABOVE Cowboy figure on a motel roof | GALLUP, NEW MEXICO

9

Thoreau's *Walden*, Walt Whitman's "Song of Myself," Herman Melville's *Moby Dick*, Mark Twain's *Adventures of Huckleberry Finn*, *The Autobiography of Henry Adams*, are all products of the same search. We may lead perfectly valid social lives. But our classic literature has largely been a private dialogue between ourselves and providence, ourselves and the land.

Caught in the toils of our heritage—the compelling need to make something of ourselves—we have always required the visitor to come along and point out what this America of ours might actually be about. Where we are hopelessly subjective, unable to disentangle ourselves from the complex conditions of ethnicity and religion that have shaped and scarred us, the outsider is free to compare and contrast, to make an objective sense of the grand and often highly comical picture we present. From Crèvecoeur, Alexis de Tocqueville, Charles Dickens, and the expatriate Henry James of *The American Scene* down to Andrei Codrescu and Simone de Beauvoir, theirs has been our one great mirror.

The *America, America* of the photographic team of Sonja Bullaty and Angelo Lomeo, at once a journey and a memoir some fifty years in the making, comes out of the same awareness. What strikes us as we turn from one stunning tableau to the next is the aptness, the consistency, of the vision. It is as if the America we had passed through all our lives, but had never *seen*, were suddenly being revealed to us. The essentials are there—the sweep of the vast horizontal spaces, the vertical aspiration of the skyscrapers, the wonder at the changes of a season, at the rebirth of nature, at the possibility offered again and again of rebuilding a life.

Bullaty and Lomeo met in the proverbial darkroom. It was in New York in 1947. Angelo was the manager and Sonja one of the renters when he appeared before her with a gift of some apples. It hit exactly the right chord; as Sonja says, "I love apples." Angelo had grown up in an Italian-speaking family in the close-knit Hell's Kitchen ghetto, the son of a grocer who had run a popular store until ruined by the Great Depression. Angelo remembers the gypsy life of the times, being dispossessed and moving from one apartment to another every two months, and the way it broke his father's spirit. And he remembers his isolation, shunted from one school to the next, until finally landing in the city's School of Industrial Arts. There he studied painting and design and came under the spell of Edward Hopper's light, an influence that holds to this day.

In the midst of this dereliction a New Deal agency, the Civilian Conservation Corps, offered Angelo a chance to reinvent himself out West as a lumberjack and firefighter. For a seventeen-year-old kid whose only previous encounter with nature had been Central Park, Montana was a visual revelation. As Angelo recalls, "Wherever you pointed your camera, in any direction, there was beauty. It got to me then, and to this day," he admits with a shy grin, "it still does." On the side he shot the scenery with a folding postcard camera. A general store bought his prints and sold them to passing tourists. That decided him. He returned to New York to learn how to make a living as a photographer.

But instead he was soon drafted into the army. The experience gave him a firsthand acquaintance with the horrors of the war, the concentration camps and the forced labor warehouses of Nazi Germany. By then he knew that he didn't want to spend the rest of his life "sitting behind a desk designing toothpaste packaging."

If Angelo was the kid from the other side of the tracks making the most of what circumstance brought, Sonja came from a rather more privileged background. She grew up in Prague in an intellectual Jewish banking family. Her father was a collector of incunabula—manuscripts dating from before the invention of printing. When he read for pleasure, it was apt to be something

in Greek or Latin. It was his ambition that Sonja understand the world by spending time in different countries and cultures. In the course of her life she has done exactly that, if in a way "perversely different from what he envisioned."

As a sensitive teenager Sonja felt the rumblings of the coming Holocaust early on in the seven-year Nazi occupation. Her father, otherwise so brilliant, failed to sense the depth of the coming evil. When, too late, he understood it, it was no longer possible to get out of the country.

Their situation changed abruptly on Sonja's eighteenth birthday, when the family was forcibly deported to Poland. Four years of concentration camps followed: the ghetto in Lodz, Auschwitz, Gross-Rosen, the death march across the burning city of Dresden, and a last-minute "escape of sorts, because otherwise I'd have been shot."

Sonja's father had given her a camera when she was fourteen; compensation of a kind for the school, the activities, she could no longer attend. Possessing a viewfinder, in the midst of such evil, gave her a needed hold on reality. When she made it back to Prague in 1945, she found herself the lone survivor of her family, obliged to accept shelter on the floors of schools. But somehow she knew she wanted to be a photographer, and she found herself gravitating to the studio of the great one-armed photographer of atmosphere, Josef Sudek.

How Sonja became what Sudek called his "apprentice-martyr," she doesn't precisely recall. As Sudek said years later, "You were much too preoccupied by what you

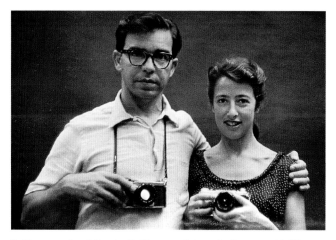

Self-portrait of Sonja Bullaty and Angelo Lomeo, 1949
NEW YORK, NEW YORK

had gone through to bother much about any of us, or to take in your surroundings." But Sudek's wartime assistant, Vladimir Fuka, remembers the surprise Sonja occasioned: "After the war, unexpectedly, a new face showed up at Sudek's studio. A Jewish girl. A scarf tied around the pretty, still almost childlike face. She had lost her hair in the German concentration camps. She had no one, nobody had returned. The trays in the darkroom that had been deserted were now taken over by Sonja. Photography became her destiny."

In Sudek's studio Sonja helped "mix developers and find negatives." And she learned something watching this great master of atmosphere print his dark, moody, virtually abstract compositions. But it was Sudek's presence that stamped her: his imperviousness to everything—trends, material possessions, others, the demands even of his own celebrity—everything but the inner landscape, the private light, he was bent on capturing. She remembers sitting with him, camera in hand, on a gravestone, waiting for a last ray to strike. To this day Sudek's remarks are part of her, to be quoted at will. Working in the park's early morning light, Sonja passes on his "Hurry, slowly," for her a whole way of being.

But even at the time, there was another just as determining discovery for Sonja: Henri Cartier-Bresson's spontaneous response to life, to the instant—his "decisive moment." Sonja's photographs combine Sudek's introspection and serene observation of a place with that "elusive captured moment that transcends our notions of reality."

It was also Sudek who, years later, urged her to think of a book of photographs as possessing a form, something with a "beginning, an end, and a bit of a spine." Sonja and Sudek share a number of affinities: a love of windows and the mystery of reflections; a fondness for patriotic kitsch and the seemingly banal; a fairy-tale-like understanding of how, once the children go to bed, their toys come alive. Like the surrealists, they want to stretch the borders of appearance and take us to that "invisible bridge" of Tagliabue's poem, where *light* and *darkness* are merely names for the new connections realized in the moment of vision.

But dominating all that they share in common is a passion for music. The best part of Sonja's apprenticeship, she recalls, was sitting with Sudek and his friends, listening to music. As Sudek himself wrote, "If you take photography seriously you must also get interested in another art form. For me it is music. This listening to music shows up in my work like a reflection in a mirror. I relax and the world looks less unpleasant, and I can see that all around there is beauty." Critics talk, perhaps wrongly, of the painterly in Bullaty and Lomeo's compositions—the echoes of Hopper and René Magritte; of Vincent van Gogh, Claude Monet, and Paul Cézanne; of the Venetian colorists—which they have carried into another dimension.

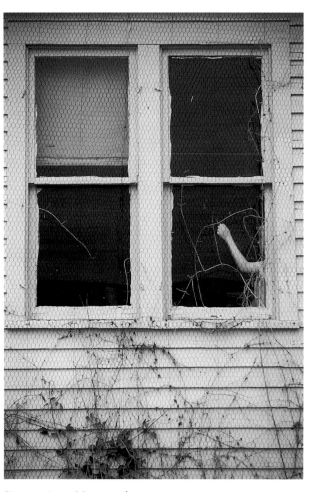

Pioneer Auto Museum | MURDO, SOUTH DAKOTA

But in *America, America* it is again and again the musicality of a scene—the verticals, the balances, the reverberations in space—that brings the awe, the elation, the quickening of pulse.

■ ■ ■

Some distant New York relatives of Sonja's found her name on a survivor's list. They invited her to come stay with them and, very generously, sent her a one-way boat fare. Sonja was not entirely convinced that America was what she needed. When she reached Paris, she had only the funds for a three-day stay. But Paris was still very much Paris, and by much skimping and a little luck, she managed to stretch her funds into a stay of three months.

It was a rather haunted Sonja who arrived in New York on a storm-smashed boat in midwinter of 1947. For a long while, all she could see were the "ghosts of those who were no more and of a life gone forever." Until she met Angelo, there was no one she could talk to about the evil she had survived. And her survivor's habits, including the fear of possessions, were not easily shed. For years, even after she and Angelo wed in 1951, all they sat on were orange crates. A world of chairs, tables, furniture, a home you actually owned, seemed inconceivable.

Before any healing could set in, the ghosts had to be appeased. Sonja and Angelo traveled to Prague repeatedly during the 1960s to photograph Franz Kafka's city. Out of those journeys came a collection of the inner landscapes that translated into photography Sonja's experience of the Holocaust. Until then, she wrote, "it was difficult to break through to the joy of being alive and capturing that joy on film."

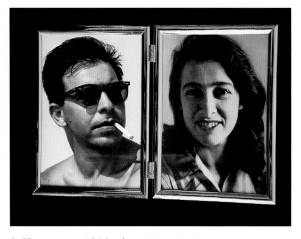

Self-portrait, 1950s | JONES BEACH, NEW YORK

they could on cans of Campbell's soup. And the jalopy broke down before they got anywhere near Angelo's Montana.

But the trip gave them a taste for what could be. Before their next try, they bought a half-ton Chevrolet pickup and converted it into a camper. In the fifty years since, they have crisscrossed the country again and again. They have shot in all fifty states, while returning to the same favorite locations. As Angelo commented in a recent interview, "One has to go back to a place quite often to really capture its spirit. We'll stay on a project long enough so that we can bring back the essence of a place."

Even then the haunting did not entirely leave. What else is her image of a disembodied female arm caught in the window of a derelict house? But if it did not go away, it did become transmuted. Mystery took over, and Bullaty became the photographer of that magical time that stretches between the end of sunset and the beginning of night, when the trees lose their moorings and their colors start to levitate, as if it's sky and not earth they belong to.

And what color could not bring, America did, helping her, as she said, "make the transition from those hate-filled times of total horror to the possibility of a better way."

But there were also aspects of America that puzzled her. In a supposedly free society, how could there be black ghettos? And did anyone up North understand the plight of the rural poor in the Deep South? The tender light-filled portrait, shot in Atlanta in 1949, of an old man in a straw hat held together with safety pins marks the real beginning of Bullaty and Lomeo's *America, America* (page 141, bottom left).

Meanwhile Angelo was insisting that Sonja see something of the West. It was hard going, as they recall, traveling in an old jalopy plagued with an egg-shaped crankcase, sleeping in sleeping bags, surviving as long as

During the 1950s they earned an income, and their first reputation, photographing the great paintings, sculptures, and objets d'art in museums and art galleries. Trying to do justice to supreme art was a challenge for which they had to learn a technique. Yet it was also, as they look back on it, a training for what was to happen. For two professionals who had never been to college, the work provided a firsthand education in learning to see, and above all in learning how to compose. From Hopper's *Nighthawks*, that great depiction of American loneliness set in a late-night diner, Angelo learned how to make the lighting condense and distill the elements of a story, while Sonja found herself drawn to the shadowed illuminations of seventeenth-century chiaroscuro—witness the Rembrandtesque play of black faces and gold horns in her "Jazz Players at Preservation Hall" (pages 126–127). The complex overlay of associations their photographs evoke are no accident, but instead something deeply meditated.

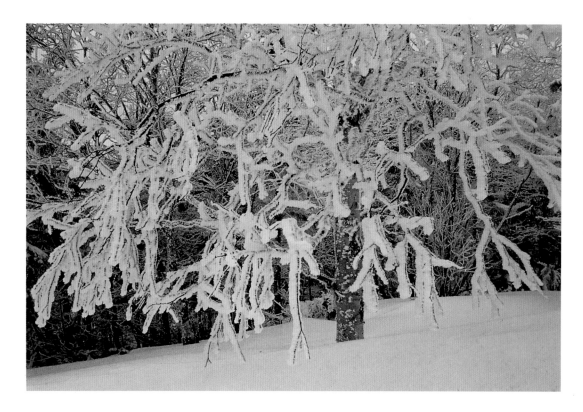

Birch tree in winter, 1970 | VERMONT

"Black and White in Color," 1971 | LITCHFIELD, CONNECTICUT

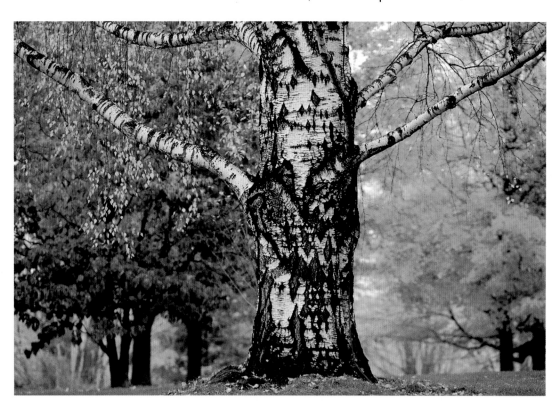

14

At the time Bullaty and Lomeo were shooting in black and white, both with 35-millimeter cameras and bulky 14-by-11-inch view cameras. Though they now use only 35-millimeter cameras, they remain grateful for the discipline of the large-format camera and the way it demanded more of themselves in trying to reach their artistic vision. But

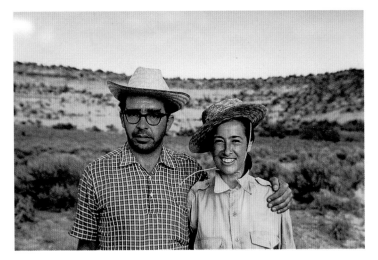

Self-portrait, 1964, Canyonlands National Park | MOAB, UTAH

choly, of a scene. True magic comes when, on top of everything else, hoarfrost appears, the frozen white dew that requires days of freezing temperatures to turn into the billowing radiances outlining a snow-drenched tree.

For Bullaty and Lomeo color is not an accident but the very language of photography, and the translation of light into color is

whatever clarity they achieved in printing its large-format negatives was often enough offset by the bulky camera's inability to capture the wind, a bird, a facial expression, or a cloud.

They were well into their career when they came to the medium now associated with them—eyestopping color. Angelo's breakthrough came from a shot he calls *Black and White in Color*, a study of black barrings crisscrossing the base of a large birch tree (page 14, bottom). This study in black and white is, however, surrounded by a shimmering pool of pink-and-gold leaves. It was precisely this juxtaposition of the two mediums, the classic minimalism of the birch against the jubilation of the leaves glinting on the ground, that spoke to Angelo.

For Sonja, a breakthrough also came with a classic black-and-white subject, a snow-covered tree (page 14, top). Her monotone composition creates an awareness of the subtle gradations between the lichen-daubed bark and the pale tender blues of the winter light. Sonja dislikes the notion of the four seasons. "There are so many!" she says, rightly. But of them all, it is winter that most enchants her, with its uncanny skies and the way the low, saturated light outlines the bones, the melan-

what they are about; something that so suffuses a subject that it becomes a state of mind, an exuberance, in itself. This subject can be, as in Sonja's photograph of the autumnal reflections in their pond, a virtual abstraction: We don't see any source, any echoes of trunks, branches, leaves. Instead we see color radiating out and filling us with the joy of a distilled moment; an entire essence so vibrantly reverberating that it might be something else—music itself—we are beholding.

At other times the color is such we stare at it in disbelief. A Badlands sky so blue it almost burns the eye, the pink of a fall maple leaf, the hot lipstick reds of a New Jersey sunset, may all look like something squeezed out of a tube. But those very tints do exist in life, you just have to seek them out. The main thing, after all, is patience.

■ ■ ■

Some photographers do staged setups. Bullaty and Lomeo won't, on principle. Instead they will sit in the car among all those surrounding wheatfields, waiting for the light to give them the picture they want.

Though Bullaty and Lomeo came of age in the heady days of photojournalism, of LIFE and *Look*, they have not found working on assignment easy. A very few of the photographs in *America, America* originated as commissions: the back-porch photograph of the two Gagné boys blowing soap bubbles (page 140, bottom left), for instance, though even there it was a very different white-bread middle-class family that *Vermont Life* originally wanted. And there were several Time-Life books done on assignment. But most of *America, America* was shot not to make a book—that, as they say, would have been too daunting—but for the "sheer heart of it" and perhaps to sell the shots later on. "Waiting for an assignment," Sonja says, "you have to sit around too long. If you feel strongly about a subject, a mood, it's better to just go out and do it." They resent magazine editors' labels—fine arts photographers, travel photographers, tree photographers—that inability "to deal with you unless you fit into a cubbyhole. Photography is life and not compartments." And they are miffed by the confusion they cause. "Do you still photograph trees?" one editor asked recently; as if there could come a time when they would have clicked their last shot of a tree! "We are photographers," they say, "and photography is our life."

Photography is a solitary pursuit, and a pooling of talents such as theirs could not be rarer. (To my knowledge there is only one other such team, the Beckers, who live in Germany and specialize in filming such old industrial sites as water towers and abandoned mines.) Sonja and Angelo are each their own person with their own driving obsessions. But there is also much that they share: a vulnerability, rare enough today, to romantic beauty; the unusual persistence—Sonja has been known to stay with a subject for several hours—required to come up with something more than a good picture.

They like to approach a subject by shooting it from every possible angle. Once they have filled in their "sketchbook," they will start to move in, focusing closer and closer until they have pulled a complex image out of the chaos that surrounds it. Everything in nature, they point out, is chaos. But in the midst of the chaos you can usually, with enough persistence, find something that expresses a vision.

When engaged on a common project, they still arrange to shoot on their own: sometimes back to back; more often wandering about, to meet up again for lunch. There is, as they say, enough competition in the world, and rather than compete, they consciously decided from the start to pool forces and share both the burdens and the joys of travel, the finding of places, and whatever credits came from the collaboration.

Their photographs, often enough, are ones no single person could have seized. No one plants himself with a tripod in the middle of a highway to capture a vertical chord of lightning and a pair of approaching headlights without having a mate to give warning when destruction looms (page 68). And while shooting an absurd sign against snow-lit evening woods, it must help to have an Angelo pointing the headlights (page 61). It may not matter who clicks the shutter when the result is in every other way a joint expression; one they have planned, chosen, and after many, many years, put together in cumulative chapters.

Bullaty and Lomeo are based in New York—for the past twenty-five years in a strikingly windowed apartment overlooking the Central Park of their *Circle of Seasons* (1984). They also own a Vermont escape hatch, bought in 1969 in reaction to the Soviet invasion of Prague, which they photographed. Set high on a remote hillside, the cottage has no electricity, no telephone, and a Walden-like pond that they dug out of the surrounding swamp.

Though the photographs in *America, America* date back over half a century, they make up only one of a number of bodies of work that have grown very slowly, side by side. Kafka's Prague was the first, shot mainly in

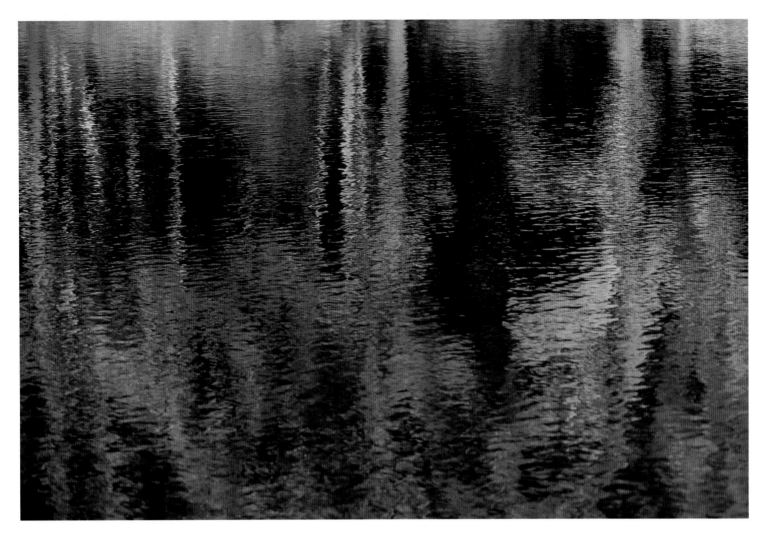

Pond reflections | BELMONT, VERMONT

the 1960s, though not completed until the mid-1980s. Shortly thereafter came *Vermont in All Weathers*, published in 1973. During most of this time the couple's work in Europe alternated with their journeys across America. They found themselves needing to balance their experience of Europe's complex cultural heritage with the "incredible natural beauty of America." And there was, in addition, Angelo's own need to touch base in Montana now and then.

It was not until comparatively recently that Bullaty and Lomeo's highly acclaimed European trilogy began to appear: *Provence* (1993); *Tuscany* (1995); and *Venice and the Veneto* (1998). The long nurturing has allowed each project to become part of them—as much a reflection of their own wit and desire as a celebration of place. While honing their compositional eye, it made them all the more aware of what America is and how it differs. It is this awareness that places *America, America* in the

tradition of Crèvecoeur and de Tocqueville. Theirs are not just supremely beautiful photographs. Instead they tell us what the land is and has been about and who we, as a people, are.

■ ■ ■

I never saw a discontented tree.
— JOHN MUIR

From the time when as a child Angelo first hid in a mulberry tree in Central Park, he has felt about trees as John Muir does—"Their shapes," he explains, "the tangle of branches and limbs, the Jackson Pollock-like feel of a magnolia in blossom." (Sonja shares much of the same fascination, and together they have more than enough pictures for a book on trees.)

But Angelo would never agree with Muir that "the clearest way into the Universe is through a forest wilderness." It is not wilderness but landscape—from the German *Landschaft*, i.e., the land created by the human hand—that intrigues his eye. In Italy and Provence the signs of human presence extend everywhere, in the dry stone masonry of a field wall, the single tree left standing in a pasture, the wooded hilltops. Everywhere you stroll, there is evidence of caring, of home farms tenderly maintained over several hundred lifetimes. Even the way a spot of color occurs in juxtaposition to another—a vineyard against a field of mustard, or an apple orchard—bears evidence of a choice, and with it, a sensibility. It is this ancient peasant creation that Angelo's richly textured photographs celebrate.

In *America, America* human presences also transform and give life to the elemental vistas. But the stunning eroticism of an Hawaiian diver, in a classic red bathing suit, plunging into the maw of an orgasmic waterfall remains something of an exception (page 184).

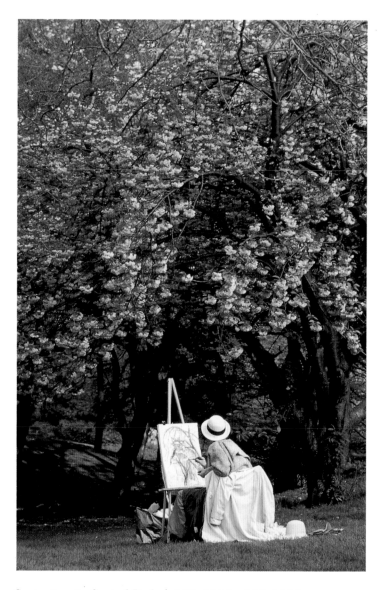

Springtime in Central Park | **NEW YORK, NEW YORK**

More often, the presences are as apt to be animal or flower as human: a lone blue heron silhouetted in front of a coral Florida sky (page 169); the pink fireweed setting ablaze an Alaskan meadow (page 187); or a vast expanse of California poppies, their petaled splashes of shimmering, dancing gold-reds beyond anything Monet ever contrived (page 55, top). The photographs, because

they are quicknesses seized, carry a poignancy. The eye of the red descending sun framing the southward-streaking geese might well be that of a last apocalypse (pages 182–183). Bullaty and Lomeo have caught these apparitions, but what is the likelihood of us, or our descendants, seeing them?

Traveling in Europe, we come to think of man and nature as complementary: castle and church, the head and the soul,

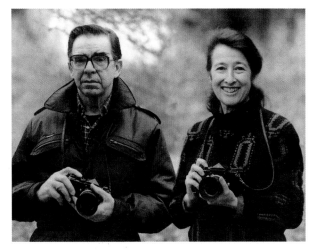

Self-portrait, 1986, Central Park | NEW YORK, NEW YORK

facing, confronting one another, from opposite hillocks. In America, man and nature may seem more at war. The spoils of one kind of human victory are caught in Bullaty's and Lomeo's shot of a desolate railroad track in western Montana, freight cars laden with logs chugging into a grim infinity (page 65). But if that vine-reclaimed jalopy is any indication, our victory may well be a brief one (page 148). What will our cities look like five hundred years from now?

Not everywhere is life so fiercely contested, and in a setting where the air is as thin as human history, the camera knows how to strike a balance. The old dark-glassed Indian woman, with her turquoise bracelets and pendants, her Sunday-best red velvet jacket and fuchsia skirt shining from the doorway of her little mountain of a hut, strikes a chromatic harmony all her own, the light itself against a cold, blue, bird-touched sky (pages 134–135).

■　　■　　■

Morning spreads over
the beaches like lava;
the waves lie still, they
glitter with pieces of light.

I stand at the window
& watch a heron on one leg,
its plumage white in the green banks
of mint . . .

Slowly the bird
opens its dazzling wings.
I am filled with joy.
The fields are awake!
the fields with their hidden lizards
& fire of new iris.

— GEORGE HITCHCOCK,
"May All Earth Be Clothed in Light"

We see photographs; but what, Bullaty and Lomeo ask, if we could hear them—the percussion timbres of dissonant light and shadow, the breaking orchestral waves, the snowy whisperings, the dynamic cloud-filled sunset climaxes? Early in the century, in *The Spiritual as Art*, Wassily Kandinsky proposed a new form of abstract painting that would work on us inwardly the way music does. It is something like this Bullaty and Lomeo have wrought with the compositional rhythms of their elemental opening chapter, "America, America: From Sea to Shining Sea."

Close your eyes and, by way of an opening theme, imagine quiet orchestral waves rising up, colliding against the shore, and gently waking us. First, Sonja's Mark Rothko sunrise of America's beginning in an Atlantic newly emerged from the night (page 32). Then, what might be the morning of the world in a shot of the Pacific at Big Sur, California, its dazzle of foam and breaking light closed off by a curtain of rising vapor (page 33). And the chapter ends with a shot of Jenner, California at sunset, a red clattering chord that seems to

reverberate on and on until it seems we are hearing nothing less than time itself, striking, striking (page 57).

Within this orchestral frame lies the America the striking waves have given birth to. And it's the beginning of earthly time, of seasonal renewal, which the next juxtaposition captures. Muir, in a memorable phrase, called the Sierra Nevada "the range of light." What better way to show its pristineness than that emptiest of frozen solitudes, Death Valley in February, touched into life by the first rays (page 34)? Then, in a subtle contrast, the magic realist shot of the White Sands missile range, wave upon receding wave of wind-molded winter dormancy (page 35). In the foreground, though, Sleeping Beauty has come alive—a glitter of resurgent sage, the fan of a yucca. How big is the scene? Big enough to get lost in, for the wind in what seems the click of a shutter has painted out the photographers' tracks. But as Bullaty and Lomeo stand there, perplexed, wondering in which white fold their van lies, there appears Big Brother in the Sky, a military helicopter. It, too, wants to paint them out, as a missile is about to be launched, and with a waggle of its wings it points out their submerged van.

From these white solitudes we have two ways to go: either into color and the blossoming of spring in the poppy-enriched desert, or back into geological time and our own beginnings, as a land, as a people. The couple looking out from Zabriskie Point at the twisted, gnarled shapes of Death Valley might well be Adam and Eve (page 36); the chapel-like Antelope Canyon, Arizona, set aglow by a shock of light, a first place of worship (page 37).

By these elemental standards the Navajo man and boy on a horse (on the jacket) among the wind-sculpted erosions of Monument Valley may seem a modern intrusion. But their presence helps transform what we are seeing into so many castles, fortified abbeys, ancient temples. As the accompanying "sunrise" even more brilliantly demonstrates, Monument Valley is America's answer to the ruins of Petra and Persepolis.

Or consider Angelo's virtuoso shot of Lake McDonald in Glacier National Park (pages 44–45). For a moment it looks as if we have left Earth and ascended into the sky, that the black shape in the foreground zooming straight toward us is not an island but a meteor. Are we in a spacecraft watching the moment of Earth's creation? Looking out past the lake's reflected first-day chaos, we behold an Edenic mountain valley stretching away, its every detail realistically presented, as if for our very own human enjoyment. We stare into the photographic magic, rubbing our eyes in understandable disbelief: can this be what our ancestors were trying to convey by calling it, "God's Country?"

An equal tour de force—not quite black and white—is Sonja's shot of a pond at 12,000 feet in the High Sierras; a site, she later learned, famously stamped by Ansel Adams (pages 46–47). But where Adams shot up into cathedral-like awe, what interests Sonja is the ambiguous, almost spooky, play of pattern; what's in the water and what's on land and the lack of any discernible boundary between one and the other. The more we stare, the more the upside-down quality of the hallucination takes us over with its unabashed visual magic. We step with her into a freeing alternate world, an America given a new dimension.

From these reflections Bullaty and Lomeo plunge inward to that sanctuary of rain, the Hoh Forest of Washington State's Olympic Peninsula (pages 50–51). We may not see the tripod and camera with the umbrella shielding it, or the photographers covered from head to toe in dripping plastic. And we certainly don't hear the whining chain saws that have clear-cut the surrounding forest up to the park border five acres away. But our fingers catch something of its eighteen-foot annual rainfall

in the mossy thicknesses coating a trunk and the way they make the other greens look almost blue, as if it were not raining but snowing. It may be a little optimistic, but Bullaty and Lomeo regard their photographs as acts of preservation—and as warnings. The country's extravagant abundance is part of the bounty with which we as a people have been gifted.

. . .

Crisscrossing rapidly from coast to coast, from one light, one season, one elemental sublimity to the next, Bullaty and Lomeo show the possibilities for visual renewal this vast sweep of land offers. With "The Open Road" begins a search for what we ourselves have made. We Americans may not be nomads like the Tuareg of the Sahara, but we do move about a lot. In *The Lonely Crowd*, written in the mid-1950s, David Riesman notes that we change residence on the average every year and ten months. And he envisions a future nation of human turtles, carrying our houses on the backs of our cars. For Riesman, mobility is the American's defining trait.

No wonder that what Whitman called "The Song of the Open Road" has proved such a lure for us all. America with its vast lonely spaces, its opportunities for random camaraderie, is summed up in Bullaty and Lomeo's seductive photograph of a very blue ribbon of highway, a roller coaster luring us on as it knifes through a White Mountain forest (page 64). And clutching our copies of *Lolita*, of *On the Road*, off we go, seeking that fabled pot of gold at the end of the rainbow. If we keep going long enough—fifty years?—we may even, like Sonja, find it, in what may be their quintessential American shot: a double rainbow exquisitely centered over a vibrant red-and-white-striped Santa Fe gas station—a lit-up island flag in the night sky (page 69).

Yet any image of an exuberant Judy Garland belting out "Somewhere *Under* a Rainbow" must be held against Sonja's photograph of gas-station blight, the top S of a Shell station deliciously cropped to spell out a visual HELL of billboards, placards, advertisements, one insistency receding over the next (page 77). That, too, is the American road.

Out there on those lonely roads we may find ourselves wanting some sign of a human presence. But even at the most desolate of moments Angelo's camera can fasten on a road sign to tell us in whose hands we are. Is it their surprise we relish: a rider on horseback glowing in the dark of a snow-lit rural road (page 61)? Or their perspicacity: a vertical warning summoning into being the curves of a wonderfully appropriate Badlands rock? Right on, we acknowledge, those arrows are us, Roadside Joe, self-importantly marching along. The signs may also remind us of how we usually take in natural beauty—through the windshield of a car.

More pictorially complex is the "EAT" sign advertising the Pickles Restaurant in Arco, Idaho (page 76, top). From the overhead sign the eye drops to a mural of a cucumber family—a minimalist trompe-l'oeil that says it all. From the mural we pick up a woman sweeping by the window and, in the highway-side window, a passing red truck: blue-collar pickings on the road. *America, America* is full of such juxtapositions—witty ones, insane ones. A road, as we all know, is also its accidents.

Photography may be, as Angelo reminds us, "95 percent waiting." But *America, America* encourages an ever alert awareness, as if we too could stop, jump out of our routines, and catch something momentous, some bit of the ongoing, daily American amazement. Who would expect the town of Friend to come to our visual rescue in deepest Nebraska (page 70)? Or take the silhouette of a rare moose, so black against an early morning's sky blue road as to make us ask ourselves, was it an apparition,

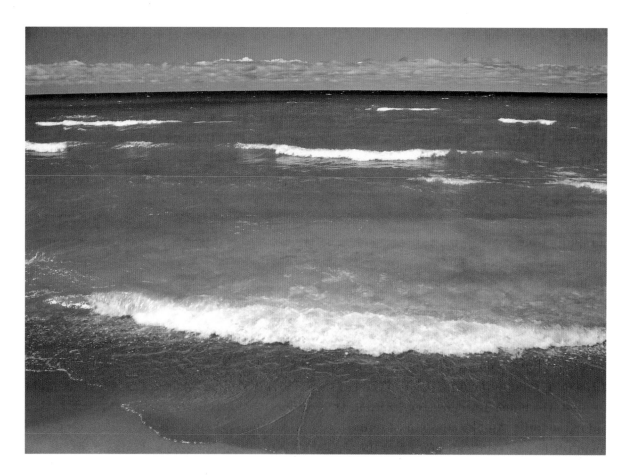

Shore of Lake Michigan | MICHIGAN

or the real thing (page 66)? Even after fifty years, "you never know," Angelo remarks, "what awaits around the next corner."

"What's that?" Angelo remembers exclaiming to Sonja as their van hurtled past an abandoned house. A quarter mile farther on, still puzzled, he decided to make a U-turn and investigate. "That" turned out to be a herd of sheep and goats, surrealistically dozing away the heat of the day on a shaded porch (page 151, top). As Angelo says, you never know.

∎ ∎ ∎

There are roads that express our go-go culture, that go places and take us out of ourselves. And then there are the little roads that seem not to go anywhere at all, lanes that wind among leaves, tranquil as a stream. Where the highways offer us a space where we can reinvent ourselves, the rural road looks inward.

Time, striding fiercely forward elsewhere, here moves to a different measure. The horses grazing in yellow exuberance in an Amish pasture (pages 82–83); the wildflowers reclaiming the Gettysburg battlefield (page 143)—all project something in common: a moment that seems to have gone on forever. Even when the Gettysburg

horizon line (synonymous in pastoral landscape with the classical Golden Age, when men and gods lived in harmony) includes an obelisk and an equestrian monument, we still feel as if we are in circular seasonal time rather than the linear time of a highway, a world of recurrence rather than one of arrival.

Angelo's elegiac shot of a blue-lit, single-track Vermont lane, taken from a perch that floats us high among the falling, flaking autumnal golds and oranges, offers another kind of rural moment; of immense glory and equal sadness, held in the perspective of the vanishing road, and our own vanishing years (page 67).

Farms are, of course, just as much human creations as an interstate. But where the interstate is a military knife stuck in the flesh of the land, a runway where cold war bombers could alight in an emergency, the farm is at one with its surroundings, fitting in even as it remakes the landscape with its wooden outbuildings, its jutting silos, the curving, crossing rhythms of its walls and fences. Bullaty's and Lomeo's photograph of the Manchester horse farm in Lexington, Kentucky (page 78), presents an American equivalent of an Old World stone château. Like a château, the farm, with its fences and narrow sliver of green lane leading up to the house, dominates the view. But the composition in green and white gives a feeling not of arrogance but of harmony, of the man-made and nature complementing one another. The marvel of rural architecture reads as a house of light.

Children's games are another way of remaking time, and it's not for nothing that baseball with its green diamond and pastoral perspective lines sums up small-town rural America; not hours and minutes, but the innings of a slow-moving summer afternoon. Bullaty and Lomeo do not give us the Shoeless Joe Jacksons, the Catfish Hunters. But there is a magical shot of a children's team exulting in the last light of an empty, exquis-ite Cooperstown stadium—as if this truly was where Abner Doubleday invented baseball (page 131, bottom). Just as evocative is their shot of a still younger foursome, framed by a white unicorn clapboard house, playing in the gold leaves and clearly becoming, with their gesturing hands, their blond hair, gold-tinted leaves themselves (page 88).

■ ■ ■

Whispers antiphonal in azure swing.
—HART CRANE, "THE BRIDGE"

Our skyscrapers, those "pin cushions," as Henry James derisively called them, are not America's answer to the great Gothic cathedrals. A nation that worships space and defines itself by its highways would always rather look out than up. Our monuments are mainly horizontal ones—bridges, shopping malls, sports coliseums.

If skyscrapers represent an exception of a kind, they have come nonetheless to epitomize the American city. A New York, a Chicago, a Dallas, is its skyline as much as a Samarkand was its turquoise-domed mosques. They are what visitors come to see. When it comes to putting on a show, bigness may be best.

If we view skyscrapers as the city's response to the challenge of the mountains, one great pinnacle swaying against the next, they are also, as Bullaty and Lomeo capture them, chromatic fantasies: steel-and-glass instruments registering the shifts of light and wind; a minimalist black-and-white-striped keyboard against which another set of striped flags plays like the flying hands of a jazz pianist. The more we look at that Art Deco wonder, New York's Chrysler Building, the more the vibrations seem to be lifting us up, higher and higher, in an ever more attenuated, more exhilarating chord (page 97).

23

This sense of a musical suite, once instilled, goes on, from the glass canyons of midtown New York to the echoing volumes within volumes of Detroit's Renaissance Center (page 110) to the pizzicati-like razzle dazzle of neon Las Vegas (pages 112–113), shot as full of jutting energies, of shimmering life, as the cities themselves.

The great virtue of the skyscraper is, of course, that it hides people, disperses them into so many windows, so many notes plinking upon glass. But it could be that, even in these photographs, there could be present a person too microscopic for us to see, adding a note of his own to the glint of a roof. I am reminded of the "Talk of the Town" piece the *New Yorker* ran some years ago about a man whose particular vice it was to sneak out during his lunch break onto the forbidden roof of one or another great edifice. Sizing up the suicidal possibilities? Hankering after a more encompassing view? No, he was merely supplying a missing note. He was inspired, he said, by those old paintings of the Roman Forum: the goat standing on a famous tomb, the cows grazing by some fallen columns, the way they brought all that silence to life. It was just that which he was doing, high up there with his lunchbox, surrounded by those steel-and-glass sentinels. And I would like to think that Bullaty and Lomeo, suitably forewarned, could have found a way to accommodate him. Can a photograph ever be replete enough?

■ ■ ■

For much of its history America remained more of an idea—a grand experiment—than anything with concrete borders, let alone a distinctive identity. It's that red-white-and-blue idea to which the "Americana" chapter pays homage.

A flag outside a home on a suburban or rural street carries one set of associations: "Take It or Leave It,"

"Better Dead than Red." Flapping against an inhuman skyscraper, or streaming implausibly in the wind opposite a Badlands wall, it carries something of our brashness, our spirit, our joy to be out there ourselves in the wind, alive and flapping.

Red and white. Red, white, and blue. Flicking through *America, America*, we keep hurtling into those stars and stripes. It may be the cloth on a picnic table; or the colors of a gas station; or a centenary display of some dolls in a store window; or the several-times-life-size Uncle Sam Yankee Doodle Dandy; or some cheerleader high school beauties; or a flag arranged out of Coca-Cola cans that Bullaty and Lomeo found in a shed behind a gas station, a reminder that Coca-Cola represents—with "OK"—our contribution to world language.

This patriotic leitmotif works against the beauty to set a counterpoint rhythm all its own. Bullaty and Lomeo don't want us to forget for a minute in whose America we are. Should attentions stray, there are other reminders: drooping eagles, aggressive, devouring eagles; old Amoco pumps with turbanlike pompadours (page 152); a map of America—an America different in shape from anything one has ever seen—caught on a motel's TV screen, along with a not exactly overjoyed Angelo in the bedcovers (opposite). Kitsch, yes, but as the patterning recurs, it all adds up to something—the insistent rhythm of a place and its people.

■ ■ ■

Crashing waves, skyscraper facades, jazzy red-white-and-blues—again and again we can sense a dynamic running through these captured moments and transforming them into something very much like music. But much as we rejoice at these musical textures, we can't help but want something more concrete: faces, lit up, blowing into their horns; a neon-lit street pouring out a sound all its own.

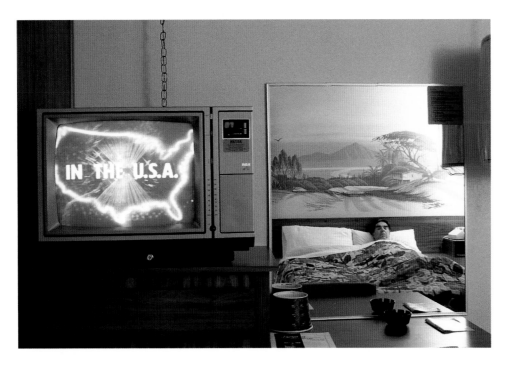

Angelo Lomeo in a motel | TWENTYNINE PALMS, CALIFORNIA

New Orleans is the musical heart of America, where jazz began and where to this day it very much thrives, at virtually every hour. Bullaty and Lomeo's portrait of a man playing a bass takes us to the human core of their enterprise (page 124). The bass is huge, truly monumental. Compared to it, the player staring out at a point somewhere above us hardly exists, the shadows have so taken him over. (For a while we believe him to be unreal, not someone playing but the specter of a poster, an advertisement proclaiming, "Jazz, New Orleans.") And the shadows have such quickness, such quivering life in them, that we read them as music itself—a man engulfed, being himself played. I am reminded once again of how Bullaty and Lomeo's photographs do not portray so much as they evoke.

I have commented on Sonja's Rembrandtesque Preservation Hall photograph, shot while she sat on the floor in impossible conditions—the impossible is always fair game!—but not on her Whistlerian tone poem of the musician playing a saxophone in wet, heavy fog (page 125). Already, several blocks away, Sonja had become intrigued by what she was hearing. Following the sound, she came upon the musician, who gave no sign of being aware there was anyone around, much less a photographer shooting him. The night, the spectral illumination cast by the fog-aureoled gas lamp, the old pole-supported house across the street, even the saxophonist's hat, all take us back to an earlier New Orleans, as if it were the birth of the blues itself we were witnessing: a man inconsolable, in a damp, lonely place, playing his heart out. And his profile against the lights of Natchez sparkling, blaring on the Mississippi, makes it seem as if we were seeing the very notes themselves suspended in the wet air.

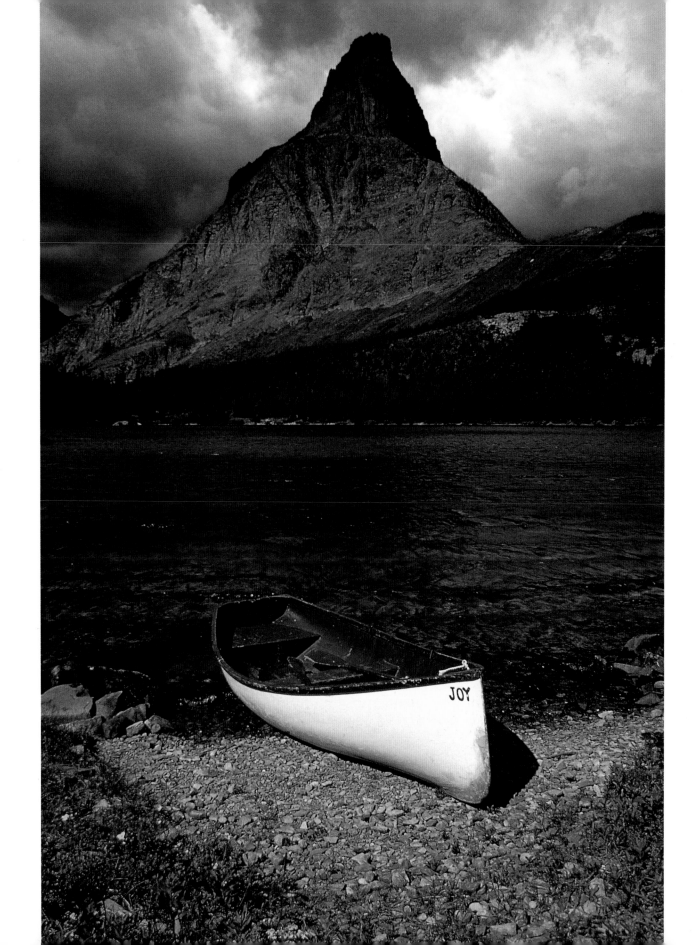

■ ■ ■

Bullaty and Lomeo could have ended with their shot of a canoe, empty, waiting for one of us perhaps and a departure of our own (opposite). But *America, America* is about the land, and the last two chapters, "Wildlife" and "Alaska and Hawaii," bring a restoration of scale and a return to a more elemental America.

The land is itself changeless. It is the light, and the movements across it, that bring it to life: the parallel fins, say, of a pair of diving whales (page 188) counterpointing the mountain immensity of Glacier Bay; the asymmetrical Smoky Mountain pine tree caught in the soft green mist of what might be an old Chinese painting, with a young black bear profiled high on a branch (page 166). (How did it climb there? Or did the bear fly in?)

But in capturing a moment of wonder, Bullaty and Lomeo are setting off a process that, hopefully, will end in all of us working together to save our endangered populations. It is fitting in this regard that the chapter contains some stunning tableaus of the animal colonists who preceded us—mountain goats (page 179), a remnant buffalo in Yellowstone Park (page 178), geese outlined against an almost apocalyptic sunrise (pages 182–183).

My own favorites, however, involve two shots of a species in no wise endangered, the white-tailed deer. In a scene of overcast wintry desolation a doe has stopped in the middle of a field to make its own stationary point— yes, life goes on (pages 174–175). The second could be an image out of a prehistoric cave painting: a stag ambling along a blue-and-purple-lit canyon wall (pages 176–177). An art of the moment has given us once again an image that could be that of the beginning of American time. From these pictures—the colors, the animal, the striking early morning light—we see afresh, our eyes restored to innocence.

In the "Alaska and Hawaii" chapter we are stretched by a new, expanded America. The focus is an elemental one: in Alaska, ice; in Hawaii, fire. Angelo's virtuoso shot of the Mendenhall Glacier came about because of a helicopter window that had been left open. The perspective is such that we are looking down on a helicopter, a minimal presence of man, atop glacial folds (page 192).

In the Hawaiian photographs we move from the paradise of a Douanier Rousseau-like flowering tropical glade (page 198) to the Oriental landscape of a live volcano (pages 206–207), its interruptions of flashing fire and billowing mist projecting out from the barely apprehensible shoreline contours far, far below. Two succeeding shots, taken in Hawaii Volcanoes National Park, feature another aerial view of a volcano's steam vents rising out of the sea, and Sonja's shot, taken walking on steaming lava, of what the first days of creation may have looked like, were our eyes capable of registering such a range of definition, of contrasting greens, golds, blacks. Here is America itself coming into being.

In its vast scope, its fifty-year range, *America, America* may at times offer a reality eclipsing what we have ourselves experienced. But the spirit that animates their photographs enables us, despite ourselves, to believe in them—the light, the shadows, the visual completeness. Their America, we are persuaded, is us in all our frailties, our hopes, our rapidly changing moments. Looking at it, we see anew nature's wonders and our amazing human accomplishments. And we learn how we may go about making something more of the variety of light, of circumstance, in which we so briefly, so uniquely, find ourselves.

OPPOSITE Glacier National Park | WEST GLACIER, MONTANA

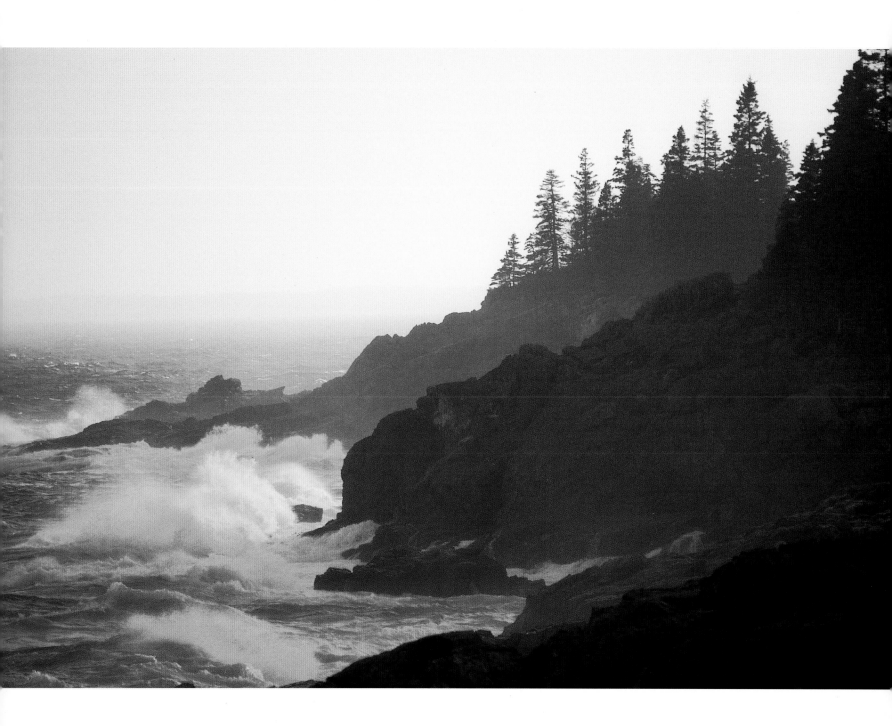

From Sea
to Shining Sea

COMING TO AMERICA FROM EUROPE, THE VISITOR FIRST NOTICES THE CHANGE IN SCALE. THE CONTOURS, THE valleys, the land masses are all so much larger. The images in this chapter project that elemental grandeur, with its wealth and variety of light and seasonal color. It is there (opposite) in the gale lathering the rocks of Maine's Acadia National Park. And the little inset of a tree (left) is nothing less than a section of the world's biggest tree, the General Sherman sequoia. These pictures strike a definite tone.

The remainder of the chapter takes us through this very large, elemental America. First, the two shots of the Atlantic and Pacific: a sunrise caught off the coast from Georgia's Cumberland Island, and an early morning at Big Sur, several hours south of San Francisco.

The next photographic theme uncovers the startling shapes of the land that awaited—defied rather—the first human settlements. A sunrise over Monument Valley (page 31) with its ancient erosions leads into a photograph of first light over Death Valley's pale dunes—the inhuman touched into life (page 34). On the opposite page another big-contoured scene from the White Sands, New Mexico, missile base brings an image of the year's awakening.

From prehuman time we move to shapes that the first human might have experienced: the couple so alone they might be Adam and Eve

OPPOSITE Gale winds, Acadia National Park | MT. DESERT ISLAND, MAINE

ABOVE General Sherman Tree, Giant Forest | SEQUOIA NATIONAL PARK, CALIFORNIA

contemplating the desolation of Death Valley from Zabriskie Point; the light entering a formation in Antelope Canyon that has the feel of an early place of worship.

Next comes a sequence of rock shapes: two battles of boulders and trees from Yosemite and Utah's Arches National Park are set off against a geologic slugfest from the North Dakota badlands. This in turn yields to a more serene photograph of the same badlands over the border in South Dakota: a single triangular formation giving way to peaks set in almost wavelike cadences.

By way of transition are two echoing shots of golden fall color near Aspen in the Rockies. And we land on two monumental images of reflecting lakes: Angelo's is of Lake McDonald in Glacier National Park; Sonja's is a trompe l'oeil of reflections caught in the High Sierras.

From these lake scenes we progress to a more closed forest setting, each displaying a different habitat. A classic boreal forest lies in northern Maine. South Carolina, immediately below, brings in a cypress swamp: trunks that we see only in the water in their musiclike reflections, vertical strokes of lavender bleeding into gray, photographed through the screen of a

pink-flowering azalea. The other images present a mixed forest in the Smokies and some dryland ponderosa pines in the High Sierras. These two pages prepare us, in turn, for the mosses and lichens, the study in green textures that is the Hoh rain forest in Washington's Olympic Peninsula.

From this internal forest world we move out with a photograph of the prairie's "waves of grain," from the song that inspires the chapter title, "America the Beautiful." The image shows a tapestry of warm honey-colored grasses set against a horizon row of shimmering grain elevators—nature and industry in rare harmony.

"From Sea to Shining Sea" concludes with a seasonal quartet: an amazing juxtaposition of a huge, over-loaded weeping cherry tree playing off against the snow in a New Hampshire apple orchard; a shimmering expanse of gold-red poppies in the Mojave Desert setting up the tonalities of a very different fall mountain display in New Hampshire. It all ends in the pyrotechnics of a pair of sunsets: the first over the north rim of the Grand Canyon; the second of the Pacific looking out from Jenner, California. The circle, hopefully, has been made complete.

Sunrise | MONUMENT VALLEY, ARIZONA

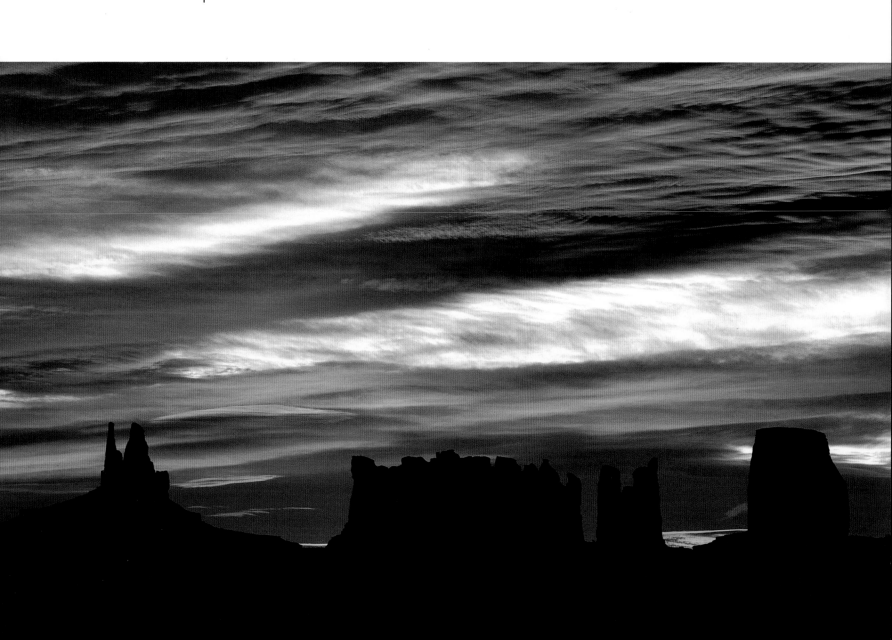

Sunrise over the Atlantic Ocean | CUMBERLAND ISLAND, GEORGIA

Morning light over the Pacific Ocean │ BIG SUR, CALIFORNIA

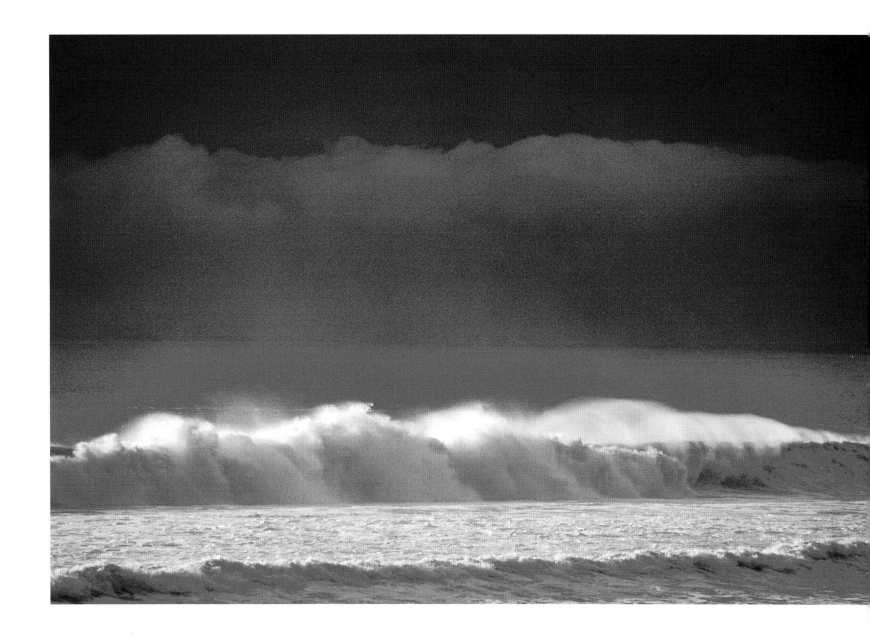

First light over dunes | DEATH VALLEY NATIONAL PARK, CALIFORNIA

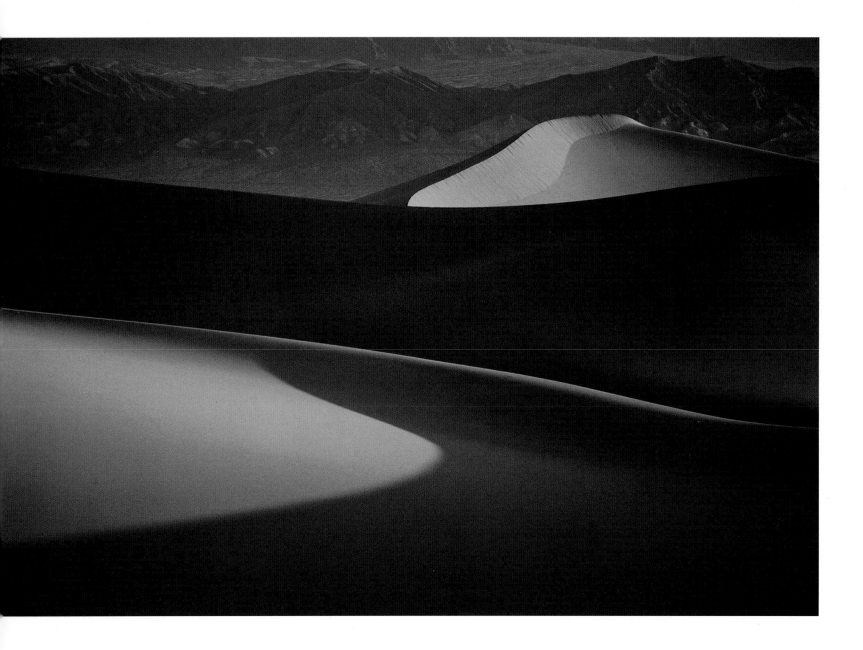

Mid-morning, White Sands National Monument | ALAMOGORDO, NEW MEXICO

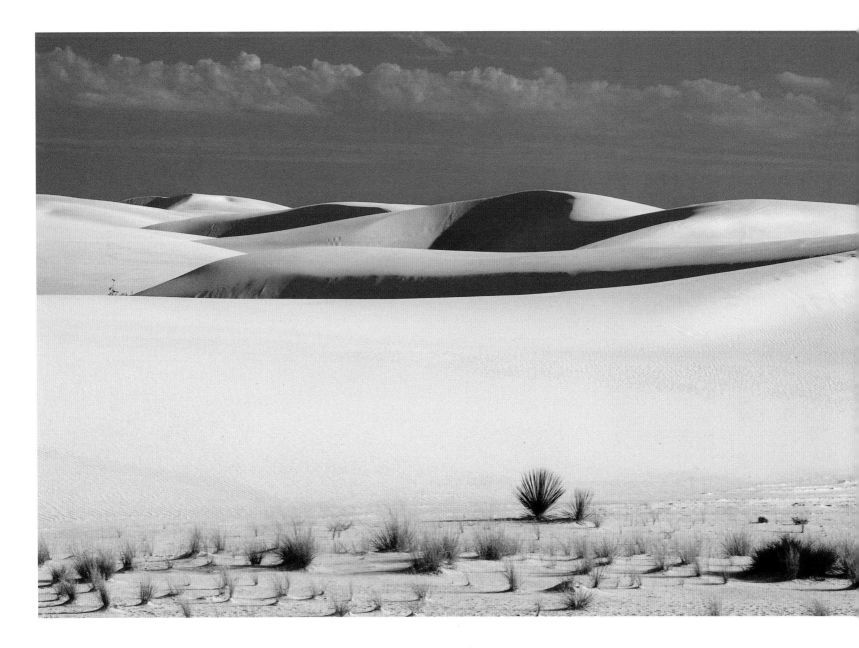

FOLLOWING PAGES, LEFT Zabriskie Point | DEATH VALLEY NATIONAL PARK, CALIFORNIA

RIGHT Antelope Canyon | PAGE, ARIZONA

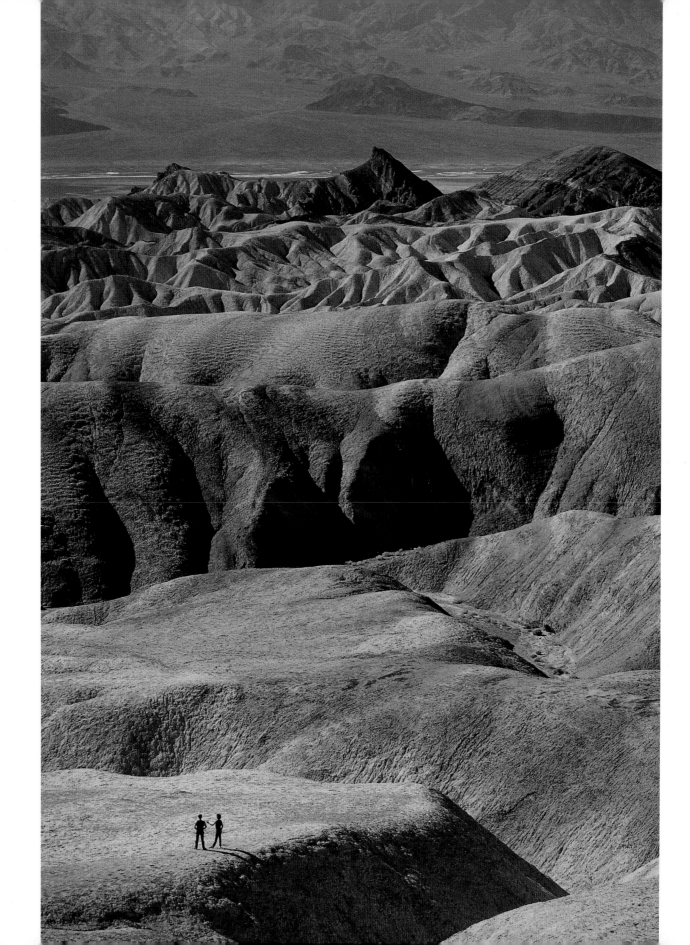

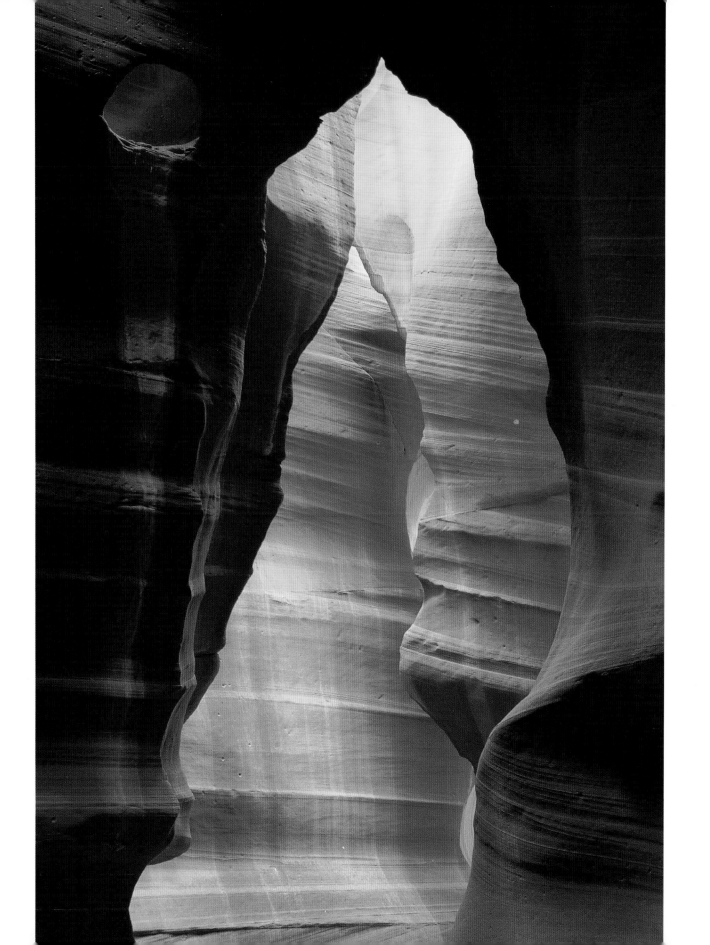

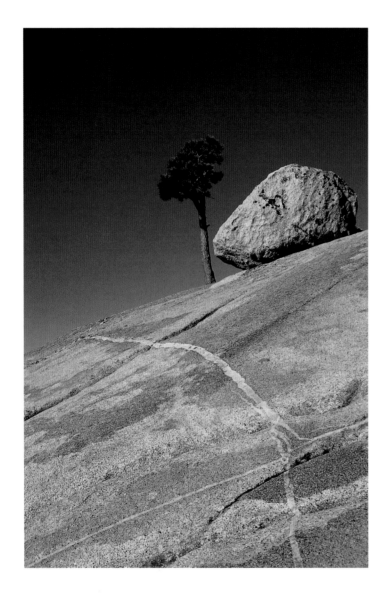

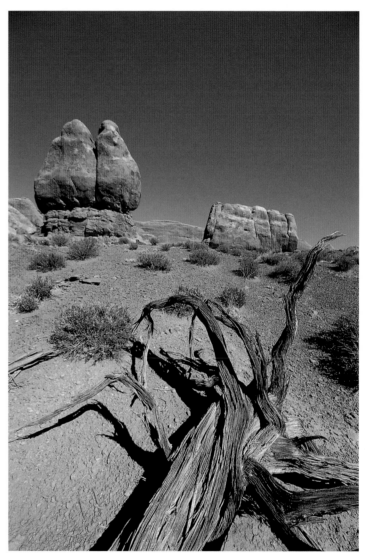

Olmsted Point | YOSEMITE NATIONAL PARK, CALIFORNIA

Arches National Park | MOAB, UTAH

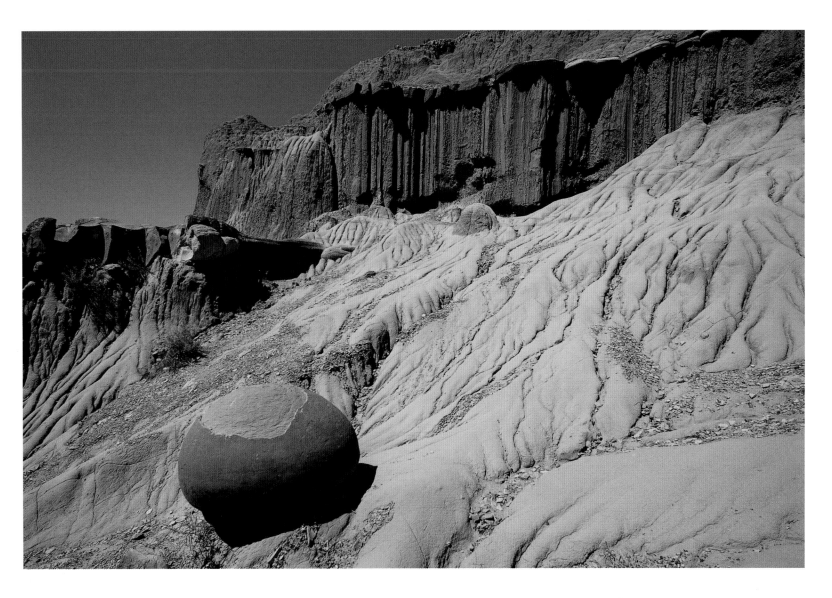

Theodore Roosevelt National Park | NORTH DAKOTA

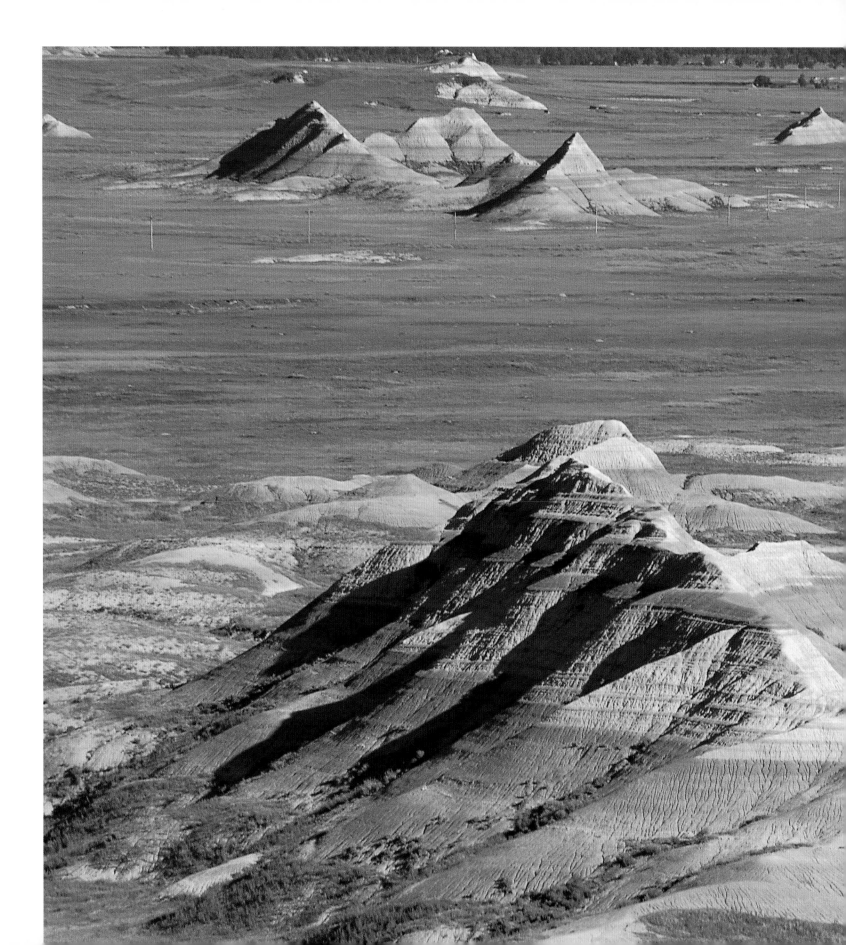

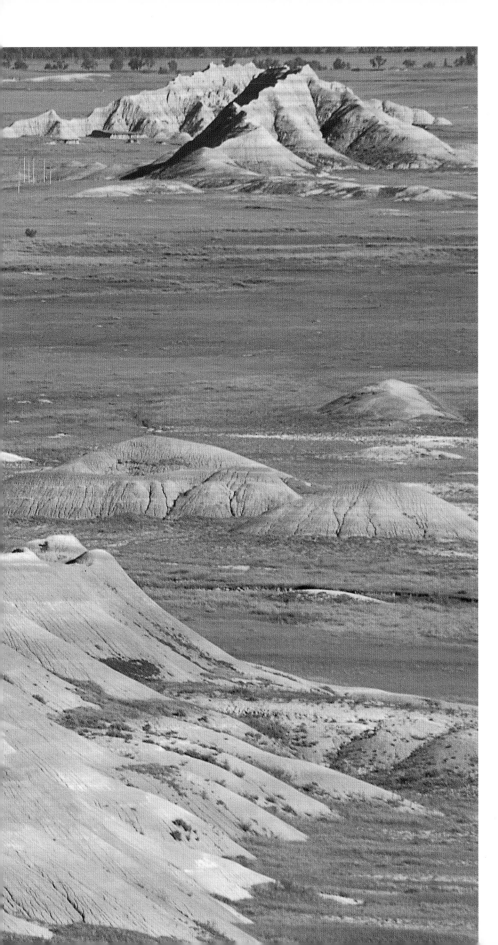

Badlands National Park | SOUTH DAKOTA

FOLLOWING PAGES

LEFT Maroon Bells in the
Rocky Mountains | ASPEN, COLORADO

RIGHT Aspens in fall | ASPEN, COLORADO

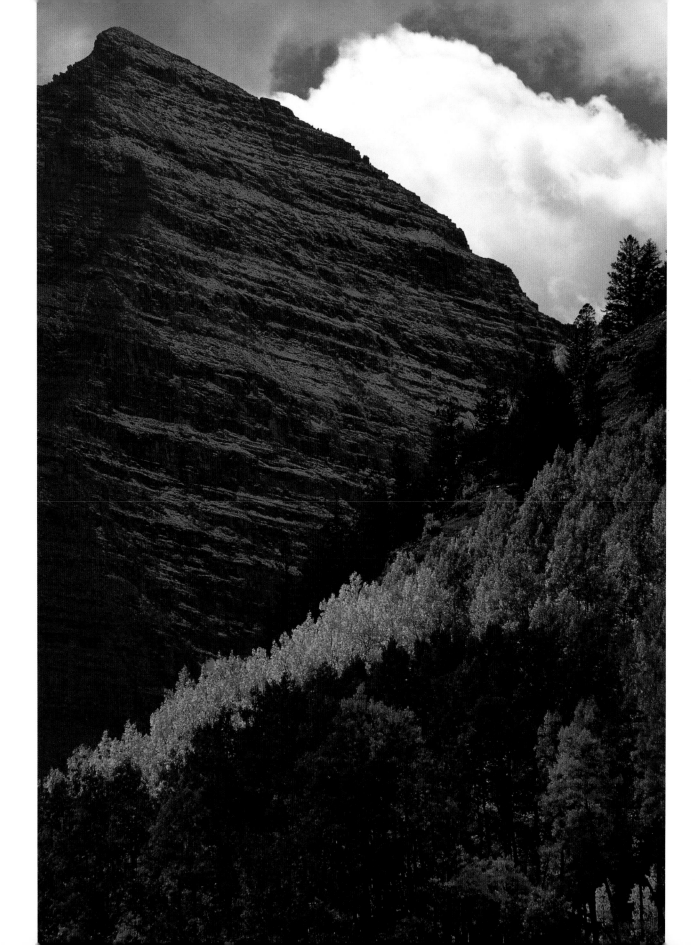

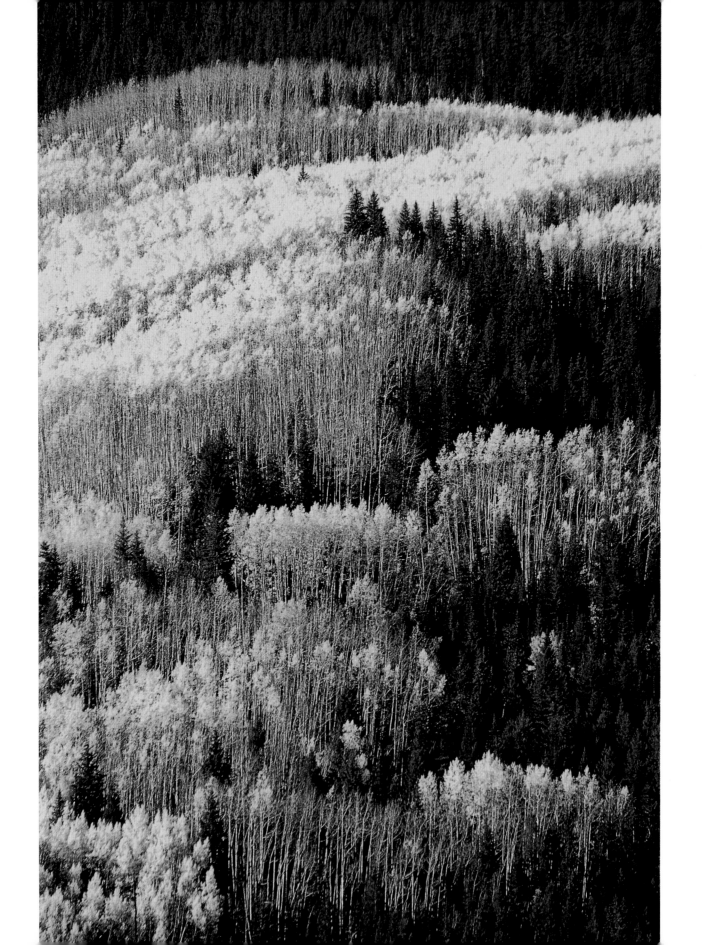

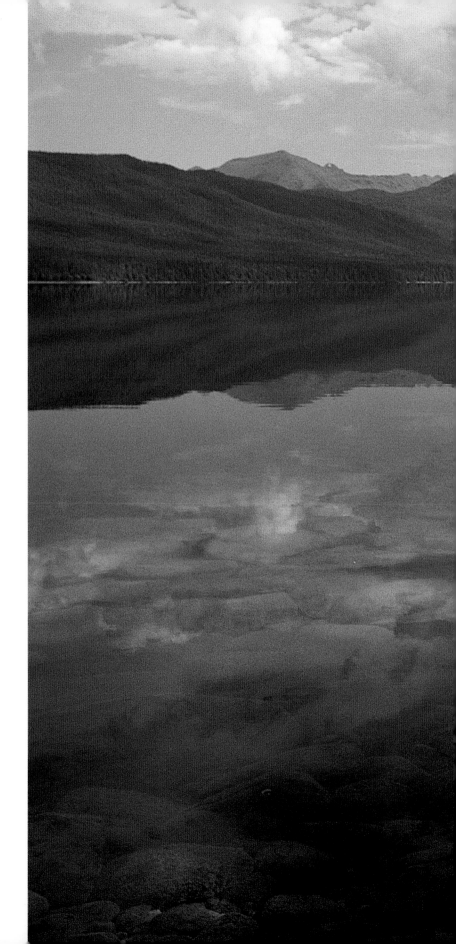

Lake McDonald | GLACIER NATIONAL PARK, MONTANA

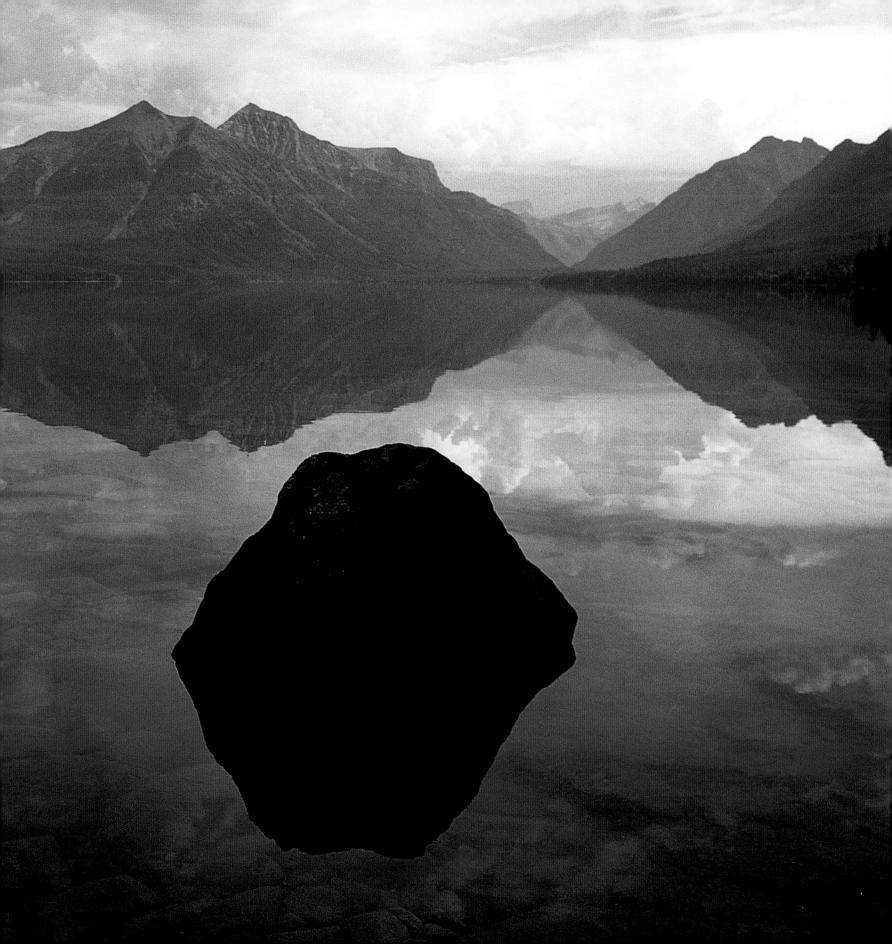

Pond in the High Sierras | SEQUOIA NATIONAL
PARK, CALIFORNIA

Forest | MAINE

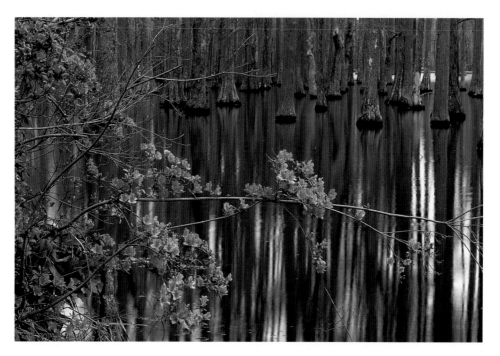

Cypress Gardens | SOUTH CAROLINA

Great Smoky Mountains National Park | NORTH CAROLINA

Ponderosa pine | SEQUOIA NATIONAL PARK, CALIFORNIA

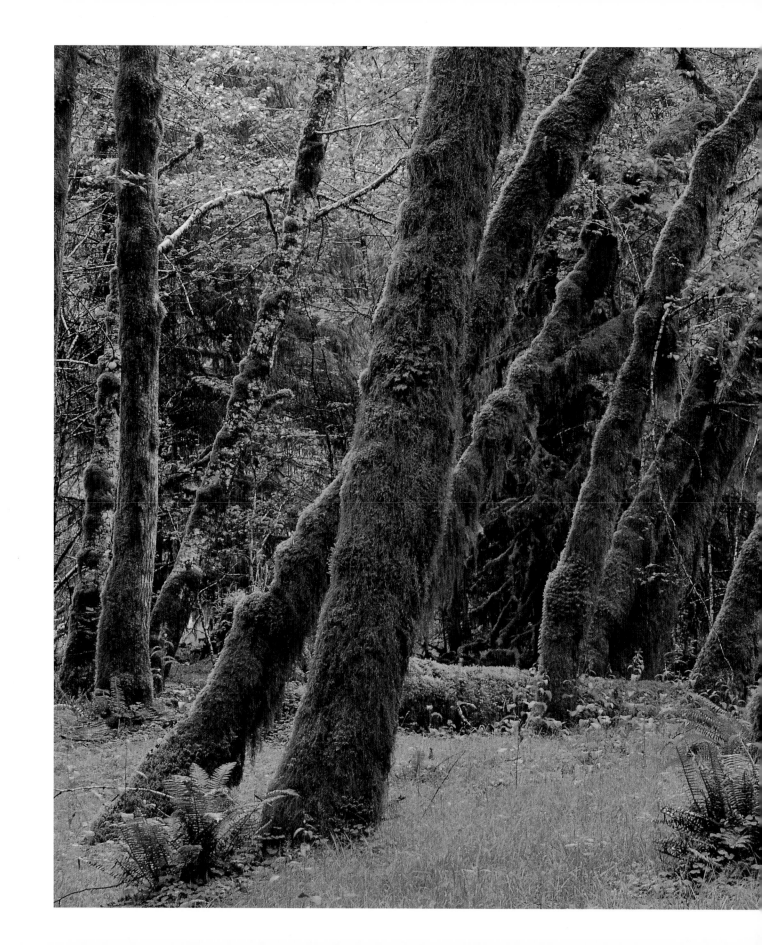

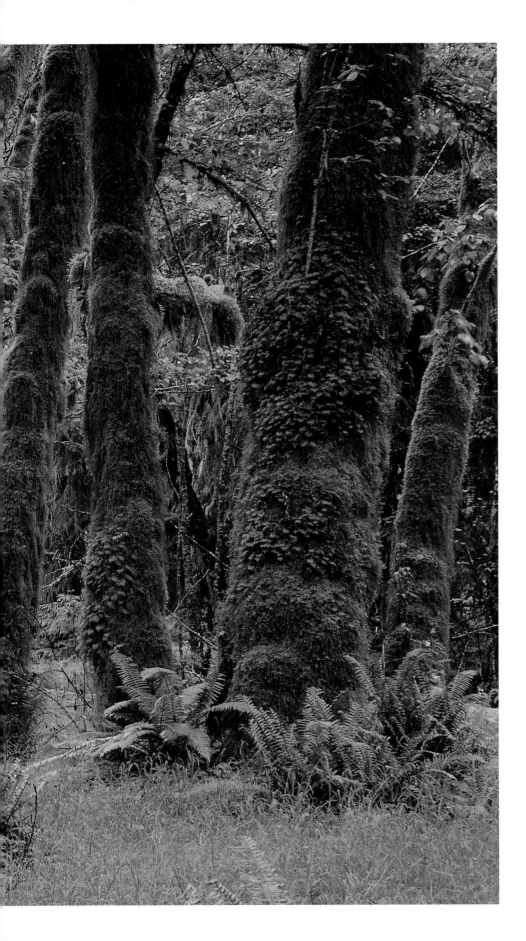

Hoh rain forest | OLYMPIC NATIONAL PARK,
WASHINGTON

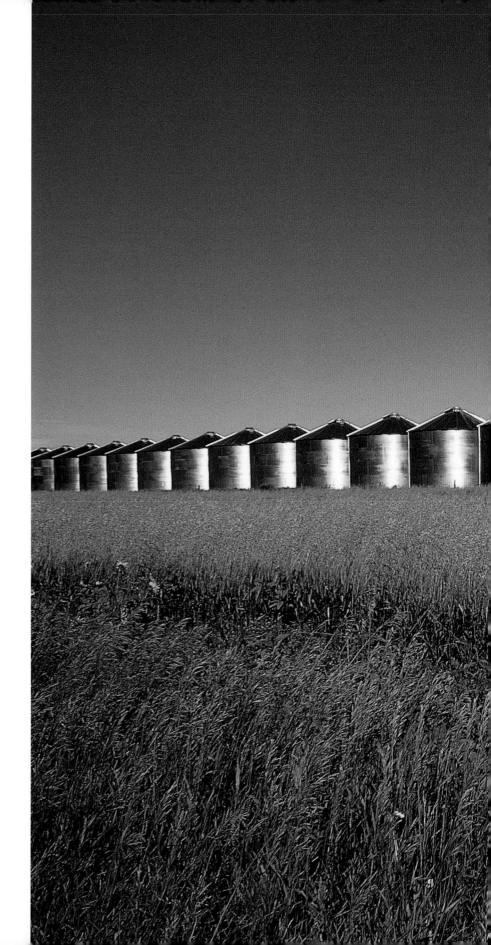

Grain elevators | GREAT PLAINS, MONTANA

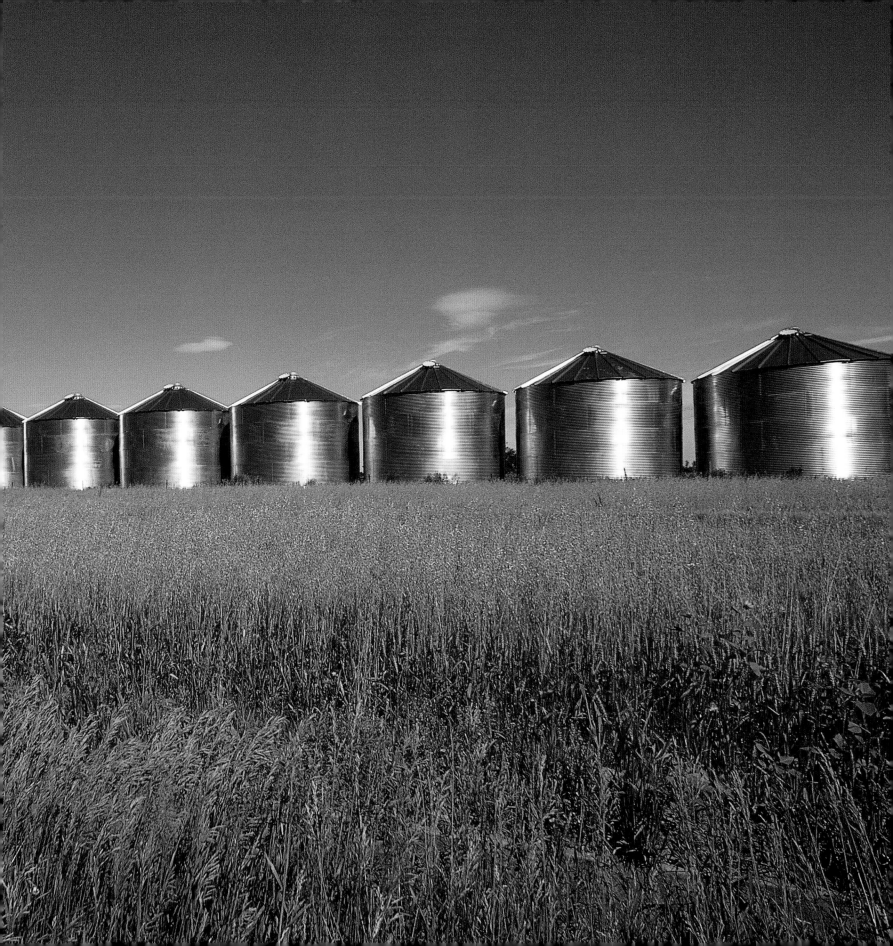

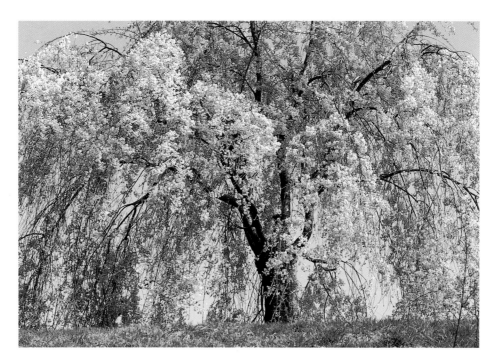

Weeping cherry tree, New York Botanical Garden
BRONX, NEW YORK

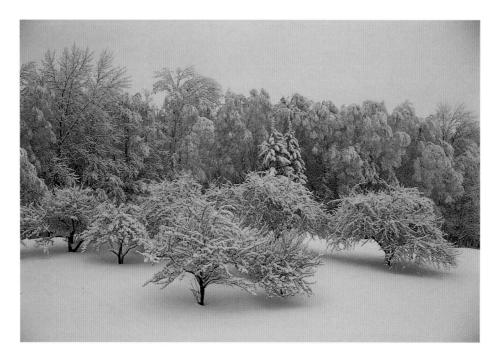

Apple orchard | NEW HAMPSHIRE

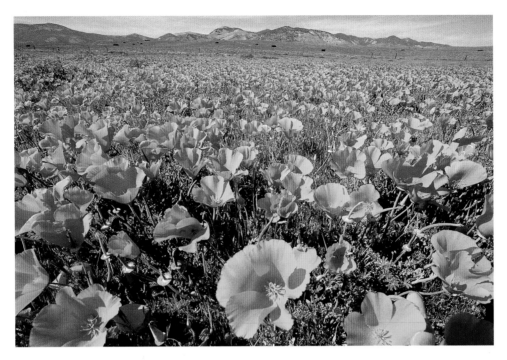

Poppies, Mojave Desert | CALIFORNIA

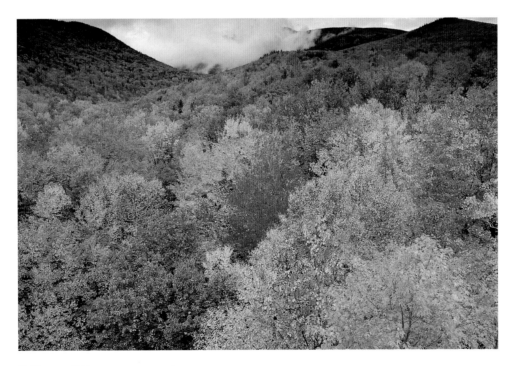

White Mountains | NEW HAMPSHIRE

Last light on north rim | GRAND CANYON, ARIZONA

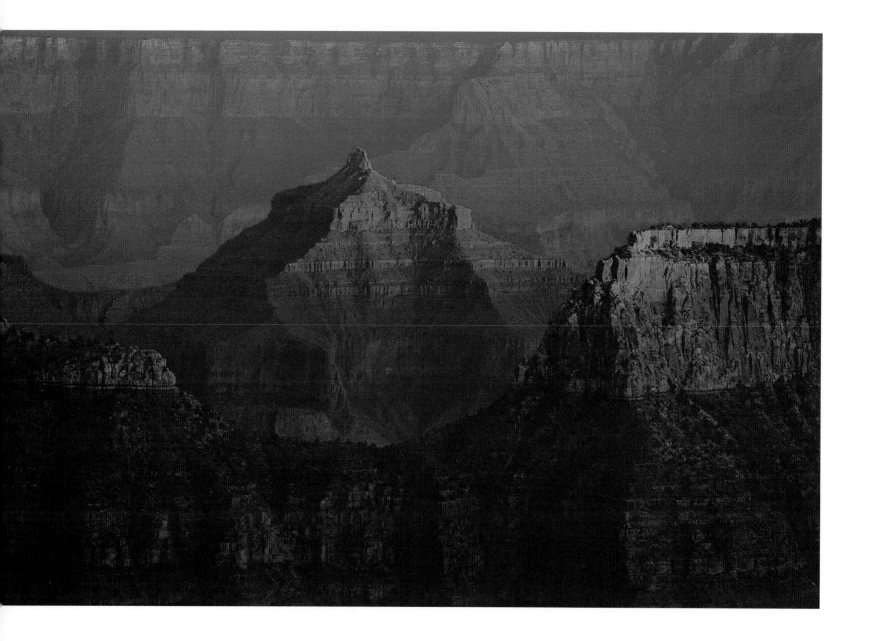

Sunset over the Pacific Ocean | JENNER, CALIFORNIA

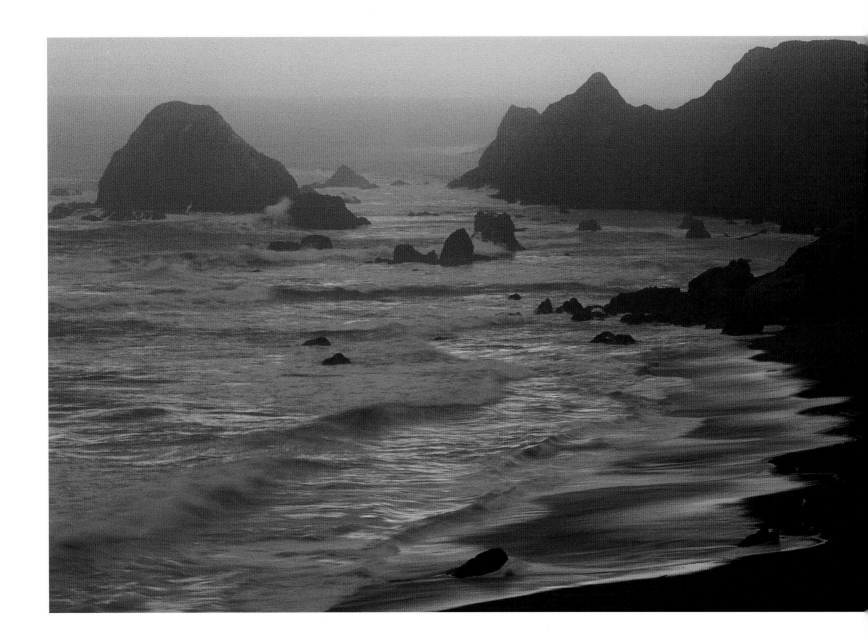

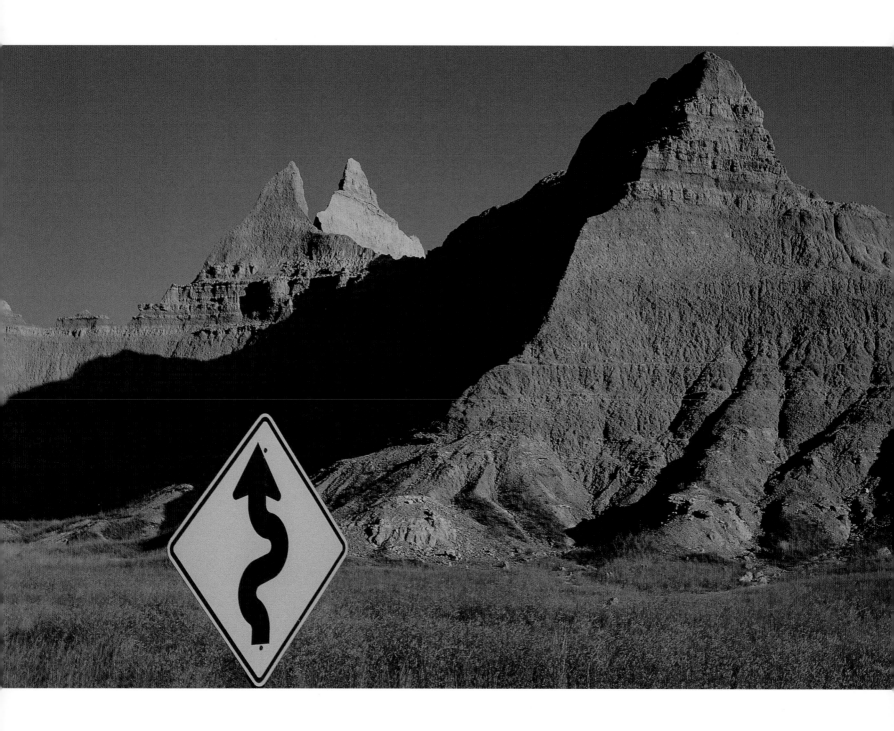

The Open Road

"FROM SEA TO SHINING SEA" GIVES US A PRIMEVAL AMERICA, MORE OR LESS UNPEOPLED VISTAS SHOT THROUGH with beauty, awe, and a reflective mystery. "The Open Road" brings us the same land, only now it is a land intersected, cut through—by us, our asphalt, our cars, trucks, gas stations, billboards, and road signs; our civilization. The beauty that is America is still very much present. But it is now a more problematic beauty, undercut by something else: satire, wit, even at times—as in the photograph on the next page of the lit-up horse-riding sign—a kind of nostalgia. Bullaty and Lomeo know that the roads that invite us can likewise define us.

Road signs represent one form of the continual dialogue going on between the road, the vast open stillnesses, and ourselves. And at 70 m.p.h. (113 k.p.h.) we need a certain amount of visual chatter—warnings, directions, exhortations—just to keep us on track. The sign, warning of a dangerous curve (opposite) is, of course, one of Angelo's jokes, because of the uncanny way the sign's curves profile the badland landscape to which it points. How fortuitous, we think! By contrast, the lit-up rider on the horse (page 61) brings a mysterious poetry, a warmth even, to an otherwise very chilling winter scene.

More problematic is the epic Death Valley vista (pages 62–63), a spectacular photograph ruined by a shriekingly red stop sign. Can't we

OPPOSITE Badlands National Park | SOUTH DAKOTA

ABOVE Interstate, Route 70 at the Continental Divide | COLORADO

just put our thumb over it and paint it out? But a sign
that so arrests us can also be an invitation, as those
signs of my childhood were, to look and listen as well.
And, maybe, if the sign makes any impact, we may be
offended enough to start trying to rethink our relation
to the land. Roads don't have to be ugly.

The next page brings, in two vertical photographs, the
same kind of juxtaposition. On the left side, the seductions
of travel, a road without any chattering intrusions cutting
into an undiluted White Mountain landscape. Looking
down at the gray ribbon of the highway, we feel the rush,
the vertigo of the call of adventure, the blurring double yel-
low line representing nothing less than the ecstasy of speed
luring us on. Across, we see one end to that same invitation:
a death train loaded with freshly cut logs chugging through
a desolate, denuded winter landscape.

There follows another vision of the road: not a
car, but a startling, van-sized moose, reclaiming an early
morning patch of road. This in turn bleeds into Angelo's
elegy for a rare harmony, a single-track country lane
blessed with a rich, continual fall of yellow maple leaves.

There now come two truly visionary photographs of
storm systems caught on the road: a lightning storm near
Lusk, Wyoming, and that double rainbow framing a red
and white gas station in Santa Fe, New Mexico. Each is a
stupendous photograph in its own right. But seen

together, they make a series of statements about both
America and "The Open Road," about exploding
powers and vast loneliness on the one hand and perfect
containment on the other, and about mystery, magic, a
moment as wide as you can see, astoundingly caught.

The "Welcome to Friend" sign, with its old-fashioned
perspective painting of a receding highway and mammoth
truck barreling by in the middle ground, is paired against
an Amish horse and buggy from a still earlier America:
two different uses of the same kind of country road.

The chapter ends with back-to-back full-page
spreads of a breathtakingly engineered, river-wide high-
way snaking down from a pass in the San Rafael
Mountains and a photograph of two different kinds of
movement, of energy—a highway's trucks and a skyline's
ultra-modern windmills in the Mojave Desert.

In a coda, we return to the theme of signs. On the
first page, the signs are a celebration of anonymous pop-
ular art: the Hopper-like Pickles restaurant with its crude
"EAT" sign looking out from a complexly layered compo-
sition; below it, a lovely painting of receding saguaro
trees honoring the "CACTUS MOTEL." And across, "HELL"
in a Maryland town, a screaming noisy cross-section of
urban visual blight that sums up the horror aspect of our
infatuation with the car and a commercially unregulated
Open Road. Just whose America is it?

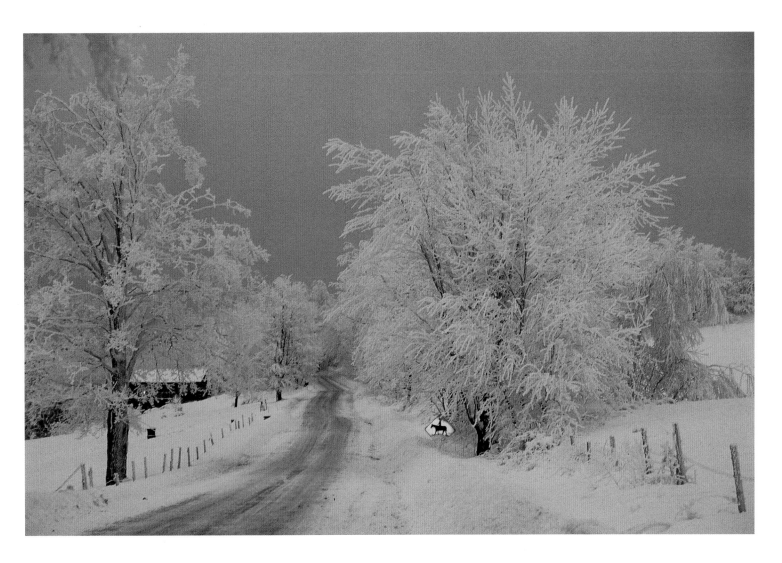

Horseback rider crossing sign | BELMONT, VERMONT

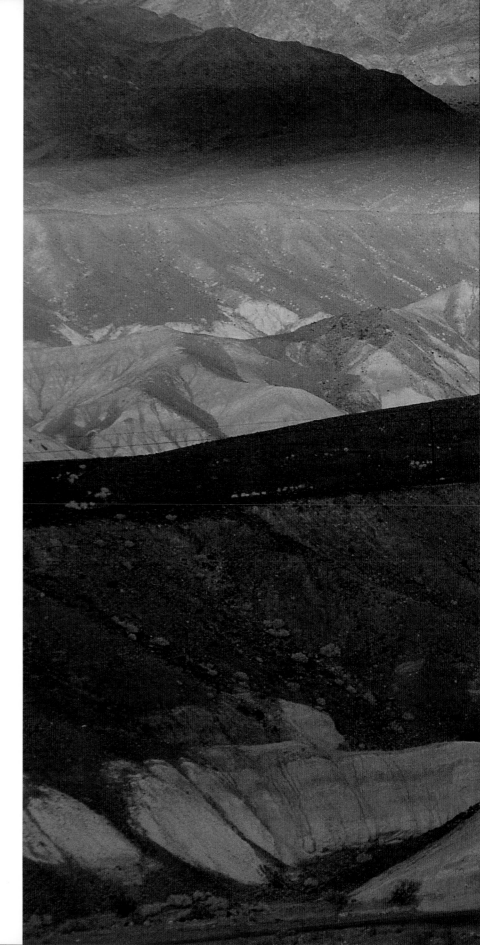

Stop sign, Zabriskie Point
DEATH VALLEY NATIONAL PARK, CALIFORNIA

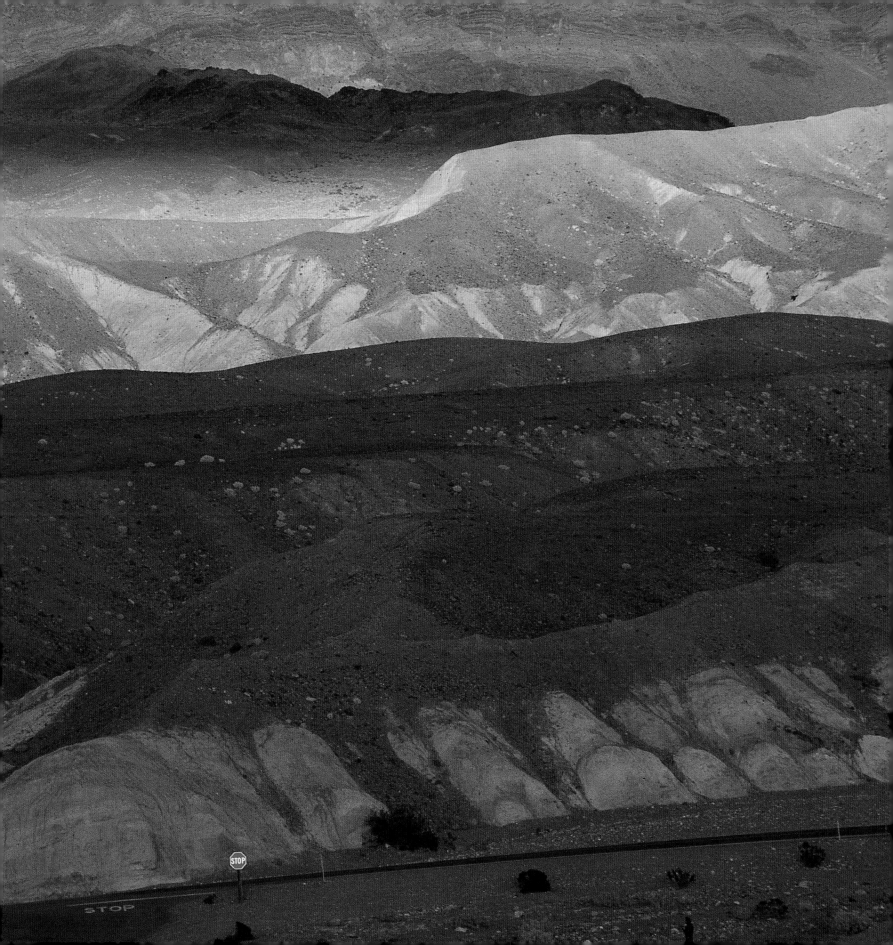

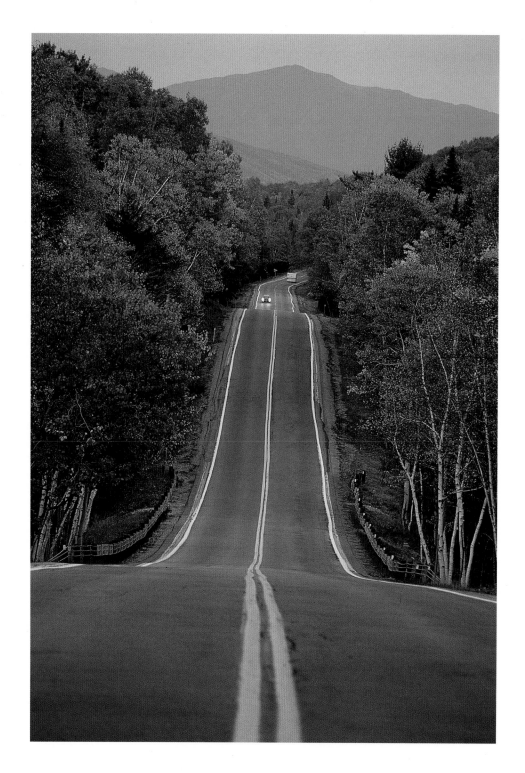

Highway through the White Mountain National Forest
NEW HAMPSHIRE

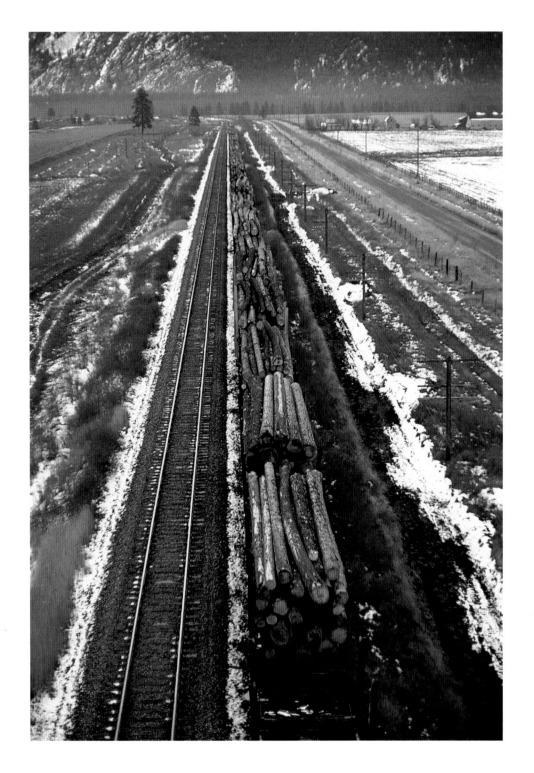

Logs on railroad cars | MONTANA

BELOW Moose crossing road | MAINE

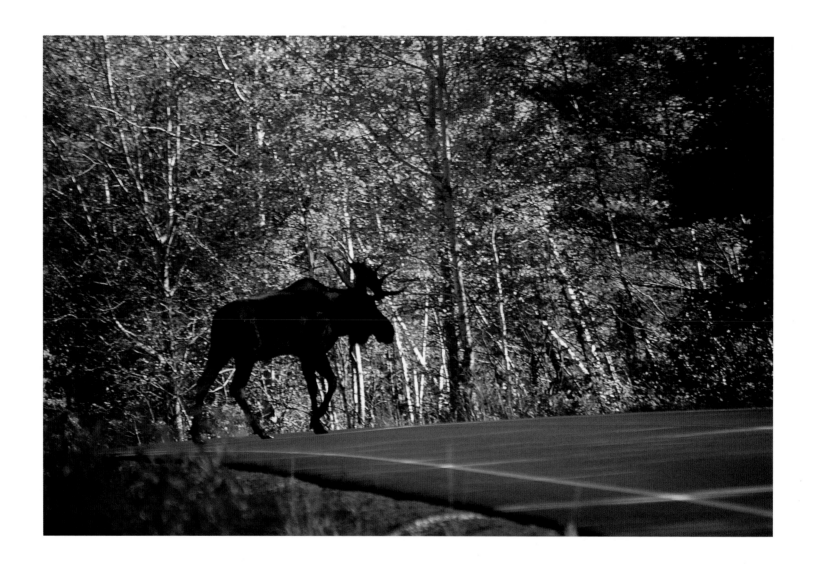

OPPOSITE Fall foliage | VERMONT

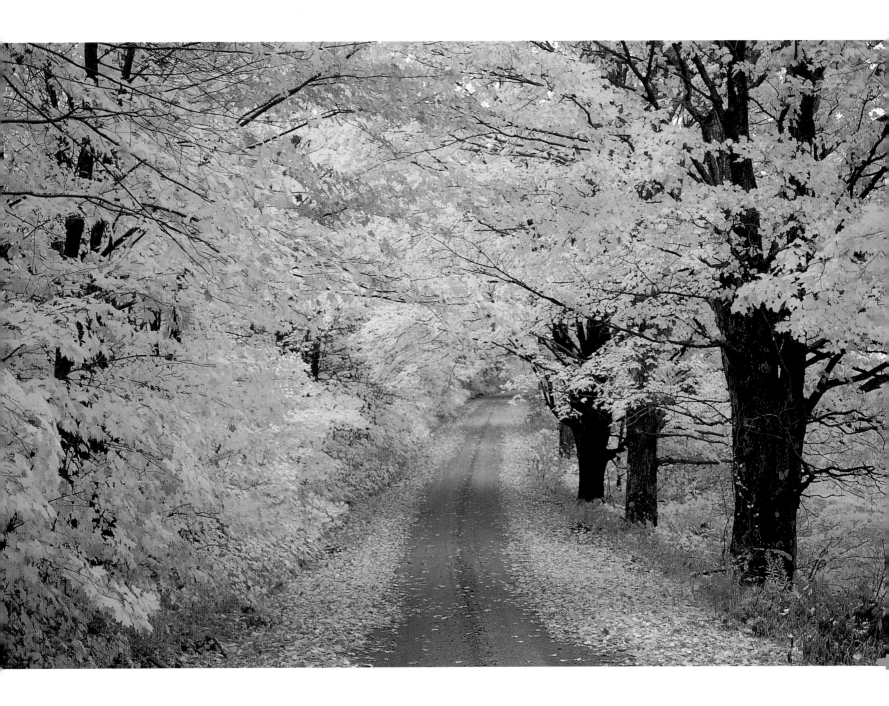

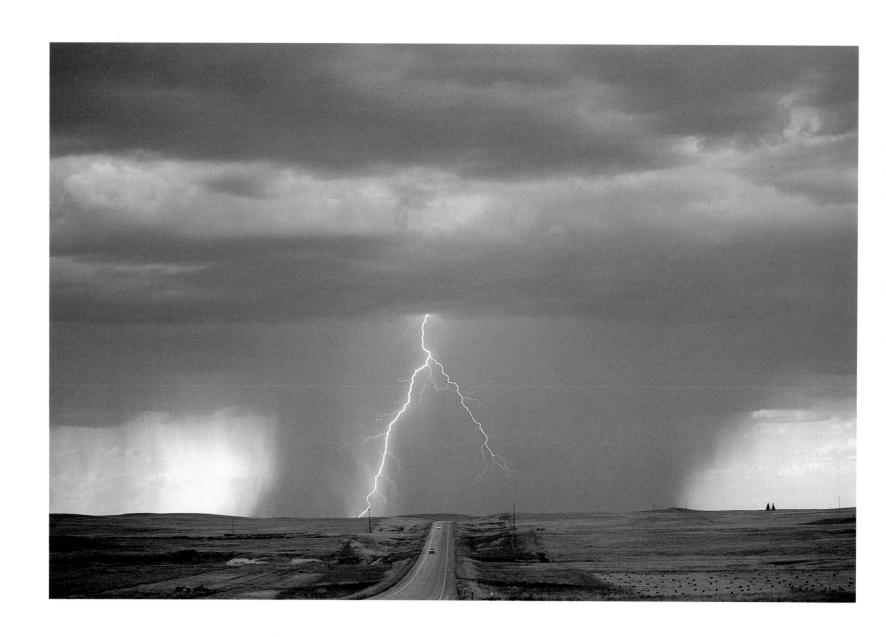

Lightning storm | LUSK, WYOMING

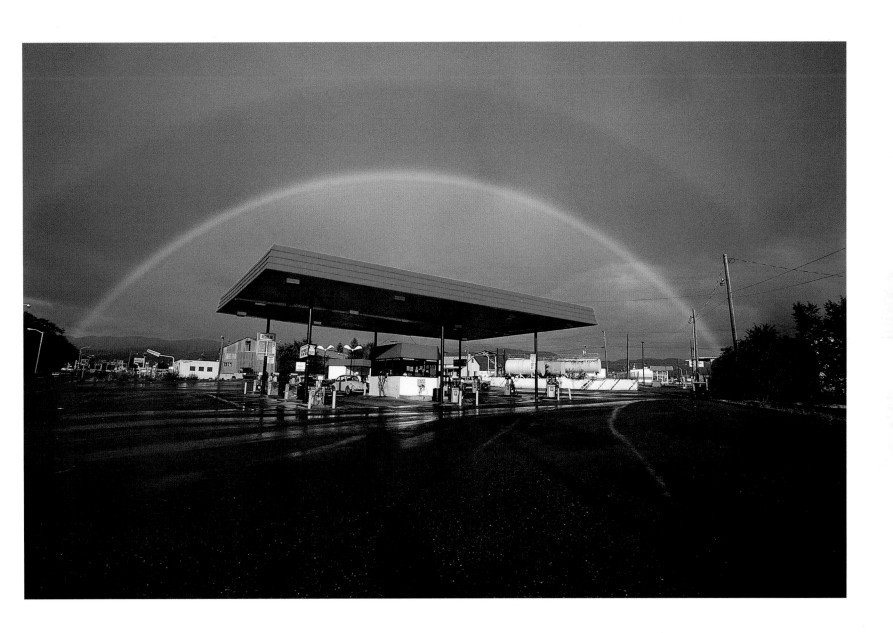

Double rainbow | SANTE FE, NEW MEXICO

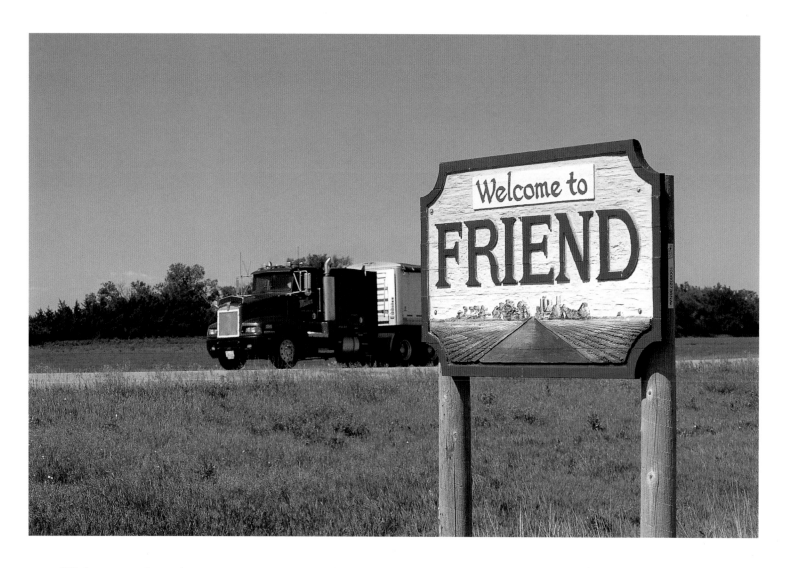

Welcome sign | FRIEND, NEBRASKA

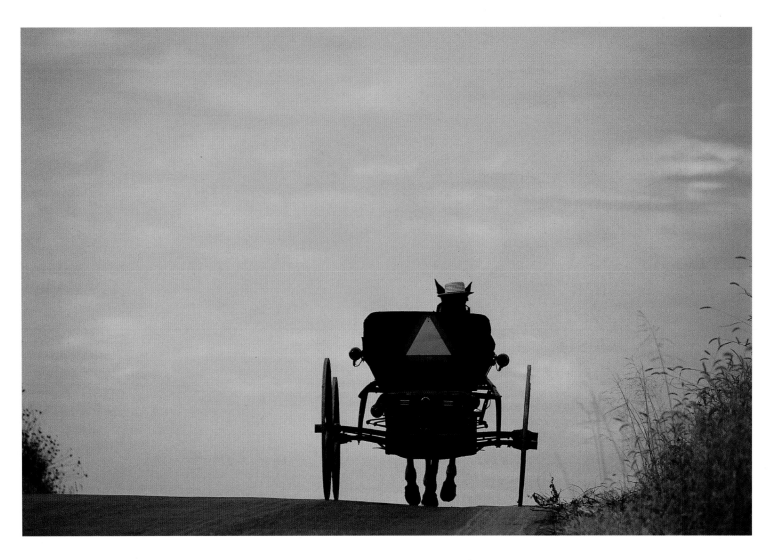

Amish carriage | INTERCOURSE, PENNSYLVANIA

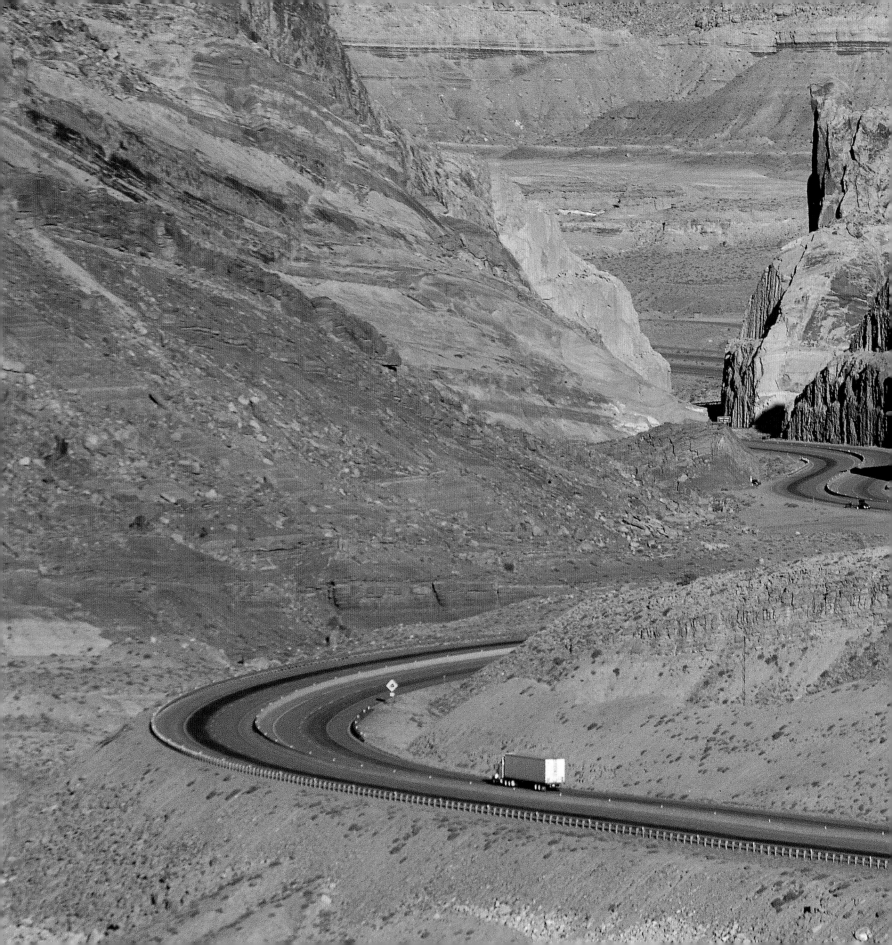

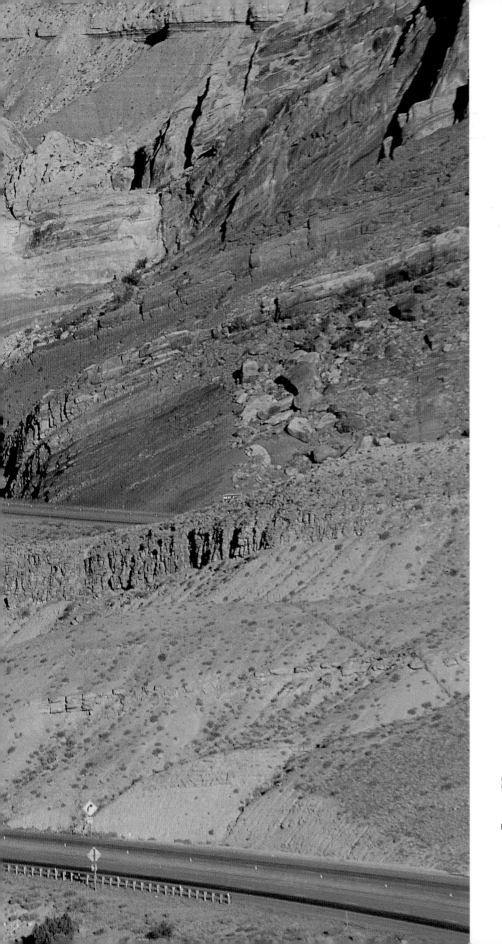

San Rafael Swell | UTAH

FOLLOWING PAGES Windmills | MOJAVE DESERT, CALIFORNIA

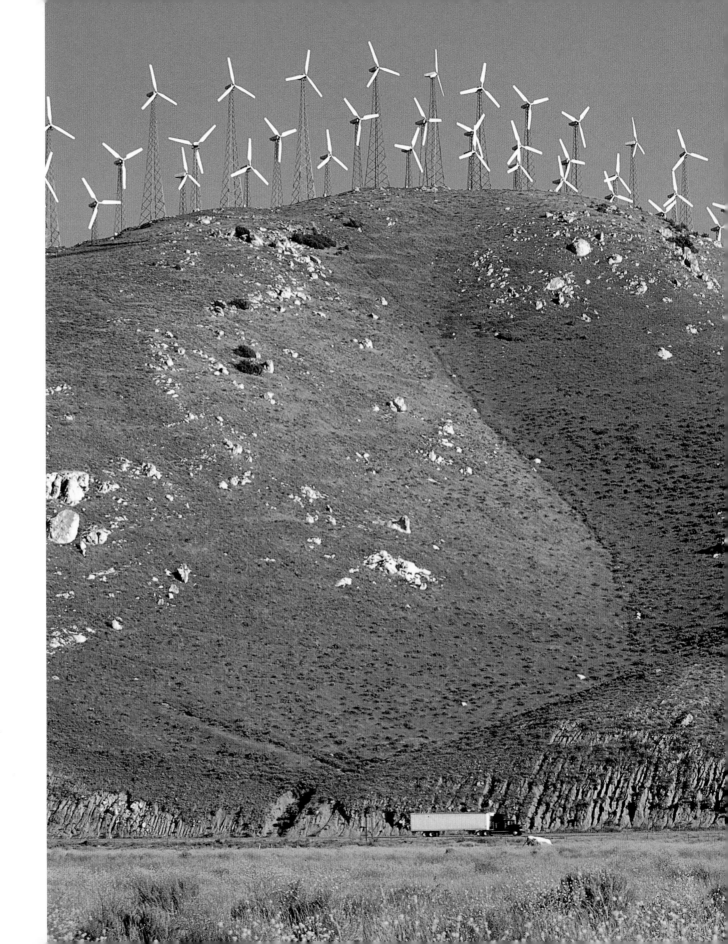

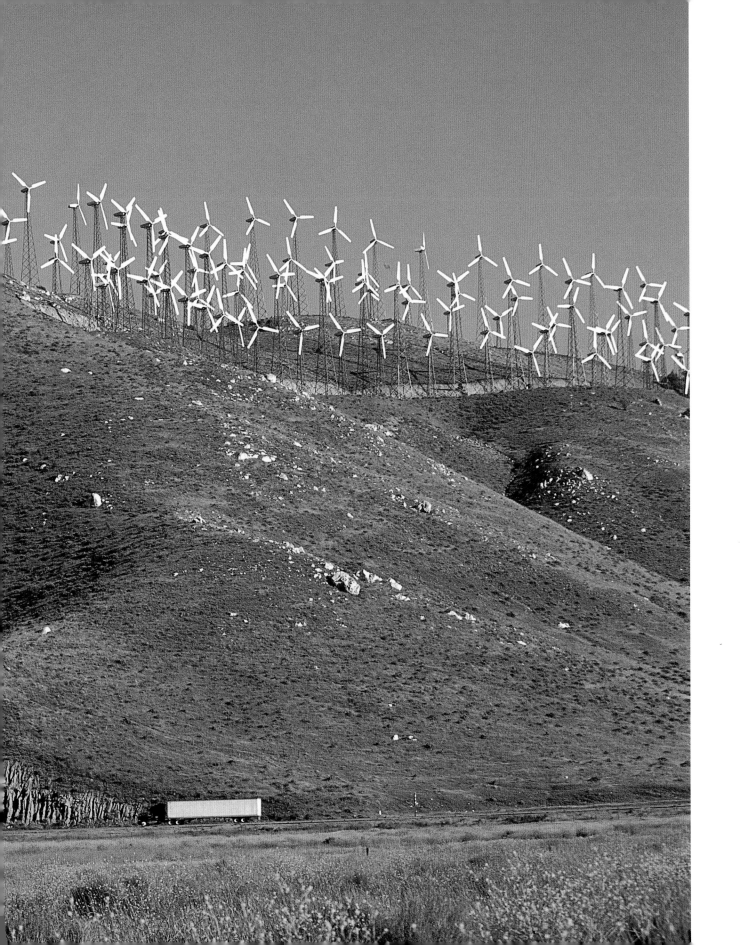

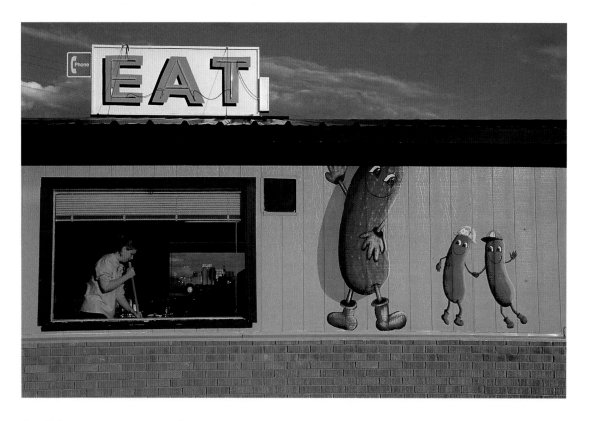

Pickles restaurant | ARCO, IDAHO

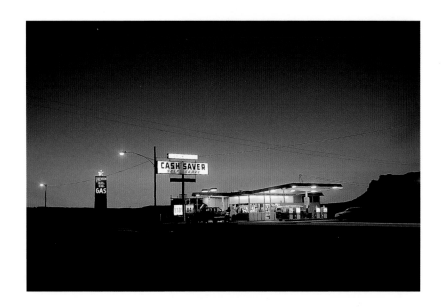

Gas station sign on Interstate, Route 70

GREEN RIVER, UTAH

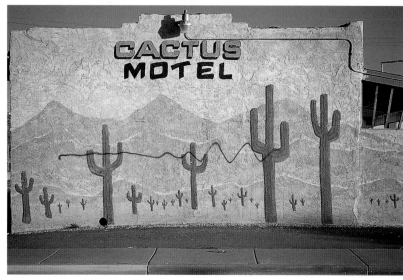

Cactus Motel sign on Route 66

GALLUP, NEW MEXICO

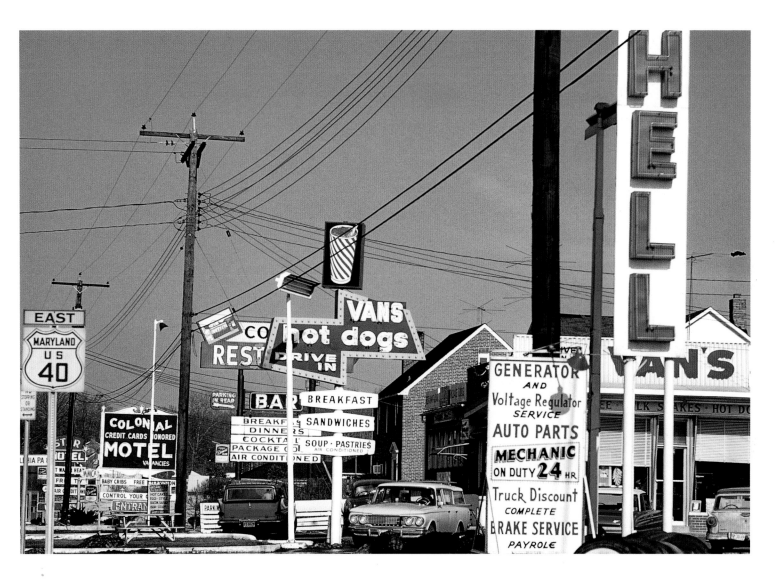

Highway signs | MARYLAND

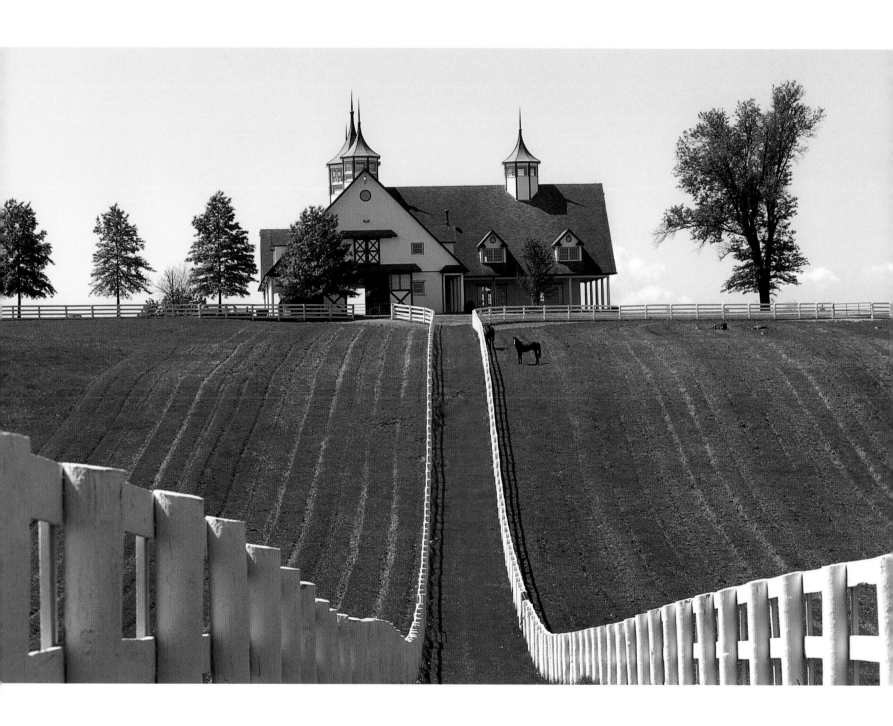

Rural Life

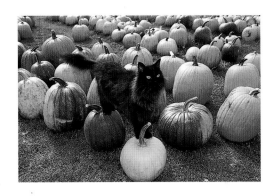

N "RURAL LIFE" WE LEAVE THE ENTICEMENTS OF THE "OPEN ROAD" TO ENTER AN OLDER, MORE CONTEMPLATIVE America. Previously the camera was caught up in the drama of possibility that great spaces offer. Now it is turned inward. The prospects, for the most part, are intimate ones, the eye pushed down into the immediacy of the foreground: children romping in autumn leaves; two men on a pier fishing; a black cat—the spirit of Halloween itself—gorgeously poised straddling a still life of the most sensuously contrasting pumpkins.

I have spoken earlier of the contained splendor of the Manchester farm in Lexington, Kentucky (opposite), of the "house of light" radiating down at us even as it fills the whole of a purposefully shortened view, an American solution to an Old World aristocratic château.

But the two men fishing back to back on a Florida Key pier in the early morning light, with their two chairs and the equally profiled pelican (another fisherman!) is more than an exquisitely balanced comic photograph: one casting, the other reeling in; vertical pilings, flat boards; a darkness rippling with expectation. Fishing is, with hunting, *the* traditional rural male pastime. But it is usually a solitary one. These two friends have invented something new, a dance, a way of being with something greater, the water around them, the new day, all that surging and trembling fishing light.

OPPOSITE Manchester farm | LEXINGTON, KENTUCKY

ABOVE Pumpkin harvest | LYNDONVILLE, NEW HAMPSHIRE

The Manchester farm is a showpiece farm, an architectural statement of dominion over the land. The Amish farm where horses graze in a flower-spangled pasture is the real working thing. But the way Bullaty and Lomeo have photographed the farm transforms it into a vision of timelessness, of man living in modest harmony with a golden abundance that stretches on and on. The same holds for the "Tornado warning" in Freedom, Oklahoma. The horse may be fenced in, but in this photograph it thinks it owns the land. In the facing photograph of Salina, Kansas, the grain elevators go on and on, just as much part of the harmony of light and color as the foreground grasses and the big sky.

Another pair of highly textured photographs shows two of America's agricultural contributions, tobacco and corn. The big tobacco leaves drying like collapsed tents look evil. By way of contrast the massed corn husks throw an image of golden warmth, of wealth, over the Amish farm with its silos and silhouetted trees peeping out of the horizon line. Framed thus, the farm becomes an object of our own yearning, the very embodiment of the pastoral dream of the good life.

The golden-haired children romping among the golden leaves of an immense gingko tree and the accompanying shot of a Halloween stick figure in a window by an open porch with a weathered swing both look as if

they form one continuous frame. A New England life, where old people sit in swings and children play, is what a house is about, and a venerable tree pours down its golden blessings.

From New England the bucolic mood stretches west to Taos, New Mexico. The glowing red clay of the Indian pueblo presents a compelling image of a powerful architecture involving man and material. While the bell towers of the Mission church address the morning sky with a stark De Chirico-like mystery.

The chapter winds down with a shot of an almost vacant Main Street in Hope, Arkansas, the birthplace of President Bill Clinton, and a strikingly angled composition of a cemetery and church near Asheville in upland North Carolina. The beguiling cross and wreaths in the foreground, the church an illuminated beacon in the last of the day, and the almost weeping sky, all together make a tender memorial for the rural life *America America* commemorates.

Lest we forget the physical human part, the chapter ends with a splash of small-town life: two kids looking intently at something we can't see on a farm community's road in Weston, Nebraska; farmers in cowboy hats attending a visually impressive livestock sale in Sugar Creek, Ohio; and regulars at an old-time diner, the Flamingo Café, in upstate New York.

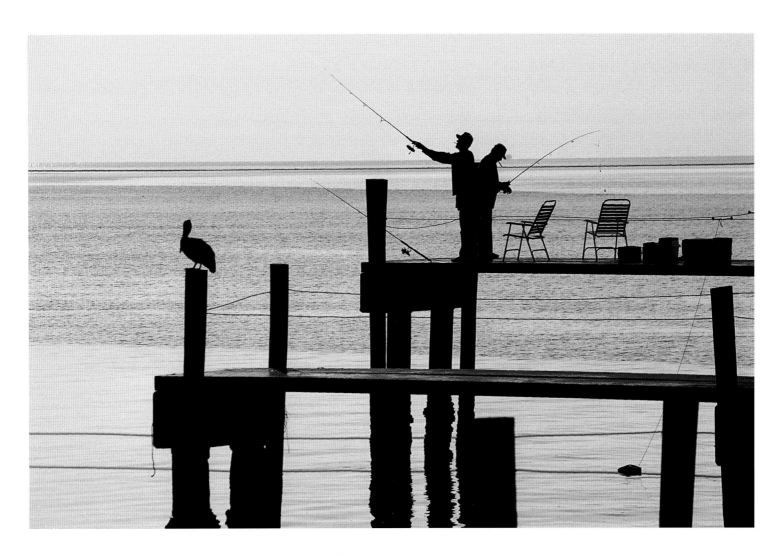

Fishing in early morning | CEDAR KEY, FLORIDA

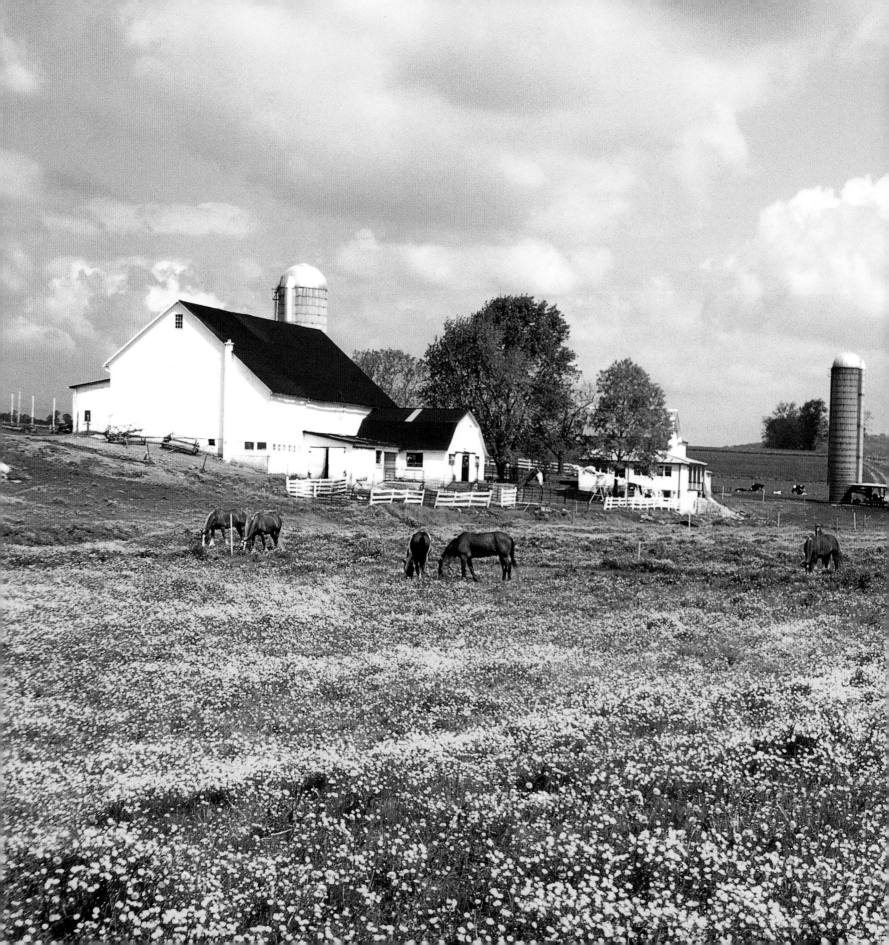

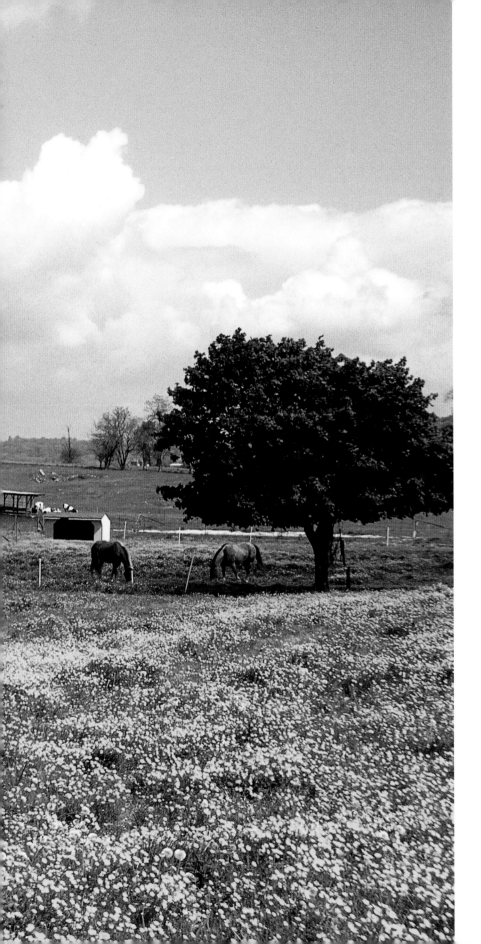

Amish farm | PENNSYLVANIA

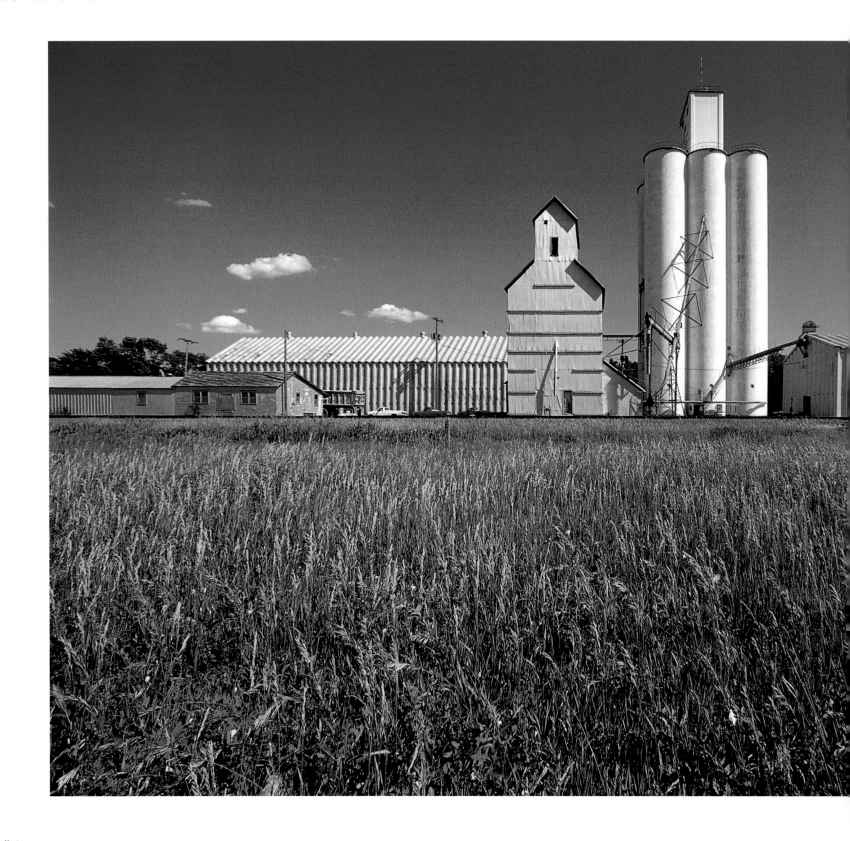

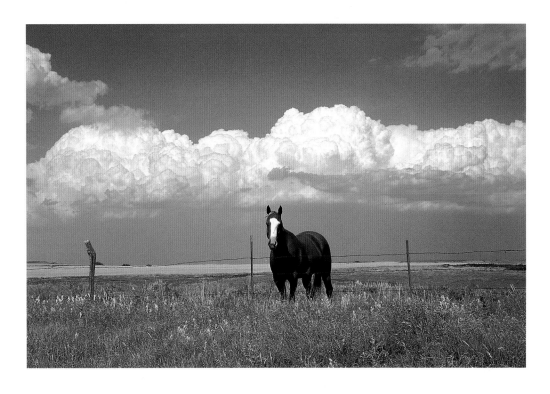

Tornado warning | FREEDOM, OKLAHOMA

Grain elevators | SALINA, KANSAS

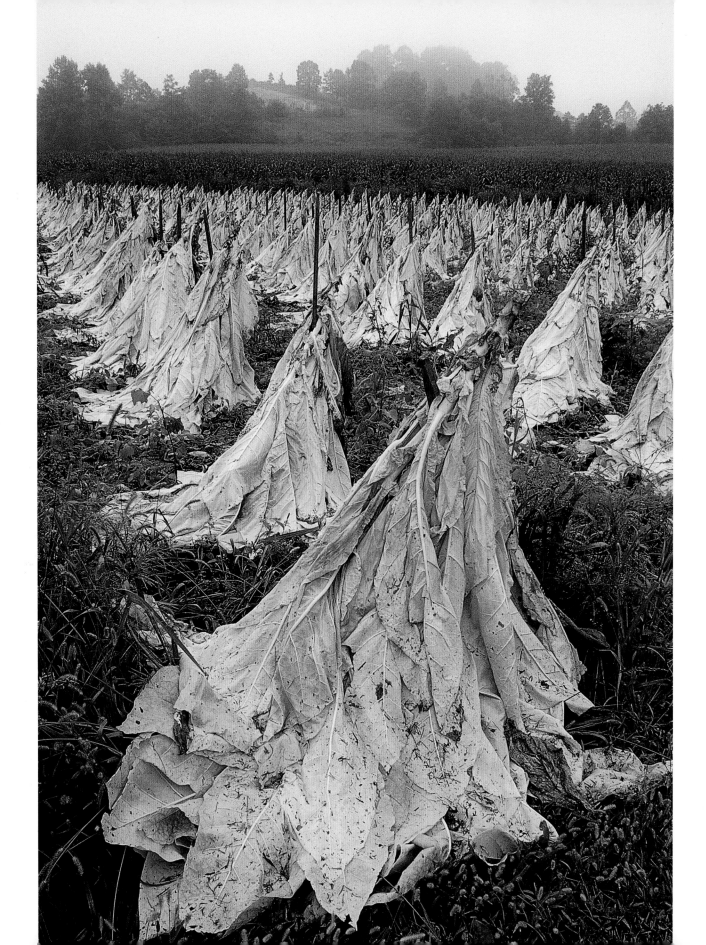

OPPOSITE Tobacco drying in a field | NORTH CAROLINA

BELOW Corn fields on an Amish farm | PENNSYLVANIA

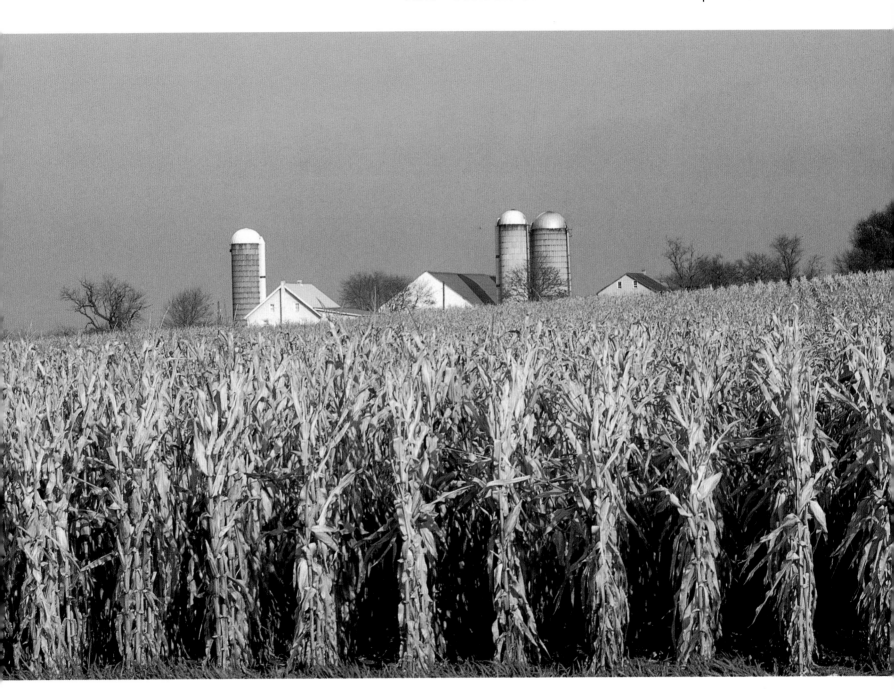

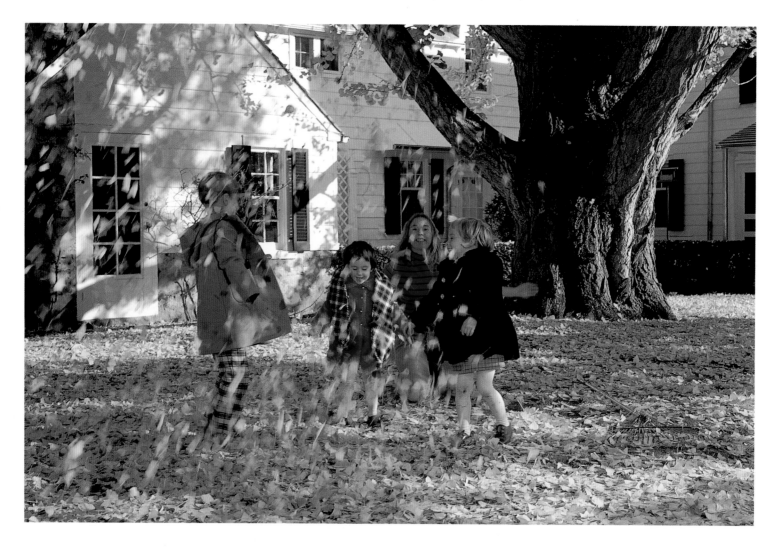

Children playing under a ginko tree | BENNINGTON, VERMONT

OPPOSITE Halloween | SHELBURNE, MASSACHUSETTS

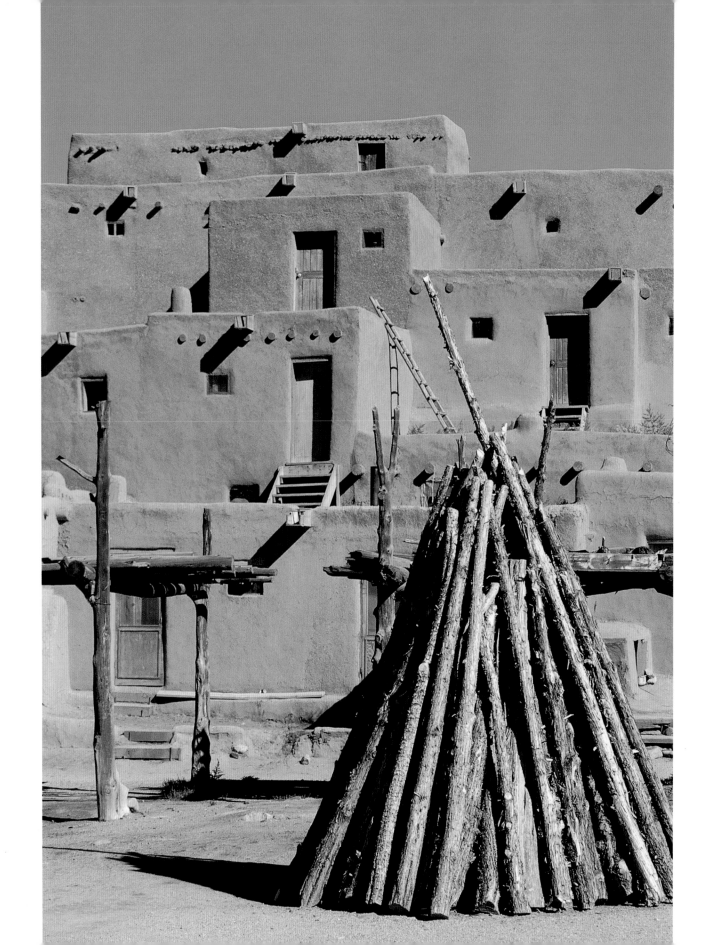

OPPOSITE Pueblo | TAOS, NEW MEXICO

BELOW San Francisco de Asís Church | RANCHOS DE TAOS, NEW MEXICO

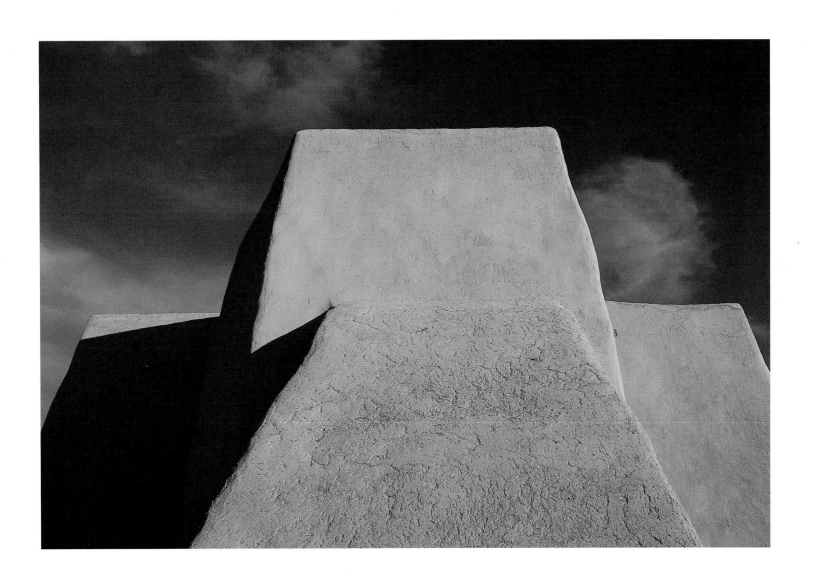

Main Street | HOPE, ARKANSAS

OPPOSITE Church and cemetery | ASHEVILLE, NORTH CAROLINA

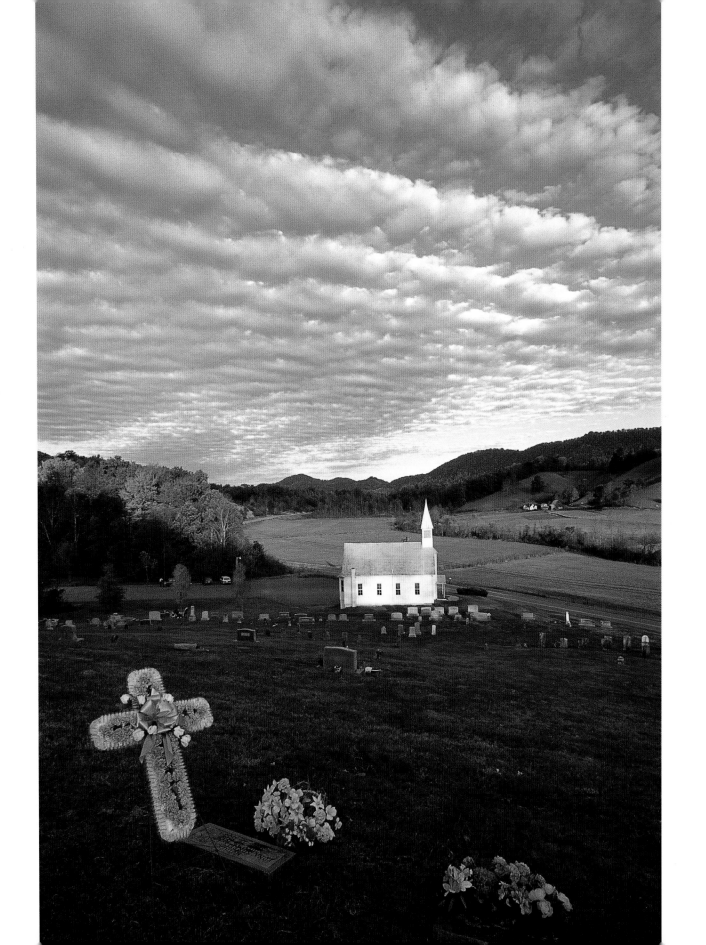

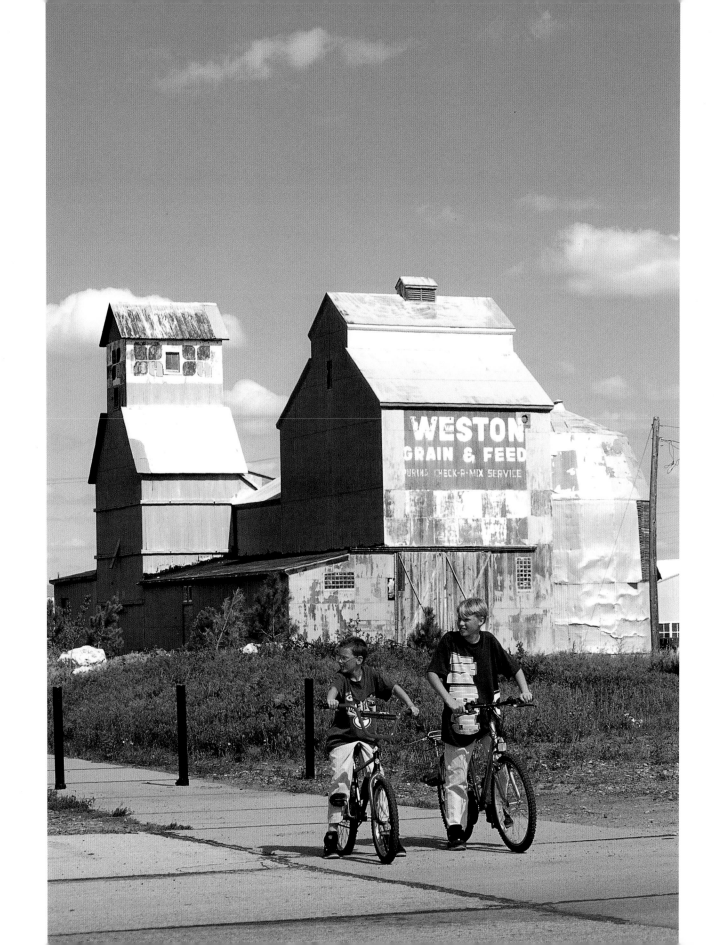

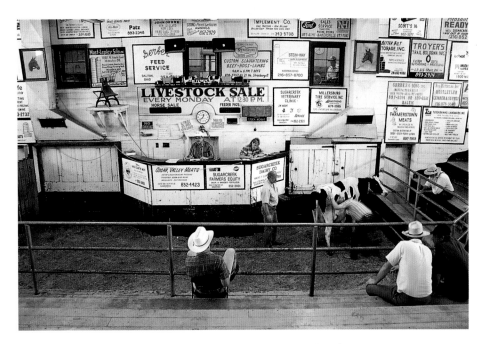

Livestock sale | SUGAR CREEK, OHIO

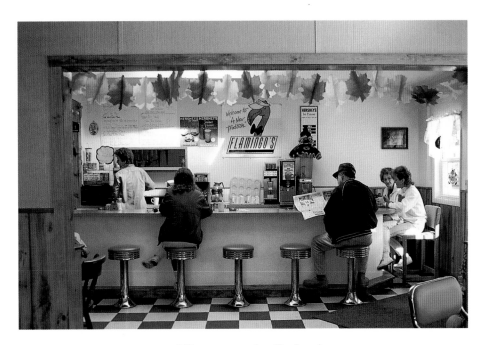

Flamingo's Cafe | NORTHVILLE, NEW YORK

OPPOSITE Young bicyclists | WESTON, NEBRASKA

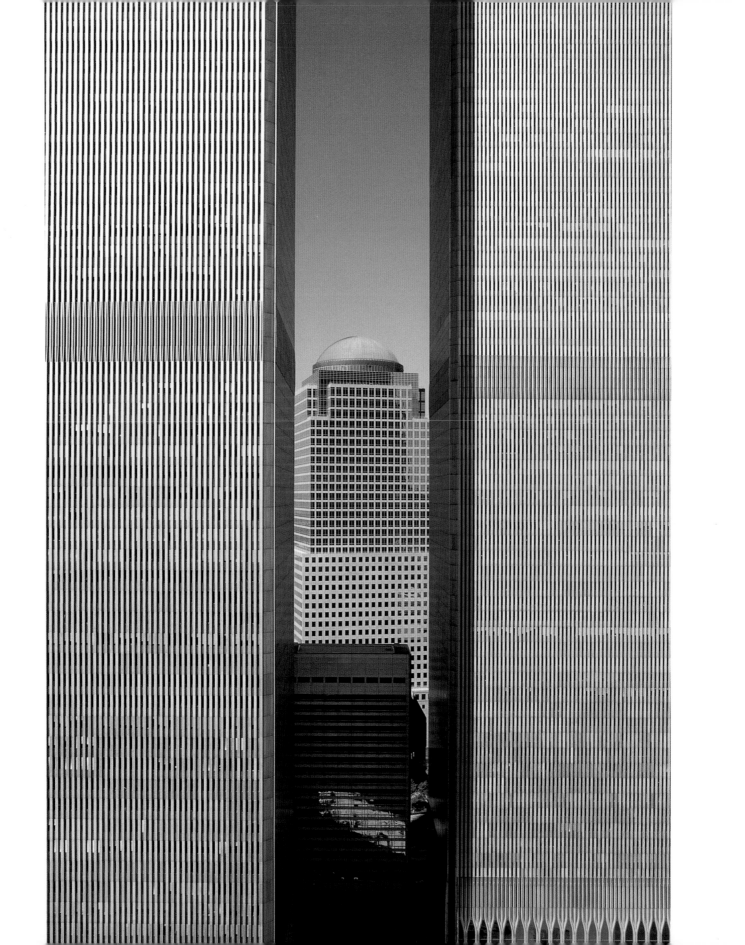

Skyscrapers

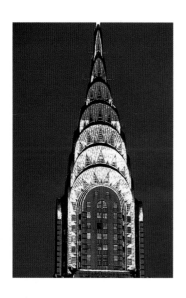

FROM THE CLOSED INTIMACIES OF SMALL-TOWN RURAL LIFE, *AMERICA, AMERICA* TURNS TO THE TOWERING projections of our big-city skyscrapers. They are, of course, an urban response to the challenge posed by the enormous scale of the American land. Yet, for a visitor, what better introduction to that new scale can there be than the sight of all those grandly massed eminences that make up the Manhattan skyline? Greet it how one will, one is, at least, forewarned.

These immense glass-and-steel towers originated as a solution to the problem of limited land—the only way a Manhattan can grow is upward. But they have evolved into an expression of corporate and civic might; another form of what Theodore Veblen called "conspicuous consumption." If bigness is best, what better way of flaunting your corporate muscle than with your own steel-girdered behemoth? Yet conspicuous also implies something glinting, glowing, reflecting as well. That's where Bullaty's and Lomeo's vision enters. For them, America's skyscrapers, with their play of enormous volumes and glinting windows, their flags streaming in the wind, are giant abstractions, pieces of music born from the same driving impulses as American jazz.

The chapter opens, appropriately, with the view, from what might be Abbeville's own offices, of New York's twin towers, the World Trade

OPPOSITE World Trade Center | NEW YORK, NEW YORK

ABOVE Chrysler Building | NEW YORK, NEW YORK

Center, the city's biggest office building complex that is a mini-city in itself. Too stark a confrontation? Well, there in the inset lurks that Art Deco jewel of the 1930s, the upward spiraling and diminishing chords of the Chrysler Building's pin-pointed tower. Then Washington's Capitol building, addressing us from an earlier Rome-inspired America, lends itself to a view that seems downright modest compared to those proudly streaming national ensigns.

Bullaty's and Lomeo's photograph of a pulsating, electrically lit Manhattan skyline sets the tone for a suite of dissonant jazzlike New York reflections that culminates in a two-page spread of windows in towering glass canyons. It is picked up again in the contrasting concentric volumes of Detroit's Renaissance Center (page 110) and, toward the end, in a pair of photographs (pages 114–15) juxtaposing a serene, palm-reflecting building in Naples, Florida, with the succession of mirages flowering within the glass of New Mexico's Alamogordo Observatory. For Bullaty and Lomeo, America's skyscrapers reflect not only civic power, but mystery and wonder as well.

A rather different wonder, spookier, more operatic— as in that last storm-lit scene of *Don Giovanni* in which the statue comes to life—seems to emanate from their Lincoln Memorial photograph (pages 106–7).

This makes us appreciate all the more Bullaty's and Lomeo's good-humored portrayal of the glitz of Las Vegas (pages 112–13). The New York, New York Casino looms, admittedly, skyscraper-high. But any monumentality is undercut by the foreground of older buildings, all those desperate quotations in a mish-mash of period styles that make it look like nothing so much as a Hollywood lot.

That brings us—by way of two somewhat parallel towers (Chicago and San Francisco, pages 108–9)—to that last urban frontier, Los Angeles. In a striking contrast of unreal reds and glaring auto lights, we see a section of the city near the airport caught in a rare and hallucinatory downpour. Across the page spreads the smoggy city of quartz in all its jumble of highways, railroad tracks, and demonic traffic lights, all its sprawling squalor and immensity.

OPPOSITE Capitol | WASHINGTON, D.C.

FOLLOWING PAGES Moonrise over Manhattan | NEW YORK, NEW YORK

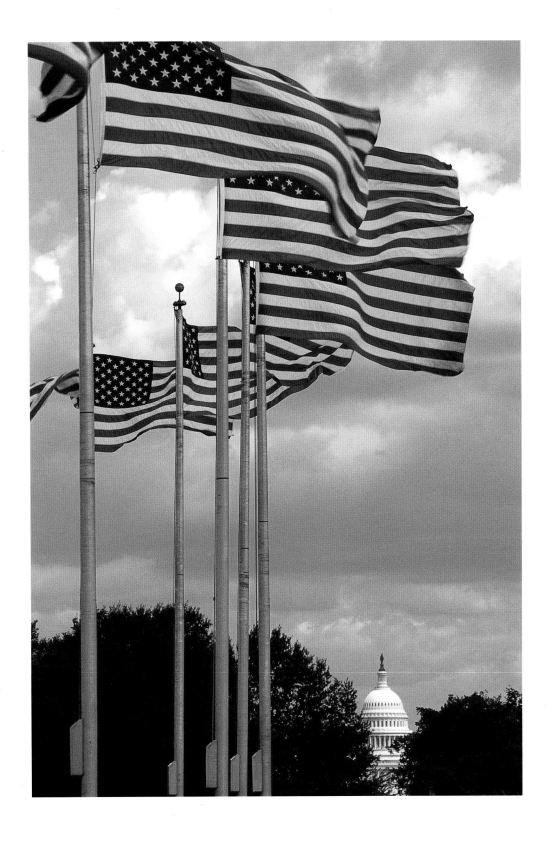

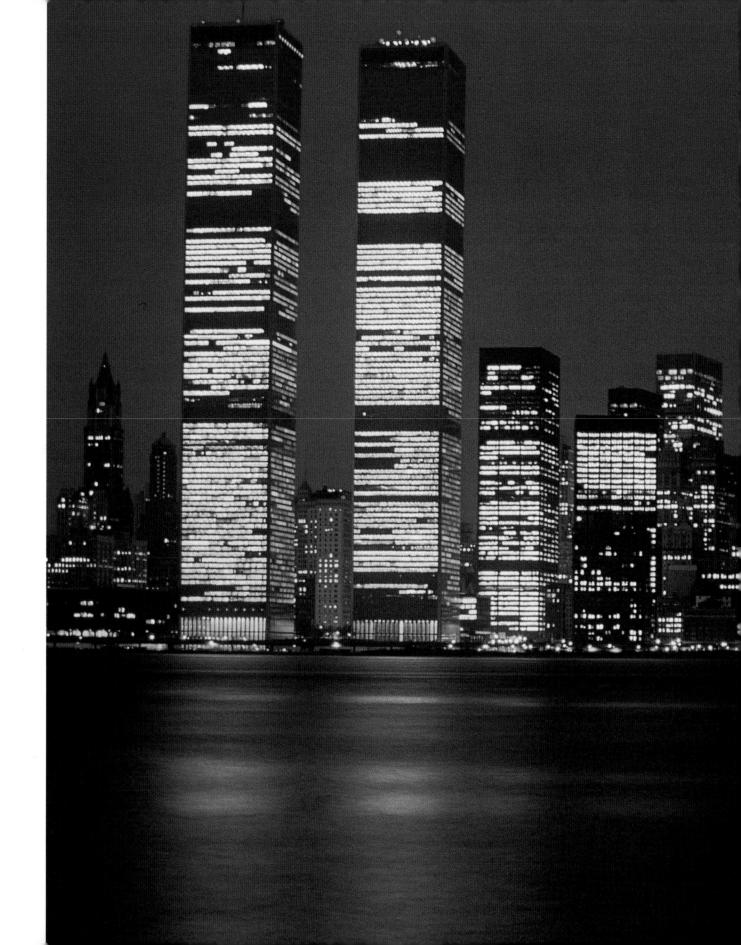

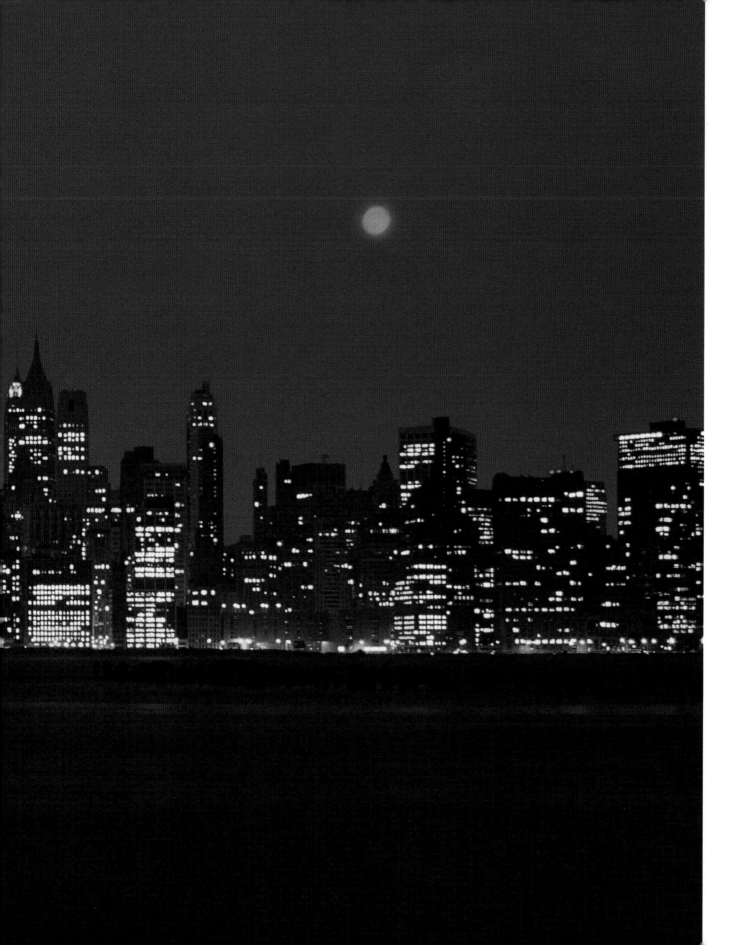

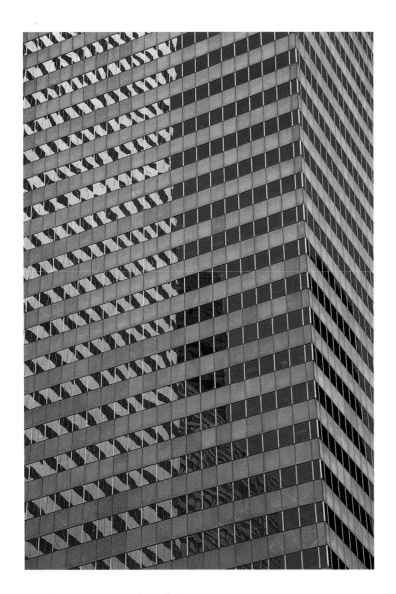

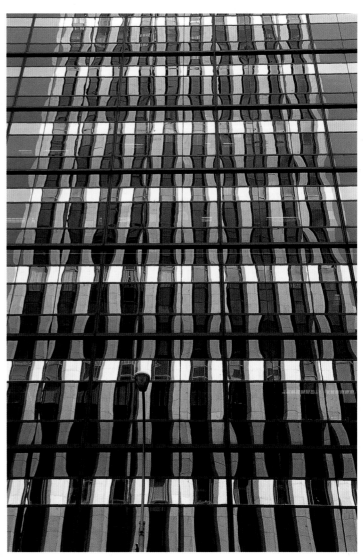

Reflections, Third Avenue
NEW YORK, NEW YORK

Reflections, Madison Avenue
NEW YORK, NEW YORK

102

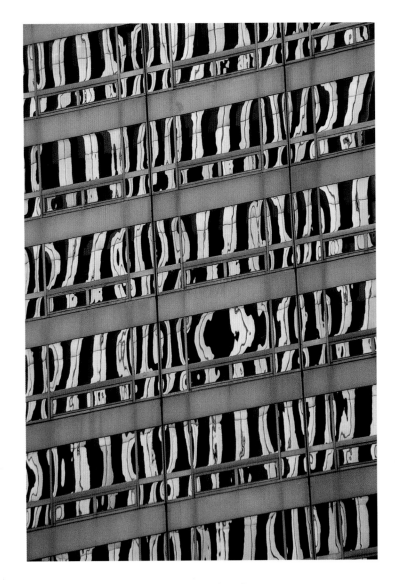

Reflections, World Trade Center
NEW YORK, NEW YORK

Reflections, World Financial Center
NEW YORK, NEW YORK

FOLLOWING PAGES Reflections, Midtown
NEW YORK, NEW YORK

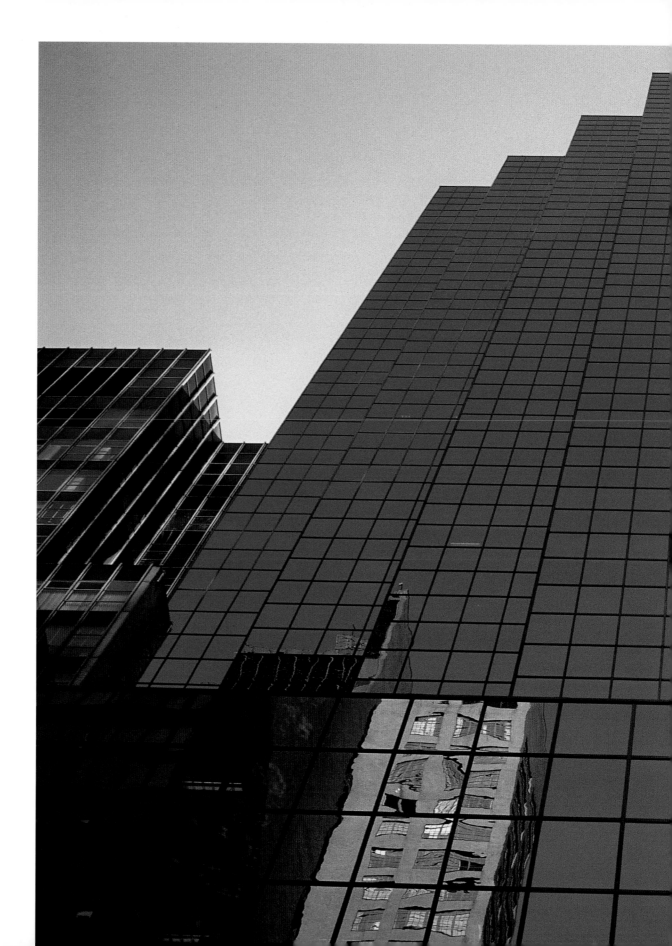

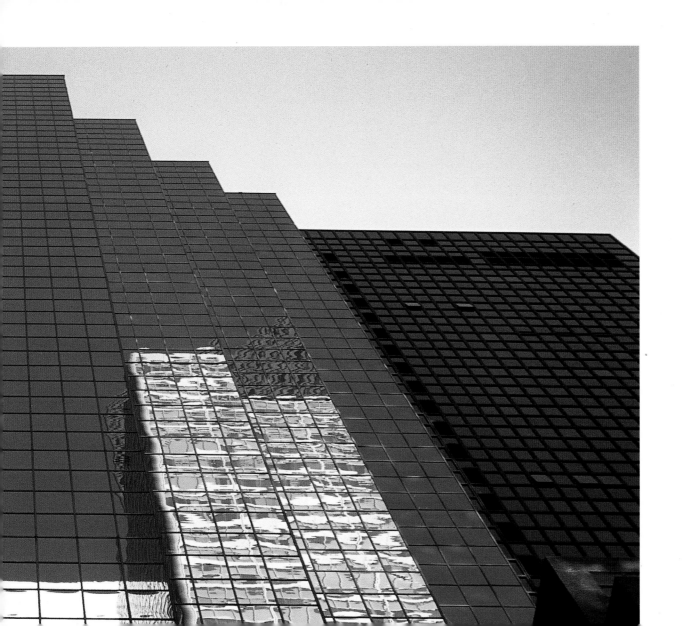

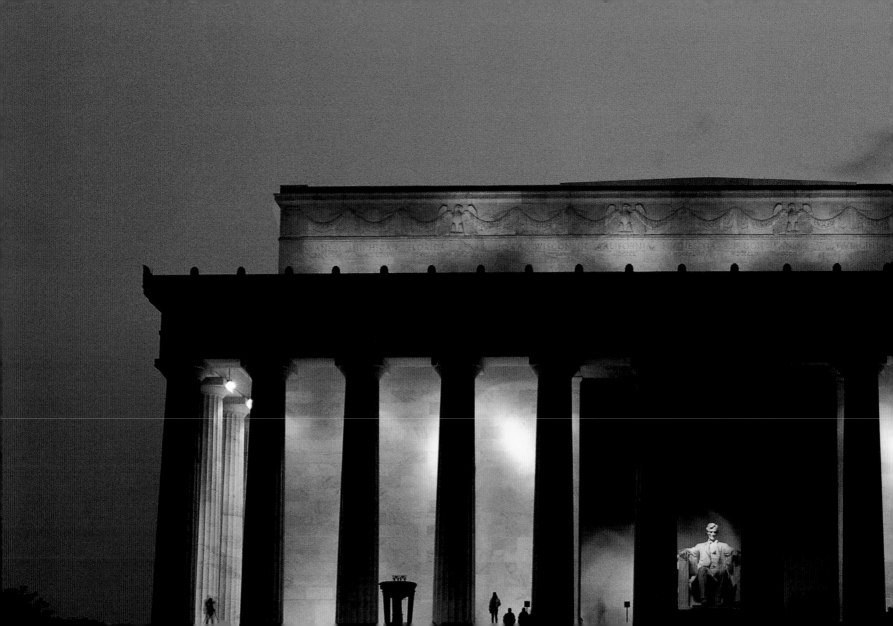

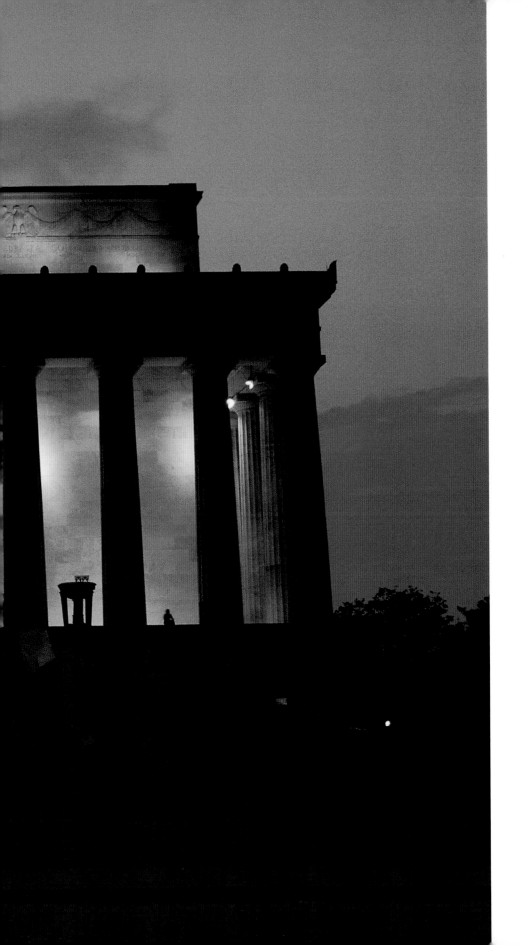

Lincoln Memorial | WASHINGTON, D.C.

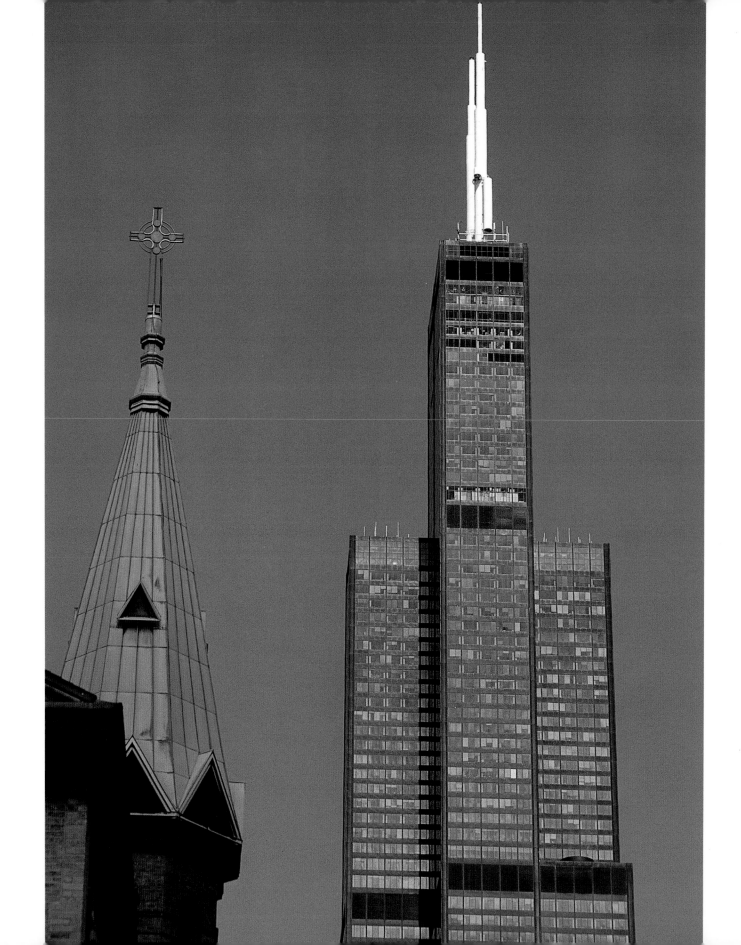

OPPOSITE Sears Tower | CHICAGO, ILLINOIS

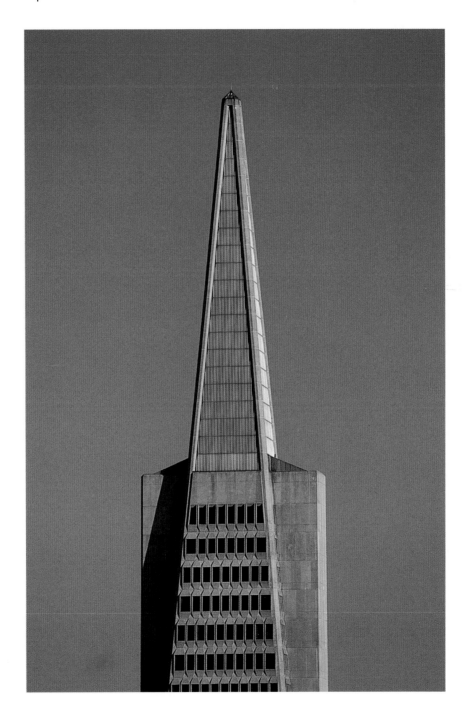

Transamerica Pyramid | SAN FRANCISCO, CALIFORNIA

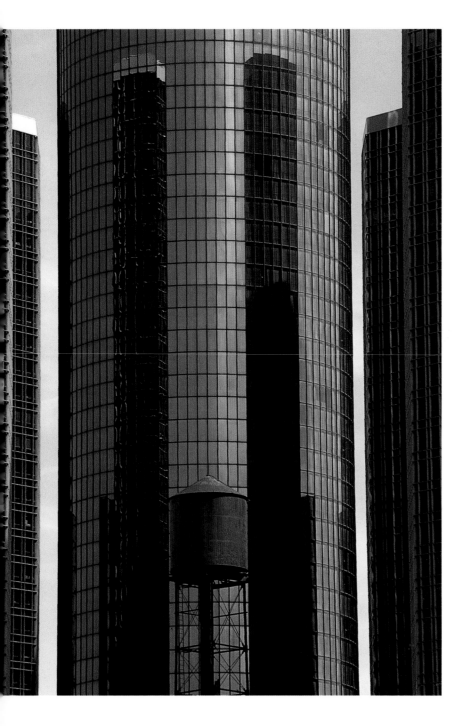

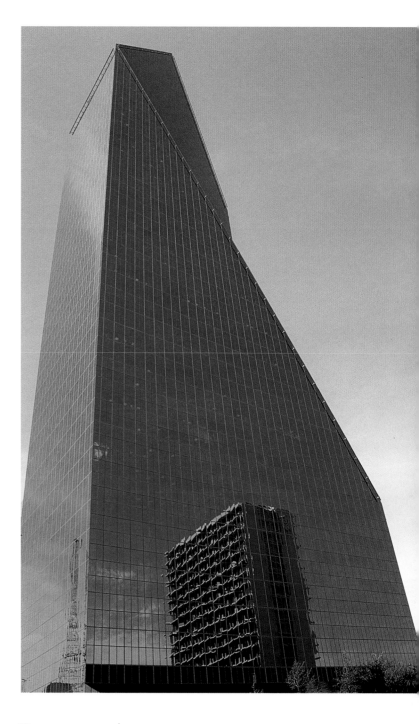

Renaissance Center | DETROIT, MICHIGAN

Downtown | DALLAS, TEXAS

OPPOSITE Grain elevator | MEDICINE LODGE, KANSAS

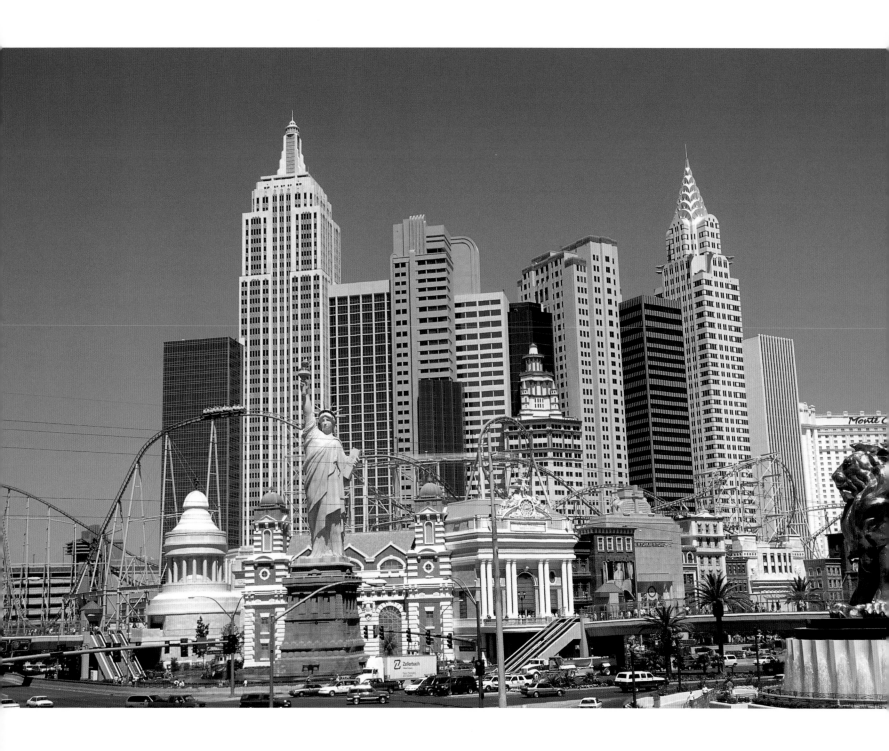

OPPOSITE New York, New York Casino | LAS VEGAS, NEVADA

ABOVE LEFT AND RIGHT The Strip | LAS VEGAS, NEVADA

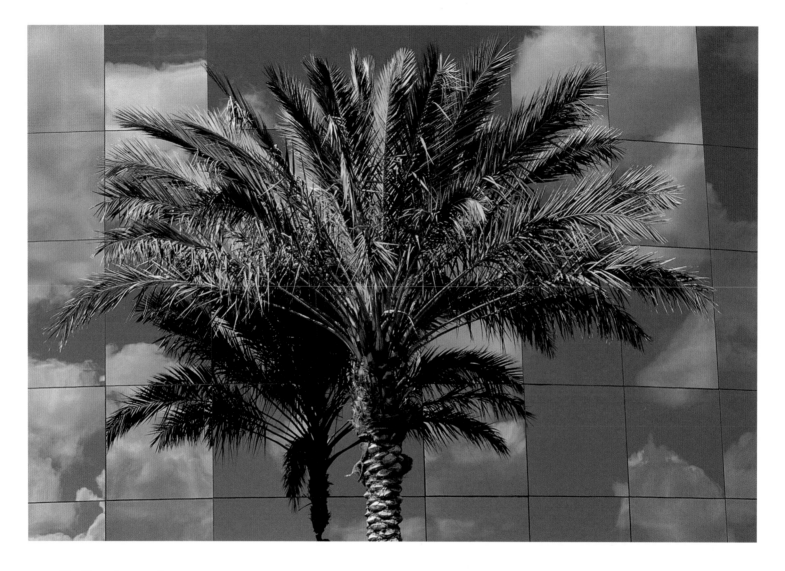

Reflections | NAPLES, FLORIDA

OPPOSITE Reflections, Alamogordo Observatory | ALAMOGORDO, NEW MEXICO

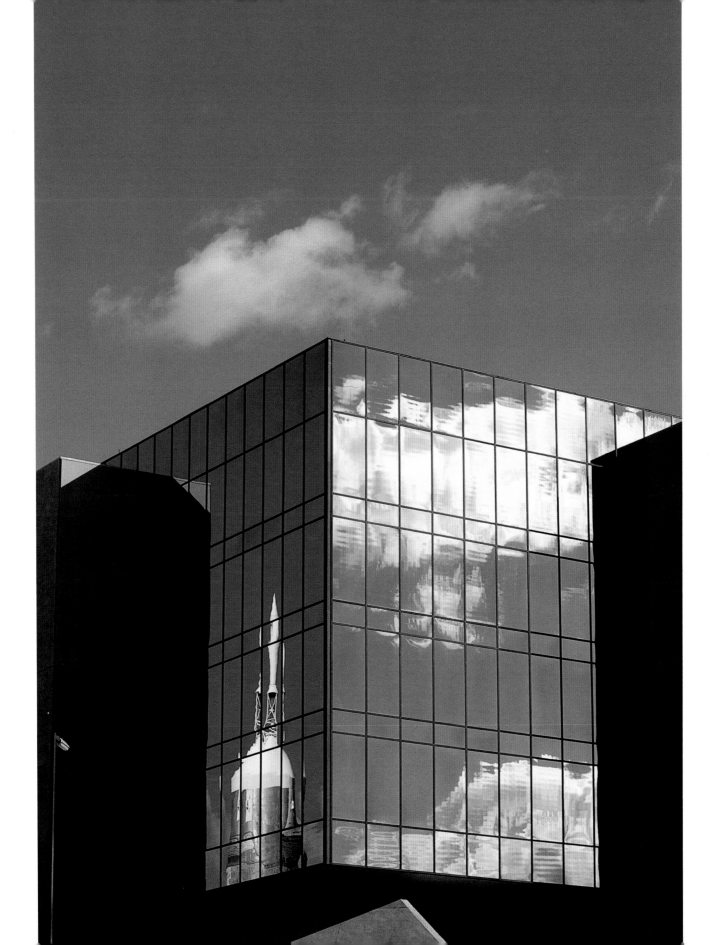

Rain | LOS ANGELES, CALIFORNIA

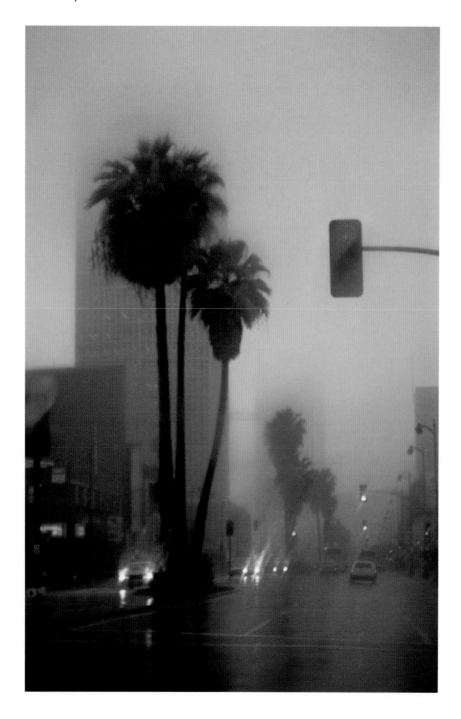

OPPOSITE Traffic | LOS ANGELES, CALIFORNIA

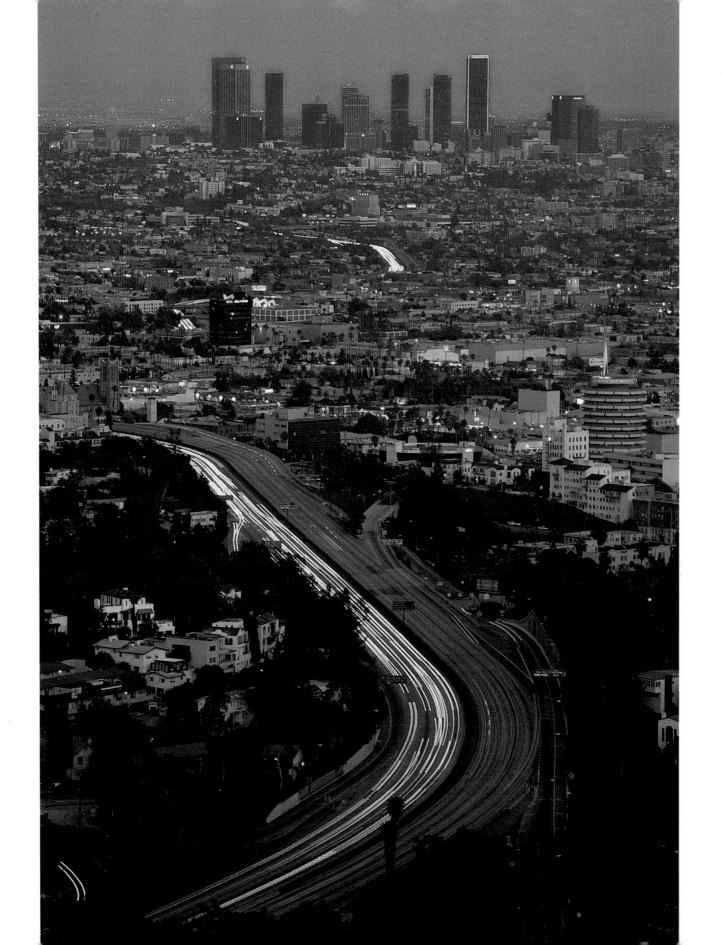

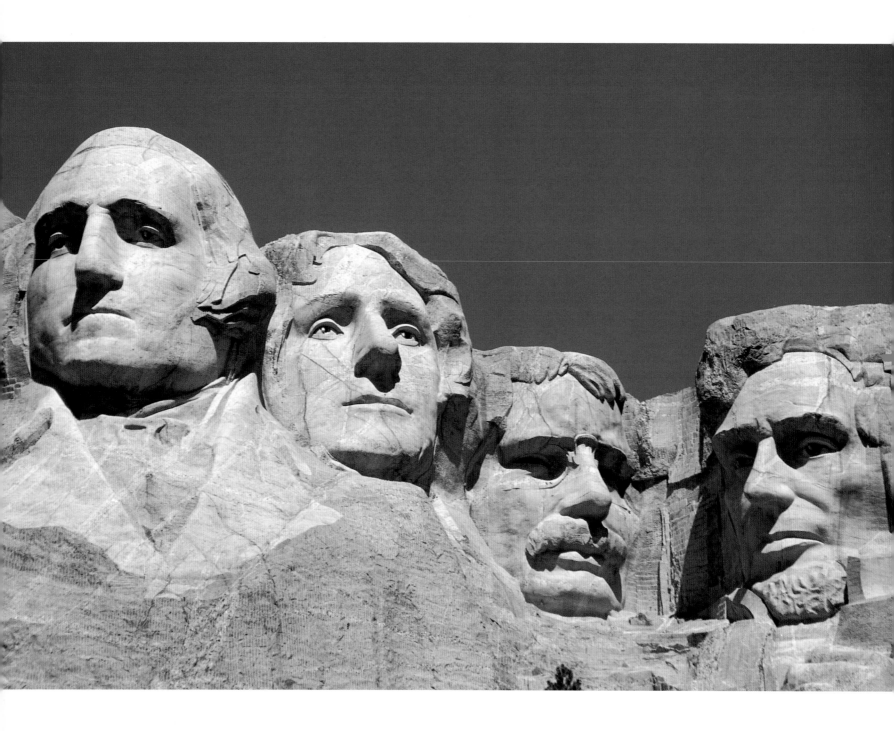

Americans

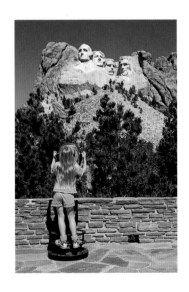

Tʜᴇ ᴄᴏᴍᴘᴜʟsɪᴏɴ ᴛᴏ ᴄʀᴇᴀᴛᴇ ᴀ ᴡᴏʀᴋ ᴏɴ ᴛʜᴇ ʙɪɢɢᴇsᴛ sᴄᴀʟᴇ ᴘᴏssɪʙʟᴇ sᴇᴇᴍs ᴘᴇʀғᴇᴄᴛʟʏ ᴄᴏᴍᴘʀᴇʜᴇɴsɪʙʟᴇ to Americans. We can't be remembered unless we have been seen, and we all know what that requires: thicker books, ever-taller scaffolding, thirty-foot ceiling lofts. But only an American would conceive of staking out the Black Hills of South Dakota in the middle of the country to carve out a sixty-foot-high memorial of the Mount Rushmore sort, one commensurate in spirit with nothing less than America itself. How American, too, after all our successes in conquering nature, to want to give a mountain a human face, or rather, for maximum impact, four of them: Presidents George Washington, Thomas Jefferson, Abraham Lincoln, and Theodore Roosevelt.

Once again American scale works its considerable magic. Despite the Grand Canyon, despite all those skyscrapers and grain elevators, most of us come away, if not convinced, then certainly awed. We feel a sense of proportion seeing that little girl in her pink socks and lime green outfit viewing the monumental presidents.

If Bullaty's and Lomeo's photograph of the little girl properly introduces this chapter of American people, their photograph of the *Peopling of America* exhibit (taken at the great immigration gateway, Ellis Island, in New York harbor) gives another kind of dimension to their enterprise: on the one side, the teeming rack of faces, on the other, the ever-present red, white, and blue.

ᴏᴘᴘᴏsɪᴛᴇ ᴀɴᴅ ᴀʙᴏᴠᴇ Mount Rushmore | ʙʟᴀᴄᴋ ʜɪʟʟs, sᴏᴜᴛʜ ᴅᴀᴋᴏᴛᴀ

After that virtual city of spirited faces, where does one go? Why to Bullaty's and Lomeo's version of the Marlboro Man, the lone Westerner on his horse. If we don't see his face clearly, it is that we don't need to. His cowboy hat is more than sufficient in the way its brim picks up the snow of the not so distant Grand Tetons. The two—the man on horseback and the awesome mountain range—are, in that early morning moment, visually at one with each other.

If we can't be the land, why can't we be that other American invention, jazz? Bullaty's and Lomeo's photographs, shot in the birthplace of jazz, New Orleans, take us to its musical core. Sonja's chiaroscuro Preservation Hall photograph lets us see how it might all have begun: in a little room, on an earthen floor, with lots of noise, a whole community of black faces with golden instruments, inventing it, weaving its polyphonic magic.

Then we return to Gotham and that temple of American capitalism, the New York Stock Exchange. Across the page we have another view of those same Wall Street denizens, only these are trying to wrest a moment of peace from all that din, those torn papers, that commotion. Bullaty and Lomeo capture them there, a little community of refugees, intensely self-centered, each in his or her own inviolate space, studiously disclaiming any relation to anyone else.

From these individuals the chapter moves to Americans proclaiming their community. A red, white, and blue marching band, all innocence and red-spotted cheeks, comes in from the country to strut its stuff for a Thanksgiving Day parade. This gives way to the more theatrical kitsch of an Easter parade, while across the page another patriotically attired team—varsity cheerleaders from Nelson County High School in Bardstown, Kentucky—pose by a statue of the great nineteenth-century tunesmith Stephen Foster.

The chapter concludes with some shots of Americans in their homes, none more eloquent than the Navajo woman in front of her little mountain of a hogan in Monument Valley, another perfect harmony of land and person, only this time the earth sets her off, all that turquoise jewelry, that crimson velvet jacket, and fuchsia skirt.

What if you find yourself walking down main street in Florala, Alabama, on a Sunday when you notice a remarkable-looking hair salon? Well, if you are Sonja and Angelo, you go in, irresistibly drawn. The result is that great shot of those two women, an image that sums up a whole era, a way of life, and a place.

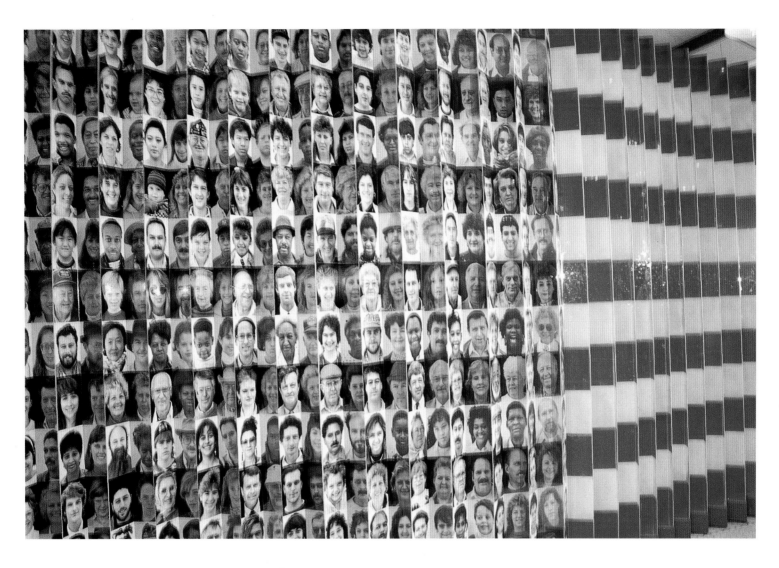

People of America exhibit | ELLIS ISLAND, NEW YORK

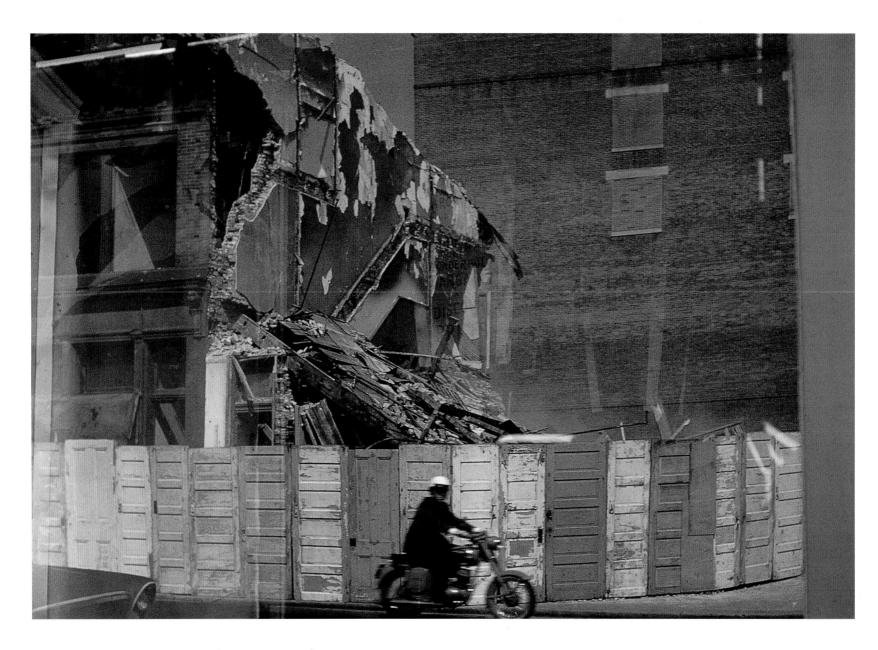

Motor biker | WASHINGTON, D.C.

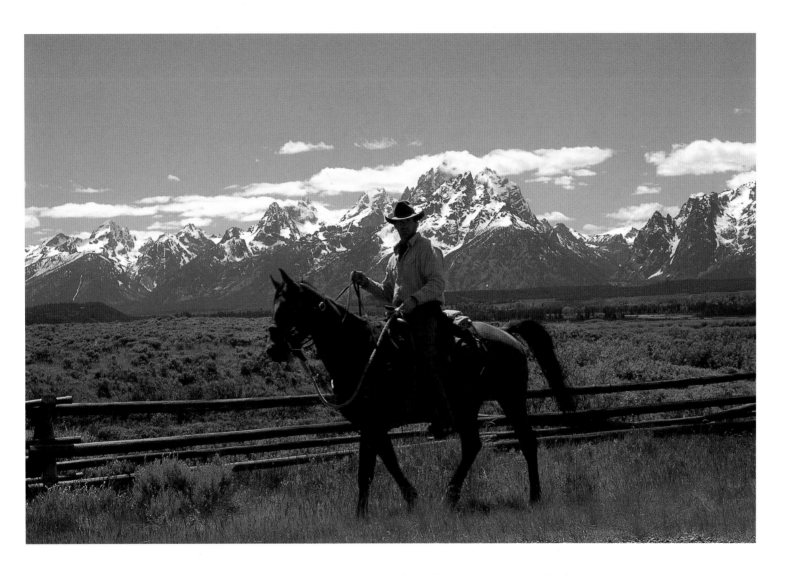

Cowboy on a ranch | GRAND TETONS, WYOMING

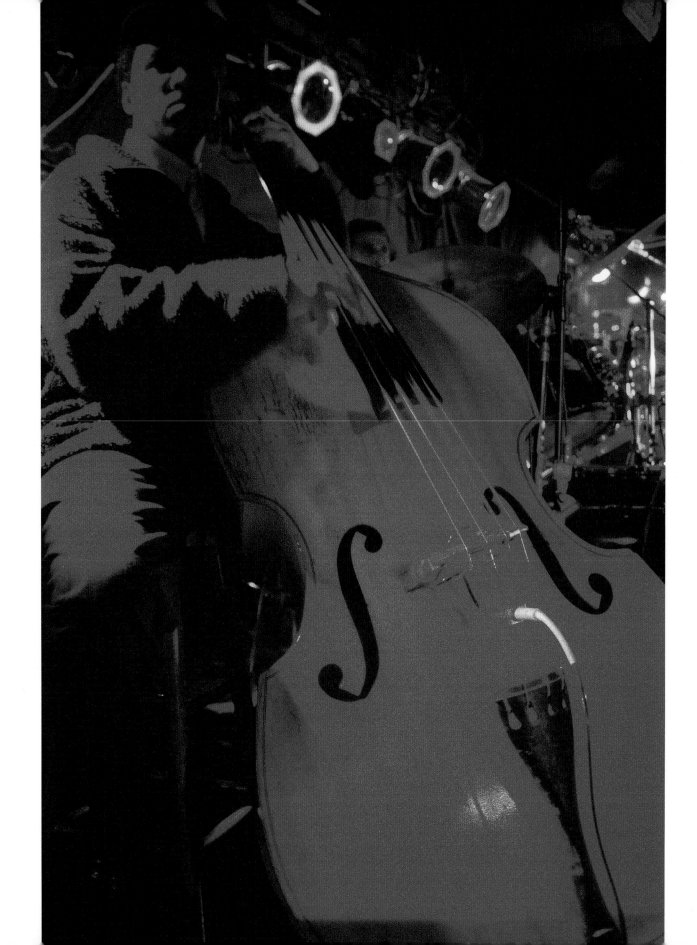

OPPOSITE Bass player | NEW ORLEANS, LOUISIANA

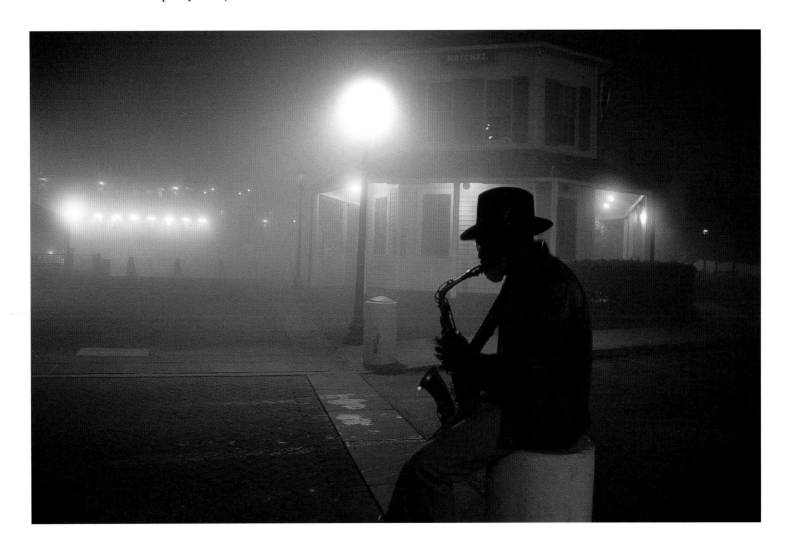

Saxophone player | NEW ORLEANS, LOUISIANA

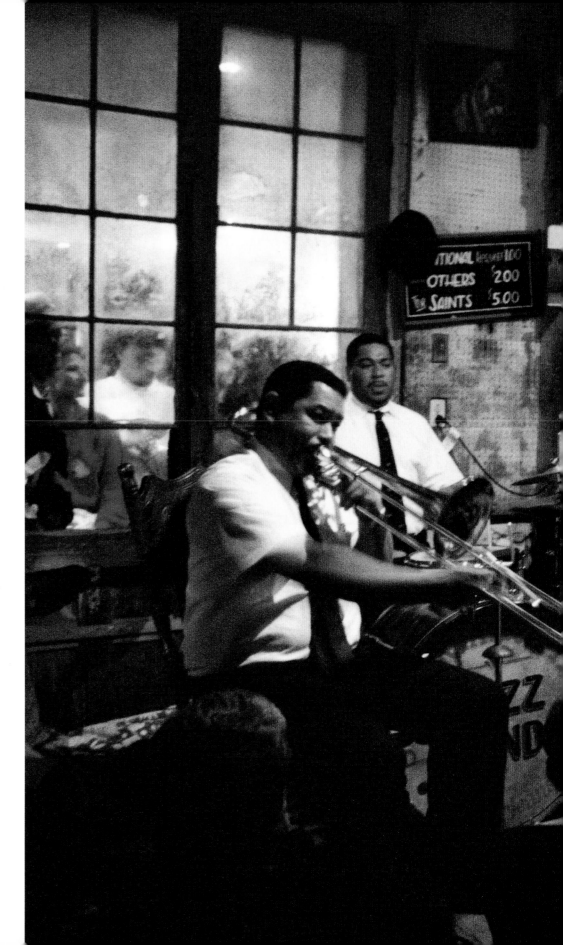

Preservation Hall jazz band
NEW ORLEANS, LOUISIANA

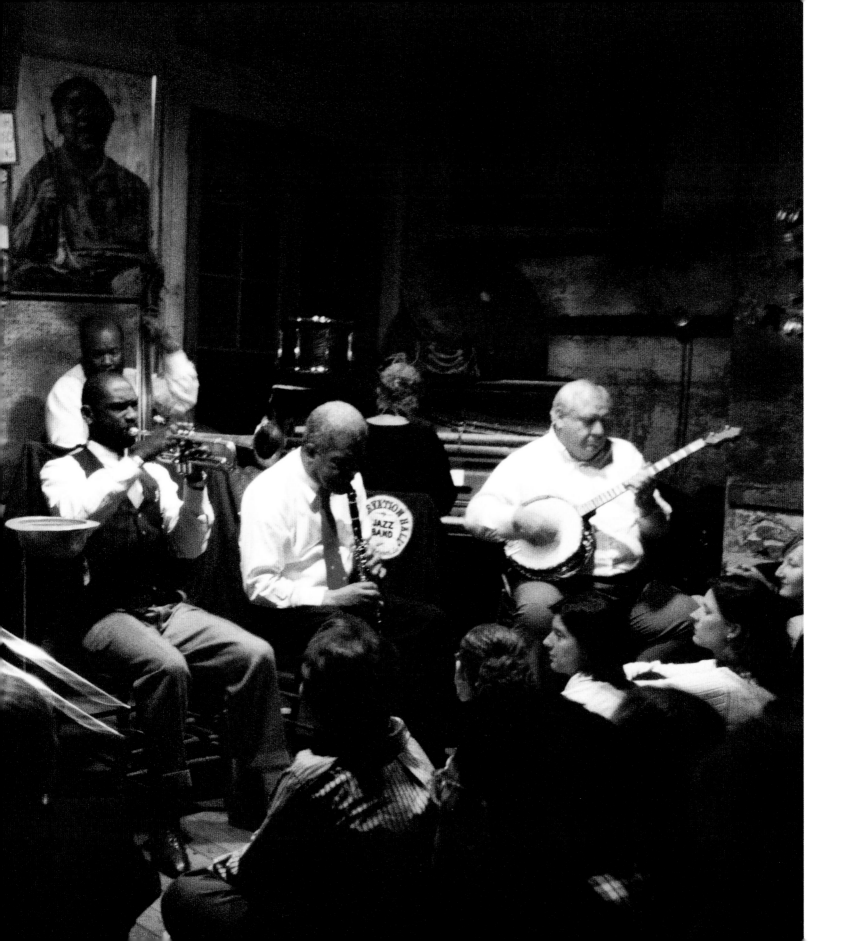

New York Stock Exchange | NEW YORK, NEW YORK

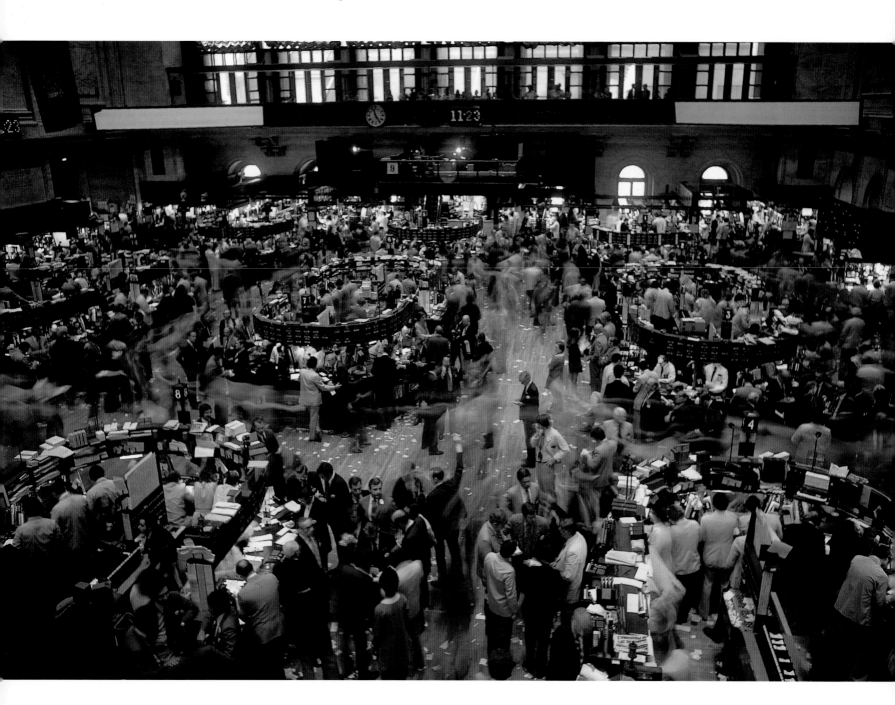

Seating area on Water Street | NEW YORK, NEW YORK

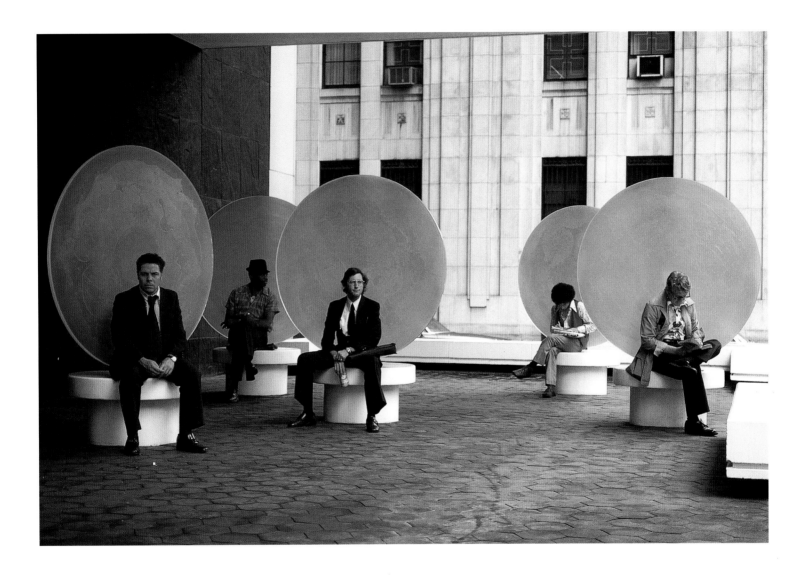

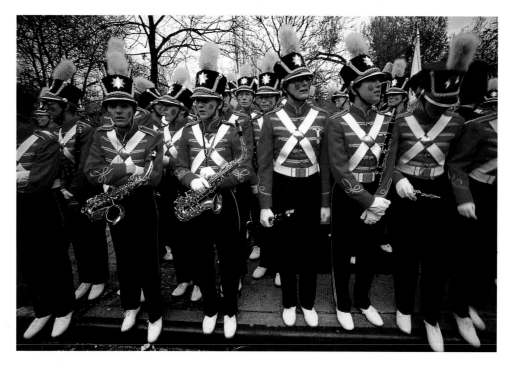

Thanksgiving Day Parade | NEW YORK, NEW YORK

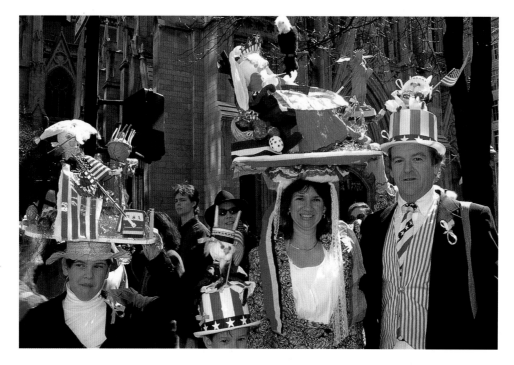

Easter parade on Fifth Avenue | NEW YORK, NEW YORK

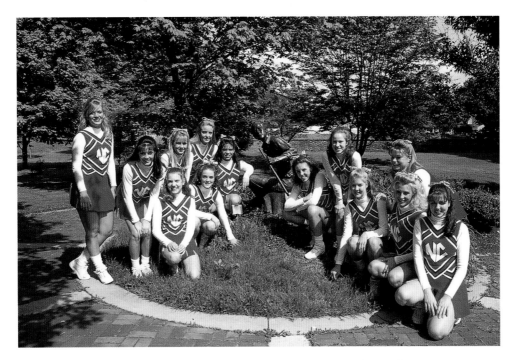

Nelson County High School varsity cheerleaders | BARDSTOWN, KENTUCKY

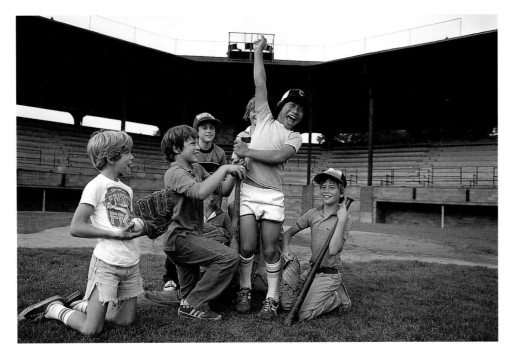

Baseball players on Doubleday Field | COOPERSTOWN, NEW YORK

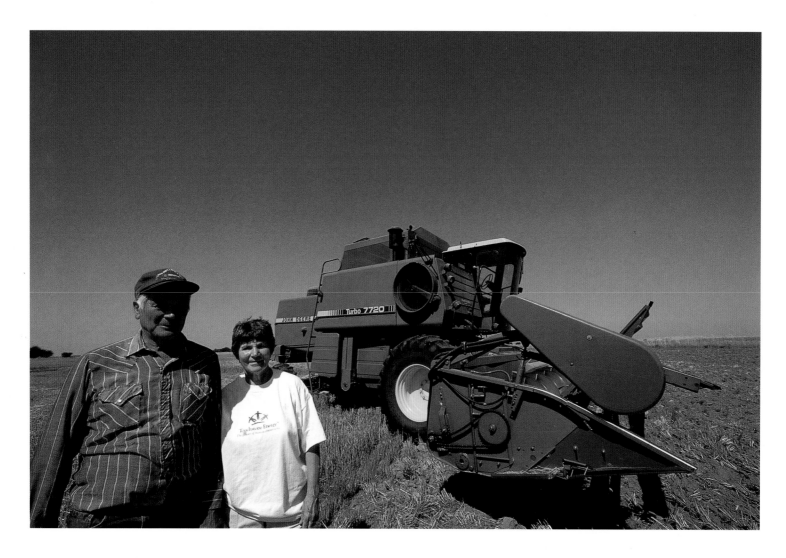

Wheat farmers | MEDICINE LODGE, KANSAS

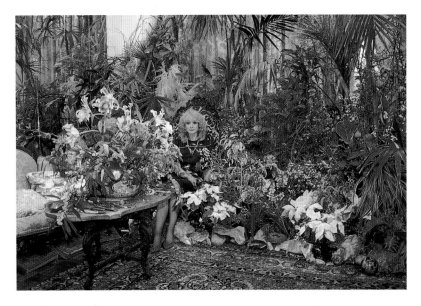

At home | NEW YORK, NEW YORK

At home | PRAIRIE CITY, IOWA

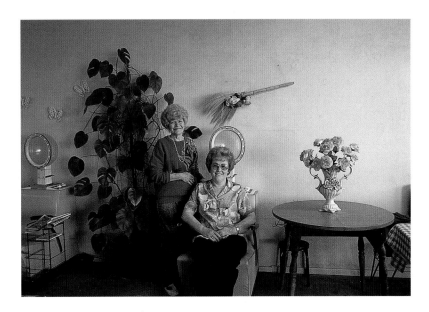

Beauty parlor | FLORALA, ALABAMA

Navajo woman in front of hogan
MONUMENT VALLEY, ARIZONA

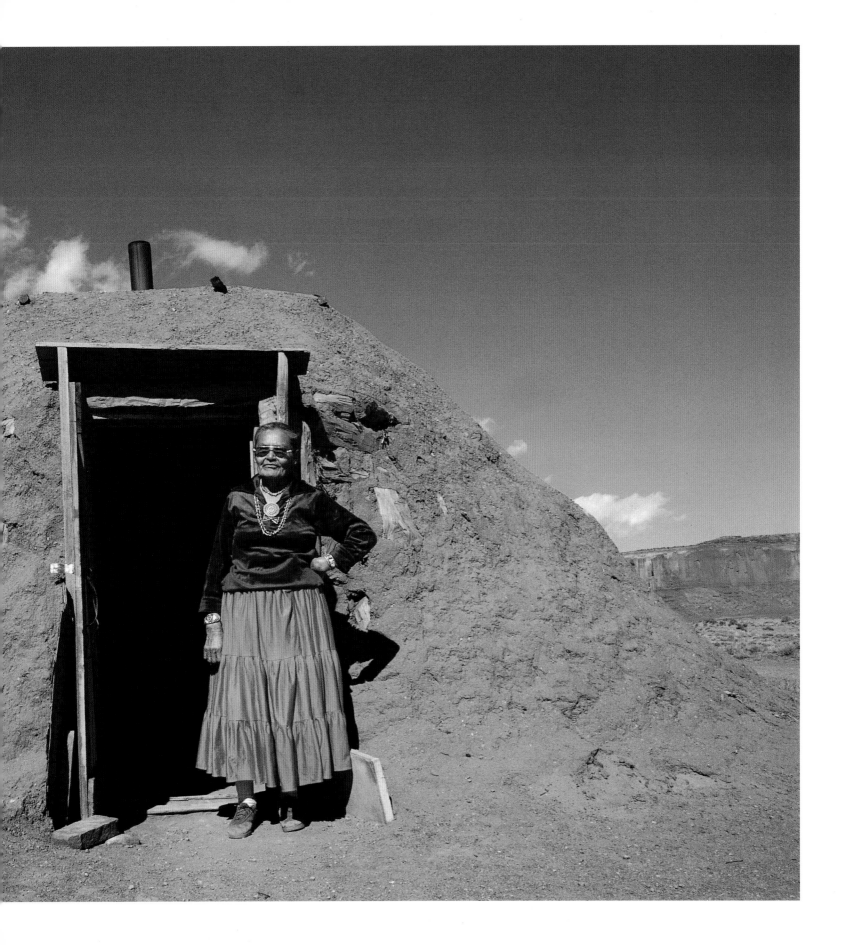

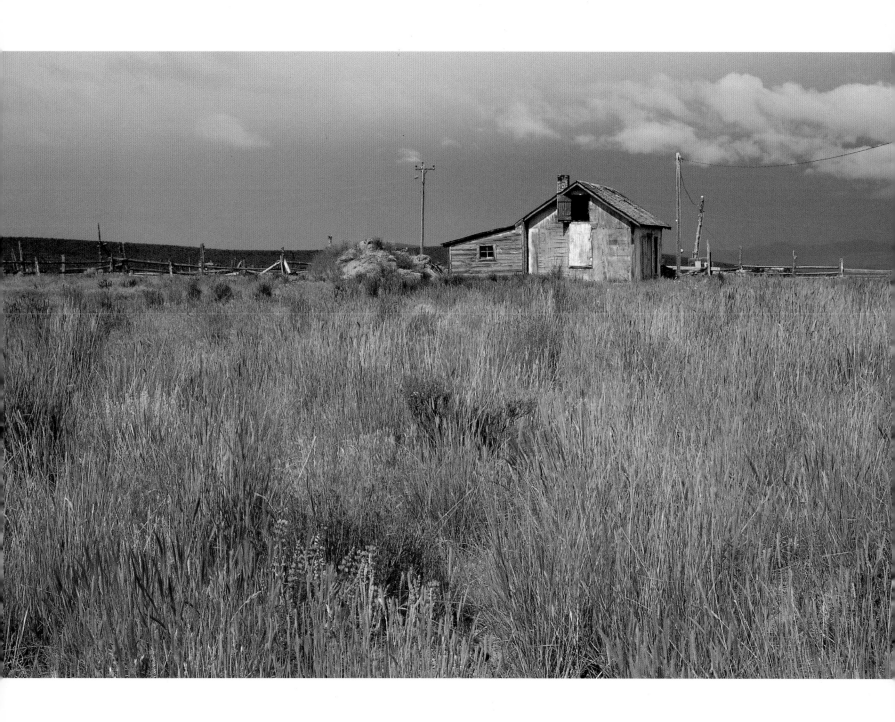

Vanishing America

IN BULLATY'S AND LOMEO'S PHOTOGRAPHS WE CAN SEE A NEW AMERICA RISING BEFORE OUR ASTOUNDED EYES— spectacular glass canyons, the latest in energy-saving windmills. The camera is there to embrace them, greet them. But what about the past, the reality that has made us what we are? The camera, on its own, can't keep history from occurring. But in documenting a moment, it can give a posthumous life to what has otherwise vanished. Something is caught and preserved: a fragment of ghetto life in the Deep South, a once treasured car before the equally beautiful weeds and grasses reclaim it. Looking at their photographs, we see our own moment in time a little more sharply.

What is it about ruins that attracts us? Is it the way they have come to blend into their surroundings—the irony between our re-creation of the life that was and what it has now come to? Or perhaps it is the power that even in an abandoned, derelict state, they still seem to exude—a mood and with it the germ of a story. And it is these stories that intrigue Bullaty and Lomeo. We don't know why that farmstead across the page in Brothers, Oregon, was abandoned, but looking at the contrast in color values between the foreground's field of sagebrush and the lowering sky, we are tempted to speculate. Something distinctly eerie is still enveloping that abandoned farmstead.

OPPOSITE **Abandoned farmstead in a sagebrush field** | BROTHERS, OREGON

ABOVE **Hopscotch player, 1959** | BRATTLEBORO, VERMONT

The two pages of black-and-white photographs of people date back to 1949 and the beginning of Bullaty's and Lomeo's American project. The Birmingham photos come out of the documentary mode of the time. They wanted to show the abject conditions of urban ghetto life with sufficient force to make us react. And only inadvertently have these photographs become, fifty years later, a testimony to a vanished life, a toughness, a tenacity. We see that in their portrait of three generations of black women, proudly defiant of what they have survived. Or in the cottonpicker hard at work in a field. Or in the four men playing dominoes on their own knee-improvised table, a real community despite the hung-out clothing and the wretched shanty huts of the skyless background.

The Gagné family photographs, shot a year later, take us into the life of a self-sufficient Vermont family. Yet instead of inert bodies sitting around a television set that a similar documentary might show today, these kids and others are doing something, and they are very intent about it: blowing a magical, light-filled soap bubble, while a brother watches, equally bemused; or a boy trying to swat a softball with an overlong bat. Also shown is a little girl in a gingham dress and pigtails (page 137), dancing out her hopscotch. Only now these individual creations have the poignancy of a vanished folklore.

From these black-and-white evocations we step back into two monuments of American history: the log cabin in which our greatest president, Abraham Lincoln, lived as a very young boy, surrounded in a verdant morning light that makes it seem to spring from an Arcadian America; and the turning point of the Civil War, the Gettysburg battlefield, all that carnage transformed into a tender field of flowers.

Following are two more abandoned buildings. A distinctive barn in a field of late summer goldenrod sets up Angelo's photograph of a once proud and now probably haunted family house straddling a hill in the Green Mountains. Surely Hopper would have approved.

Popular art says something about our dreams, our nostalgia, our notions of beauty. The patriotic eagle on a wall in Jerome, Arizona, may be advertising World War I Liberty bonds and the incongruous buffalo atop the stone roof of a derelict cabin may be all that remains of a miner's dream. Whereas the wall art found at Newspaper Rock, Utah, shows a Native American child's radiant version of a Lascaux or Altamira hunting scene.

Cars, too, when sufficiently old, can take on metaphorical attributes. The Stonington, Maine, roadster might almost be a casket, so tenderly is its garland of flowers and grasses photographed. And the old car from Bodie, California, is shot so that the wheel bumpers seem earthen mounds compared to the Georgia O'Keeffe–like bovine animal on the central hood.

The chapter concludes with two pages of porch life. The three Gagné boys have the look of kids who have just gotten away with playing some nasty trick. On that brownstone stoop in New York's Little Italy are clearly two distinct worlds, both at remarkable ease. In a different way, the sheep and goats being sheltered from the midday heat on a roadside porch comment on the Greek-columned antebellum pomp of Natchez's Stanton Hall. An impressive social variety spans a mere two pages.

Railroad station | VESUVIUS, VIRGINIA

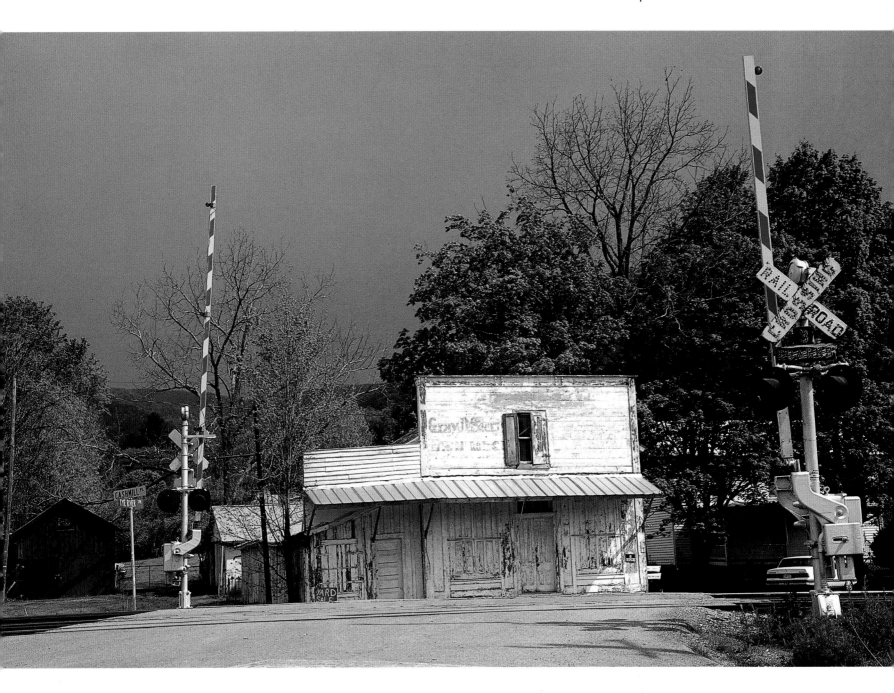

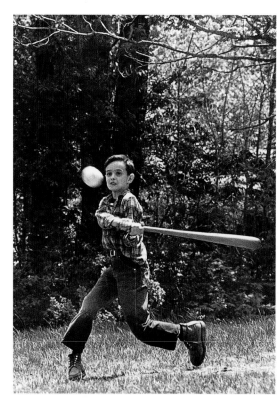

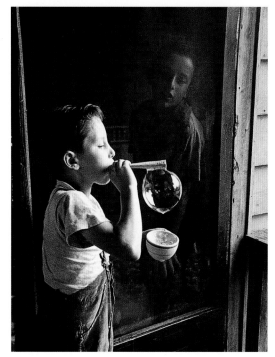

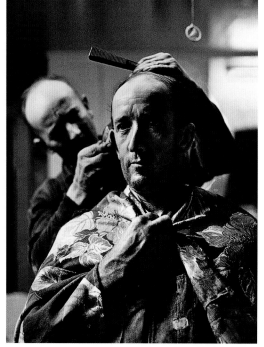

TOP, LEFT
Youngster with a fishing pole, c. 1950
HIGHGATE, VERMONT

TOP, RIGHT
Baseball player, c. 1959
BRATTLEBORO, VERMONT

BOTTOM, LEFT
Blowing bubbles, c. 1950
HIGHGATE, VERMONT

BOTTOM, RIGHT
Barbershop, c. 1950
HIGHGATE, VERMONT

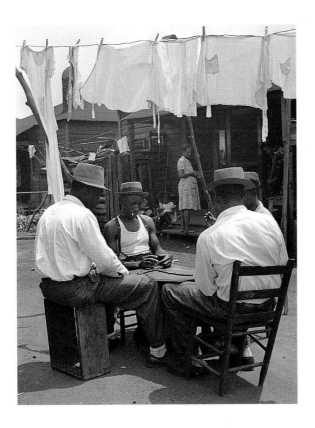

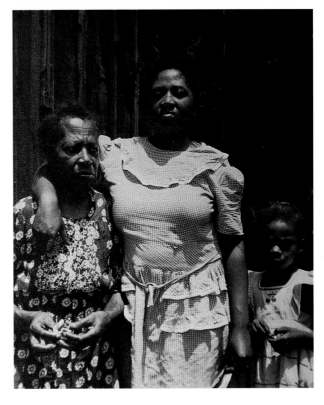

LEFT
Domino players, 1949
BIRMINGHAM, ALABAMA

RIGHT
Three generations, 1949
BIRMINGHAM, ALABAMA

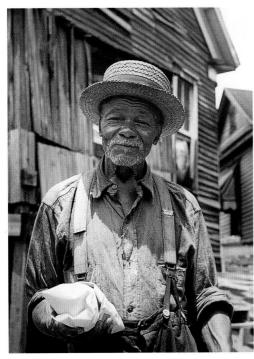

LEFT Portrait, 1949 | ATLANTA, GEORGIA

ABOVE Cotton picker, 1949 | MISSISSIPPI

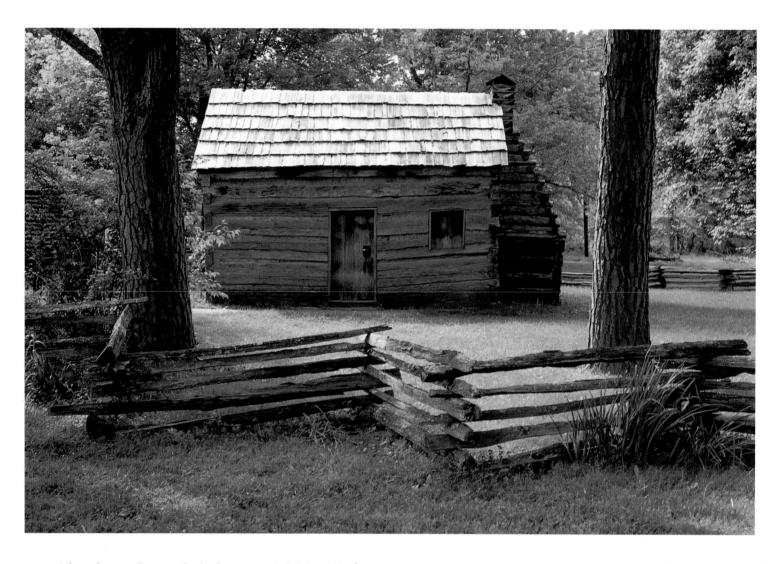

Abraham Lincoln's home, 1811–16 | KNOB HILL FARM, KENTUCKY

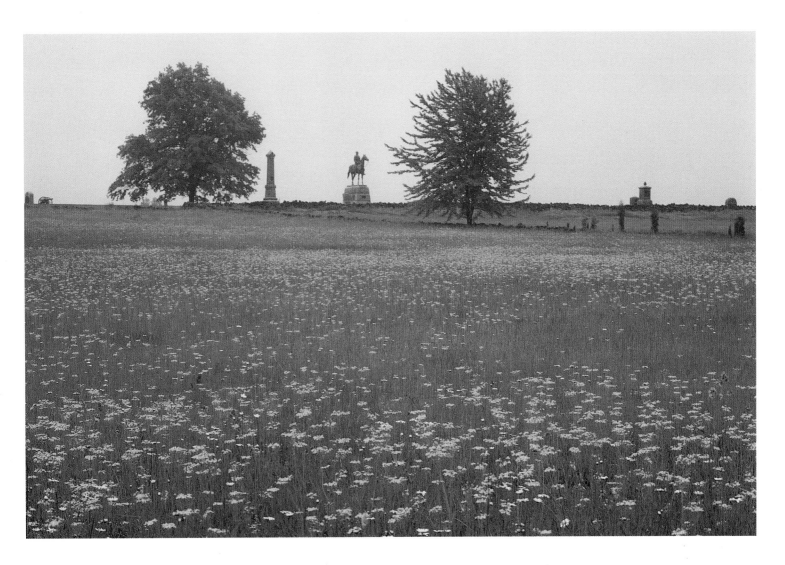

Battlefield | GETTYSBURG, PENNSYLVANIA

Abandoned barn surrounded by goldenrod | BUCKLAND, MASSACHUSETTS

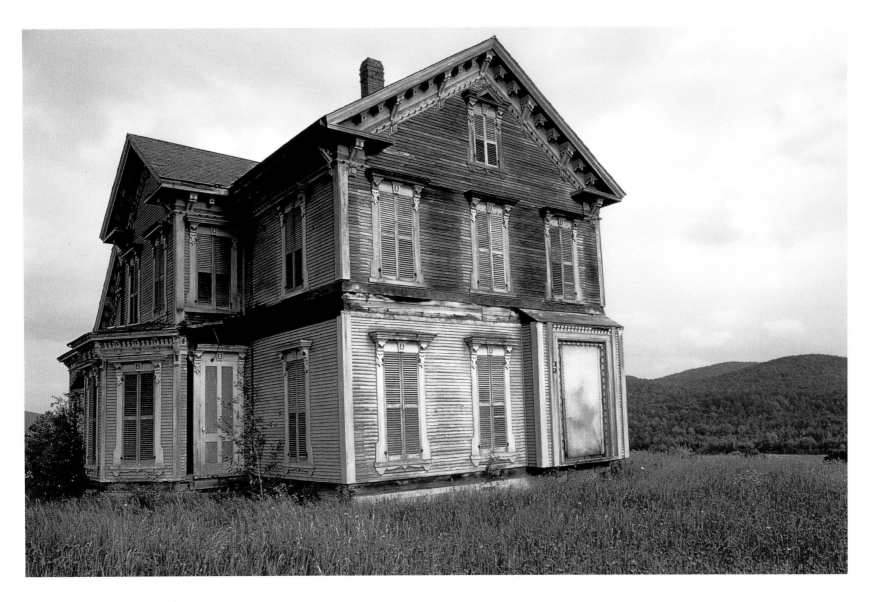

Abandoned house | MOUNT HOLLY, VERMONT

Patriotic signs | JEROME, ARIZONA

Wall signs | BAKERSFIELD, CALIFORNIA

Wall art | NEWSPAPER ROCK, UTAH

Buffalo on wall | CISCO, UTAH

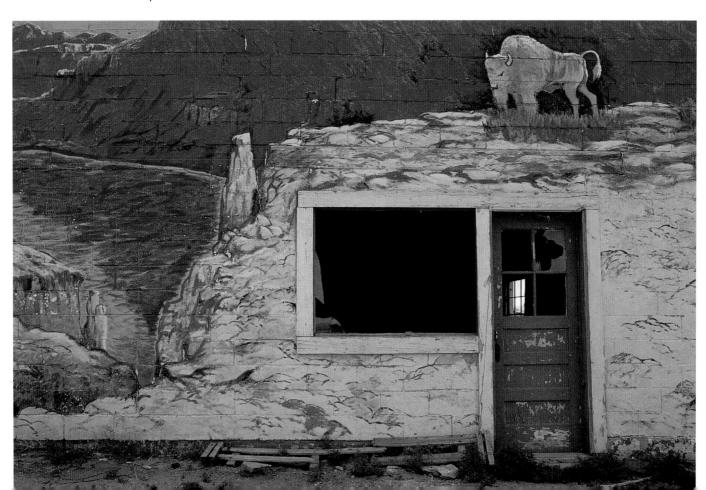

Vintage car in field | STONINGTON, MAINE

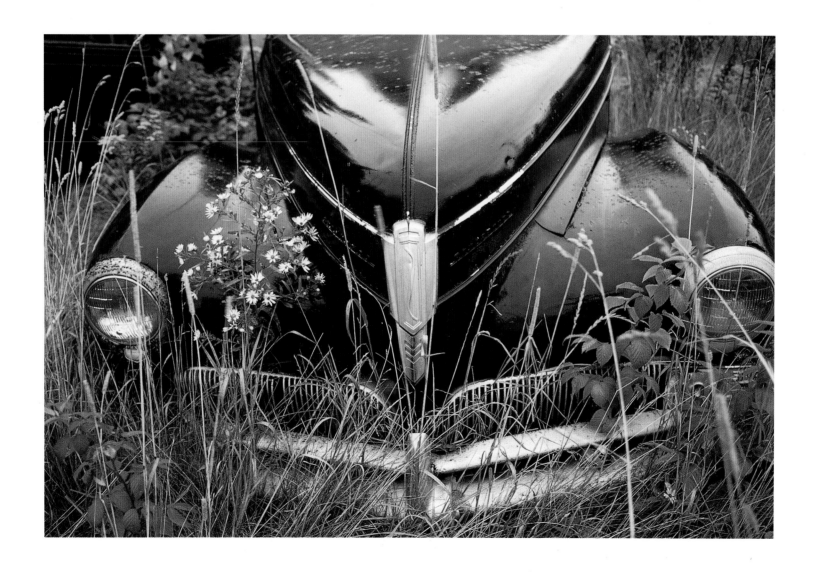

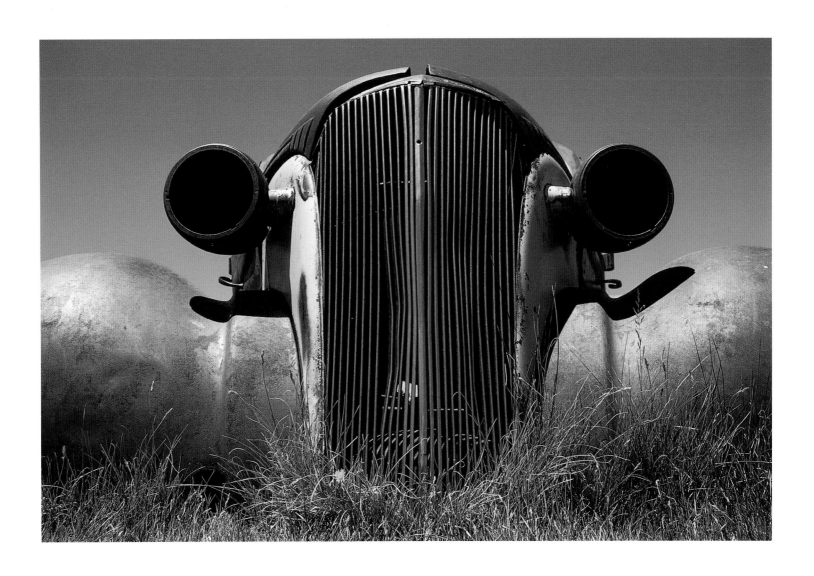

Vintage car in ghost town | BODIE STATE HISTORIC PARK, CALIFORNIA

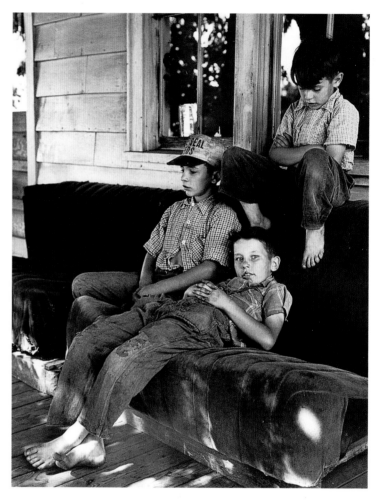

Brownstone stoop, "Little Italy," c. 1950
NEW YORK, NEW YORK

The Gagné boys on their porch, c. 1950
HIGHGATE, VERMONT

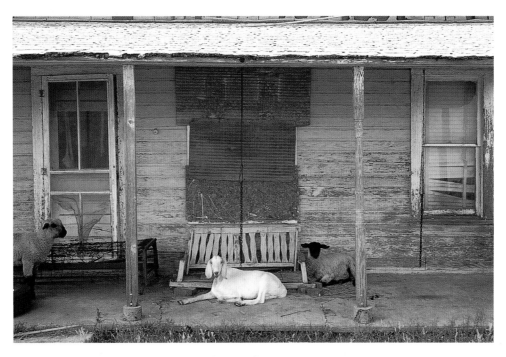

Goats and sheep on a porch | OKLAHOMA

Stanton Hall | NATCHEZ, MISSISSIPPI

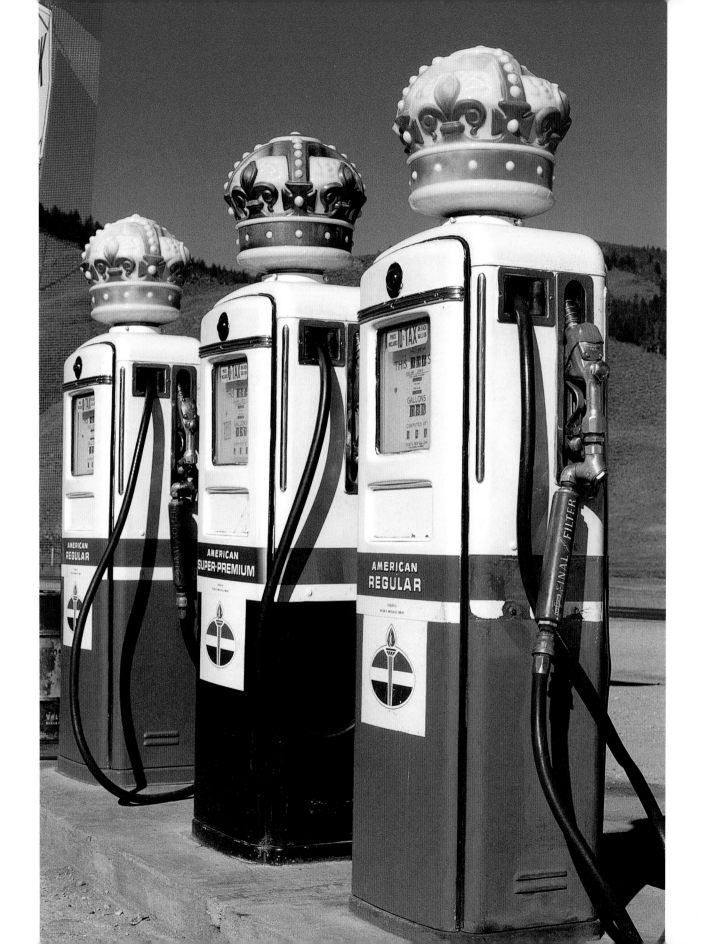

Red, White, and Blue, Forever

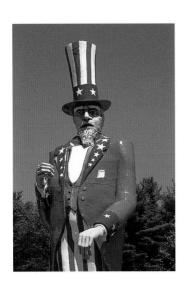

AFTER ALL THE PATRIOTIC MOTIFS BULLATY AND LOMEO HAVE GIVEN US, THOSE CHEERLEADERS AND PARADING bands and Coca-Cola flags, do we need a chapter devoted to American kitsch? Can we ever have too much of those good old stars and stripes? Not in *America America*, bedazzled as we are by that extraordinary larger-than-life-size Uncle Sam (left) that Bullaty and Lomeo came upon at Magic Forest near Lake George in the New York Adirondacks. Looking out at us from beneath his stovepipe hat, his coat as blue as the sky itself, this monumental effigy represents a definitive triumph of the popular imagination.

The stovepipe hat calls up in turn the turbaned crowns adorning the old Amoco gas pumps that Bullaty and Lomeo photographed in 1964 (opposite), perhaps a way of reminding us of the sheiks to whom we owed our oil.

The next image is the entrance portal to the Twin Cities' Mall of America. Lured to its vastness, patrons from all over the globe fly in to sample the world's biggest shopping complex. Quality is a matter of taste; bigness is indisputable.

After Mount Rushmore we might be prepared for a nearby "museum" exploiting it: if you have seen those four presidents, here we have all the others, "nearly life size." But Bullaty's and Lomeo's photograph of the

OPPOSITE Gas pumps on the highway, 1964 | ROCKY MOUNTAINS, COLORADO

ABOVE Uncle Sam | LAKE GEORGE, NEW YORK

"Parade of Presidents" with its herd of young steers glaring out from under that all too appropriate billboard turns it all into a brilliant cartoon.

Instead of a glaring billboard, the sign below offers a trompe l'oeil of what might well be an old block-lettered printed bible: "Jesus said I am the way the truth and the life. No man cometh unto the Father but by me." We may even think, coming upon it there, opposite a quiet farm in Bird-in-Hand, Pennsylvania, that the "way" it talks about is the very byway we are driving. The appeal it makes is a literate one, a gentle one, and, framed as it is, a visually compelling one.

More satirical is the striking mural Bullaty and Lomeo found in Mountainair, New Mexico, of an enormous orca-sized bald eagle bearing down on a hapless station wagon. Perhaps this streamlined war machine will capture its prey.

There follows two pages of American icons: the Statue of Liberty, a red, white, and blue mannequin cheerleader, contrasting with cutouts of Elvis Presley and Marilyn Monroe, the sex figure almost demure here, a proper early sixties hostess greeting us by the window of her Jerome, Arizona, home.

More vivid as art is the Cadillac graveyard from the Ant Ranch outside Amarillo, Texas, with its vertically stacked, exuberantly inscribed wrecks—a pop art painting alive and well.

And it ends with an Elvis-era, very fast, watercolorlike shot of a white-clad rock 'n' roll girl and her boyfriend—or is it a mannequin?—beside a Buick that could have emerged from the brush of Winslow Homer, so outrageously do the blues and whites bounce off and reflect one another. A car of the late 1950s is caught in the desolation of Route 66 in Seligman, Arizona, before the interstates put an end to such roadside visions.

Mall of America | MINNEAPOLIS–ST. PAUL, MINNESOTA

Flag in the wind | BADLANDS NATIONAL PARK, SOUTH DAKOTA

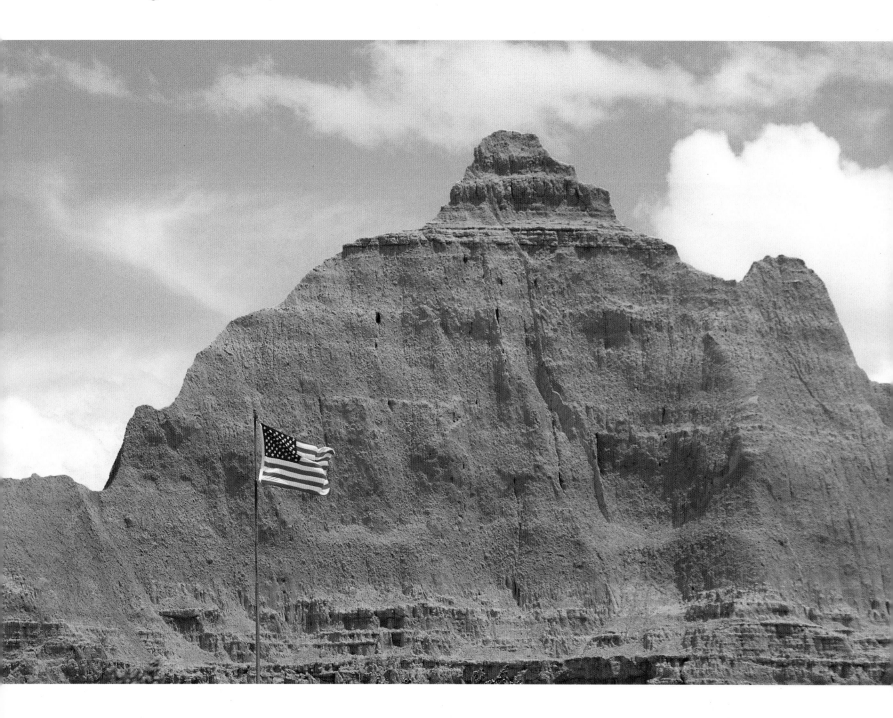

OPPOSITE Flag at Yellowhorse | ARIZONA

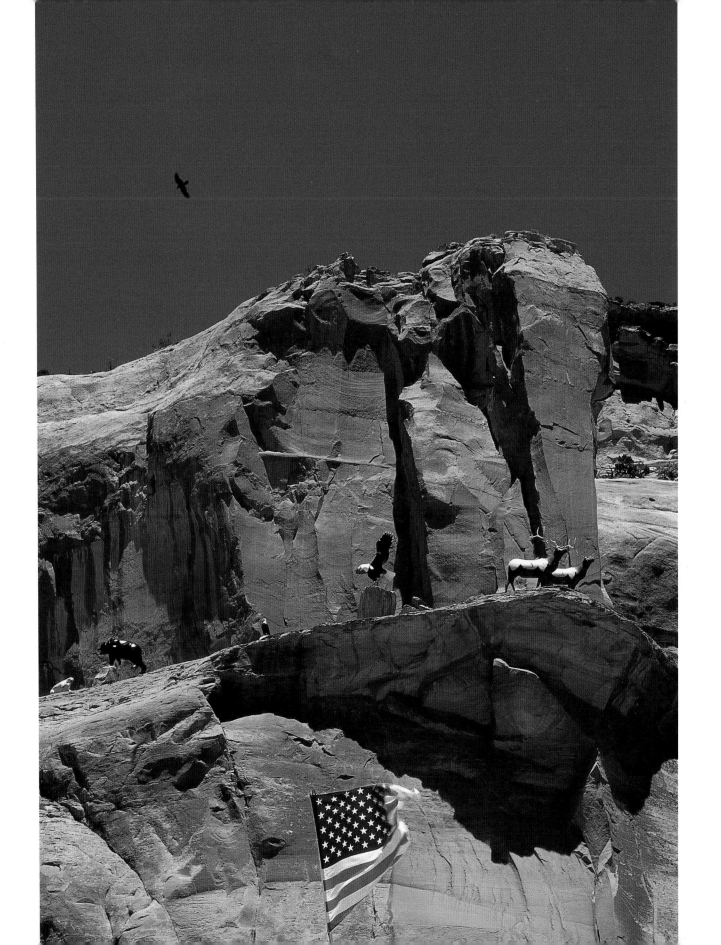

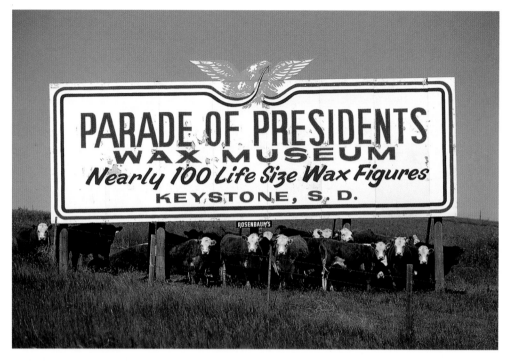

"Parade of Presidents" billboard | KEYSTONE, SOUTH DAKOTA

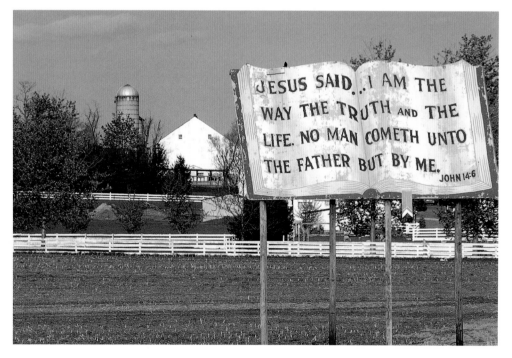

Road sign | BIRD-IN-HAND, PENNSYLVANIA

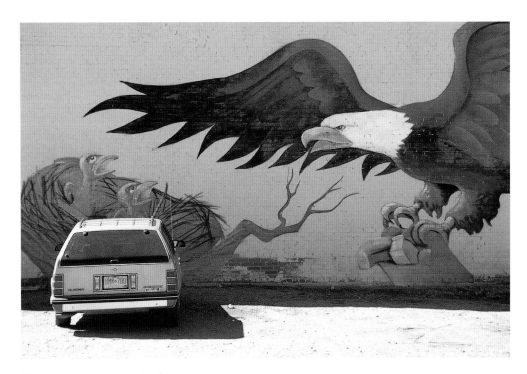

Patriotic mural | MOUNTAINAIR, NEW MEXICO

Chamber of Commerce | HOPE, ARKANSAS

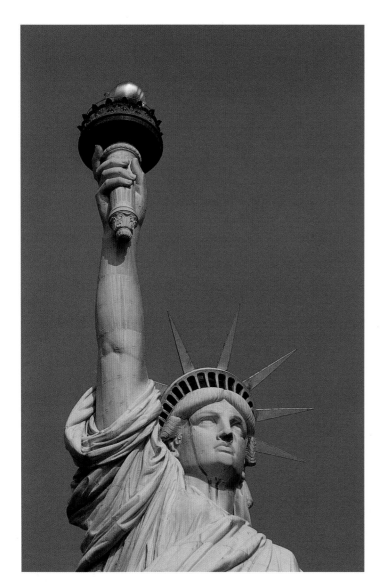

Statue of Liberty | NEW YORK, NEW YORK

Mannequin | OCEAN CITY, MARYLAND

Elvis Presley | NEW HOPE, PENNSYLVANIA

Marilyn Monroe | JEROME, ARIZONA

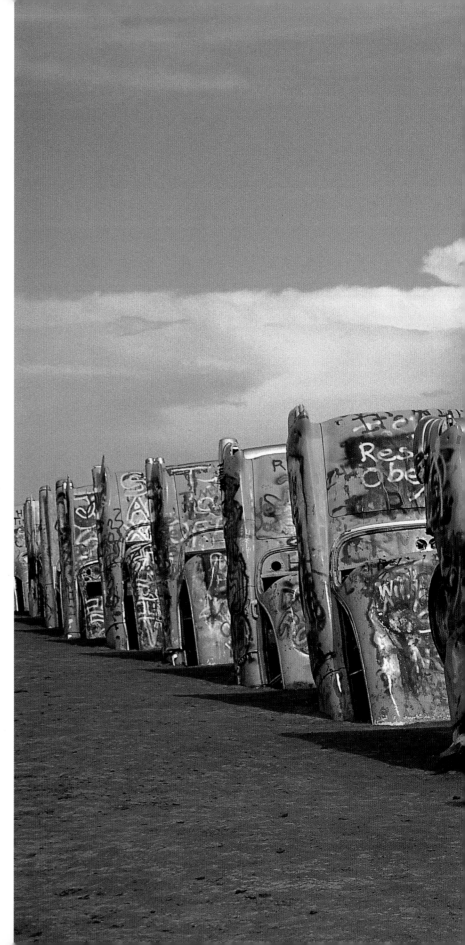

Cadillac Ranch | AMARILLO, TEXAS

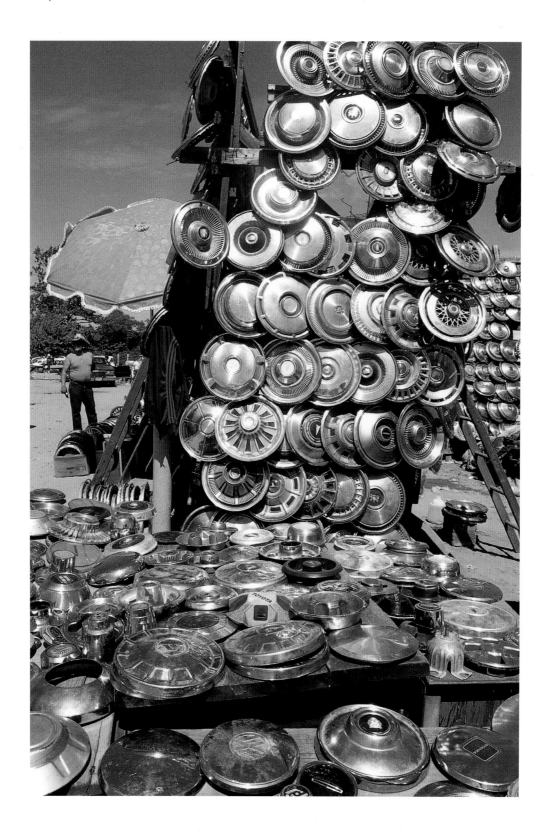

OPPOSITE Hub caps | ENGLISHTOWN, NEW JERSEY

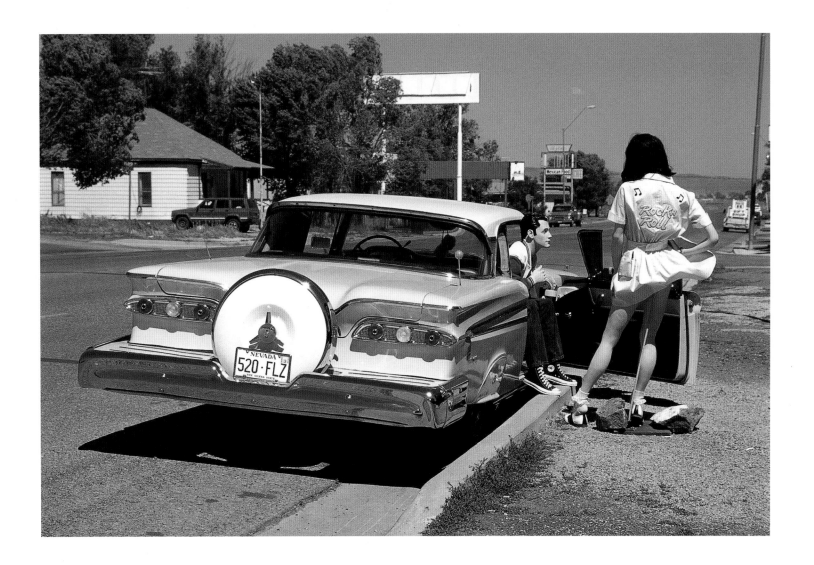

Car hop on Historic Route 66 | SELIGMAN, ARIZONA

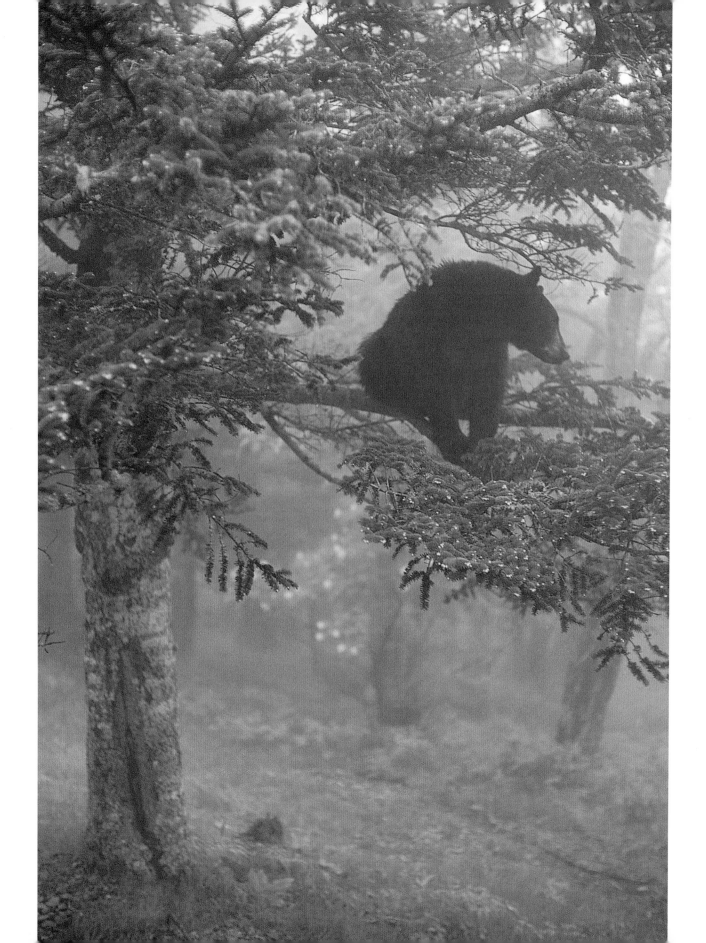

Wildlife

A SUITE OF TRULY REMARKABLE PHOTOGRAPHS INTRODUCES *AMERICA, AMERICA'S* HOMAGE TO THE WILDLIFE

with whom we now share this varied land. The young black bear (opposite) high in a spring-green pine tree makes a scarcely believable apparition. The tree looks like something out of an oriental painting, all the more because of the dense mountain mist against which the bear is profiled. Bears, we know, are arboreal, but no one ever comes upon one up that high, not one that big and in the Smoky Mountains! But in this wonderful photograph Angelo makes the improbable real and affirms our deep, childlike feelings about nature. A bear is finally just where it should be!

The red-tailed hawk (left) sitting unperturbed on the window ledge of Sonja's and Angelo's New York apartment is another such apparition, from the winter of 1999. The hawk stayed overnight with them to celebrate New Year's Day and provoked a number of shots, including a very improbable one at night, against the illuminated New York skyline.

The great blue heron, silhouetted against the early morning sun on west coast Florida's Sanibel Island, is another creature caught in an unlikely pose: wings spread out, the water a dazzling sizzle of reflections beneath. We normally come upon these four-foot herons leaning out over the water, or cautiously stalking before chancing a sudden dart of the

OPPOSITE Black bear | MT. LE COMTE, TENNESSEE

ABOVE Red-tailed hawk on window ledge | NEW YORK, NEW YORK

beak. We are not so apt to catch them in a spread wing, quasi-dancing position. Yet the heron is not dancing but fishing, making use of the light to erase itself behind the mask, the umbrella that is, of its wings. For us, the heron is an embodiment of light and of dancing.

Waves bearing down on a beach often look like horses with their manes and tails flashing in the wind. In Bullaty's and Lomeo's photograph the metaphor is reversed as a herd of wild ponies pass just outside the mild breaking waves on a sandy beach in Assateague, Virginia.

From this study in motion the chapter presents a trio of portraits: a mare and a foal, a loping wind-and-light-ruffled coyote, and a remarkable portrayal of a red fox in which the still-life features are almost as arresting as the amazingly lit fox's face.

There follow two deservedly big-scale photographs, each of them animated by a deer. The first is as much of a wildlife shot as a study of atmosphere on a bottomland farm at the end of a long New England winter—mud, snow, a gloomy gray overcast, and in the midst of this desolation, a white-tailed deer. In the second, from Utah's Canyonlands, the stag running against a purple-and-blue rock wall seems like something from a cave painting come alive. Rub your eyes enough and you might be back at the dawn of human history.

These give way, in turn, to two privileged portraits: a rare enough buffalo bull in a flowering meadow in Yellowstone's Hayden Valley; a pair of mountain goats taken in the high timberline area in Glacier Park's Logan Pass.

From mammals—a chipmunk in a marsh, an (alas) all too rare prairie dog estate—we come to birds. A photograph, taken in the Smokies, of goldfinches, lovely muted grays and golds luminous in the slight overcast, shows them just where they should be, among late summer thistles. And the chapter ends with the black shapes of a flock of migrating snow geese caught against the emerging sun's fire-painted sky.

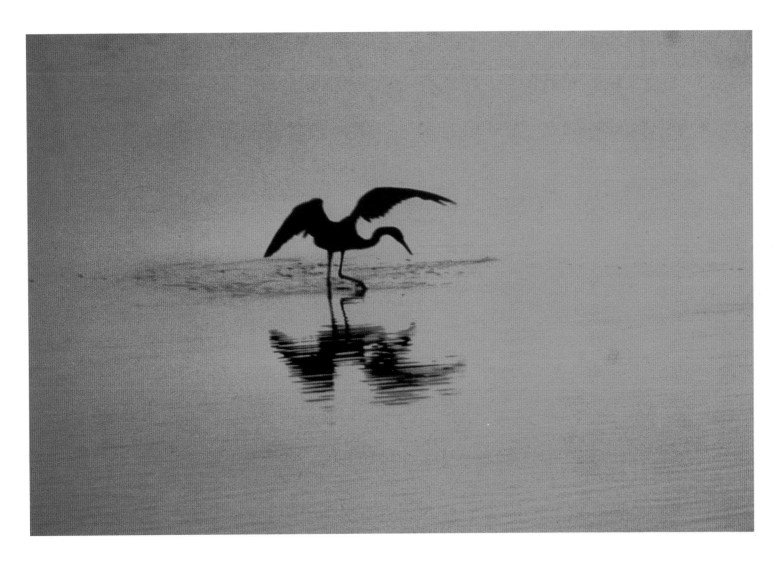

Great blue heron fishing | SANIBEL ISLAND, FLORIDA

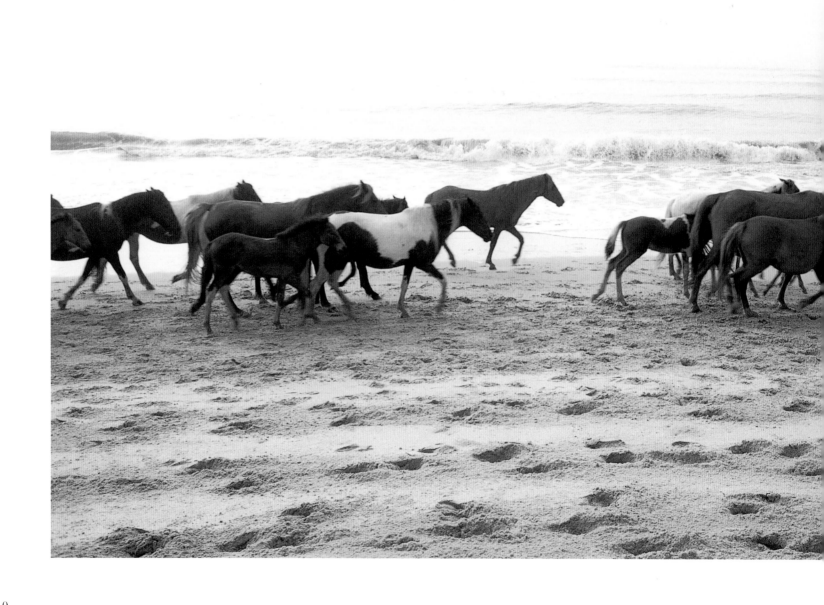

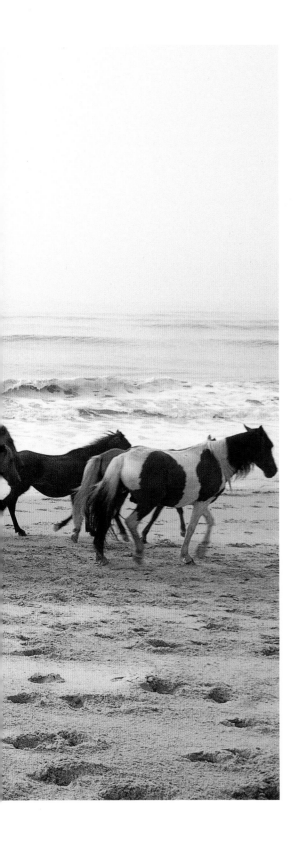

LEFT AND ABOVE Wild ponies | ASSATEAGUE ISLAND,
VIRGINIA

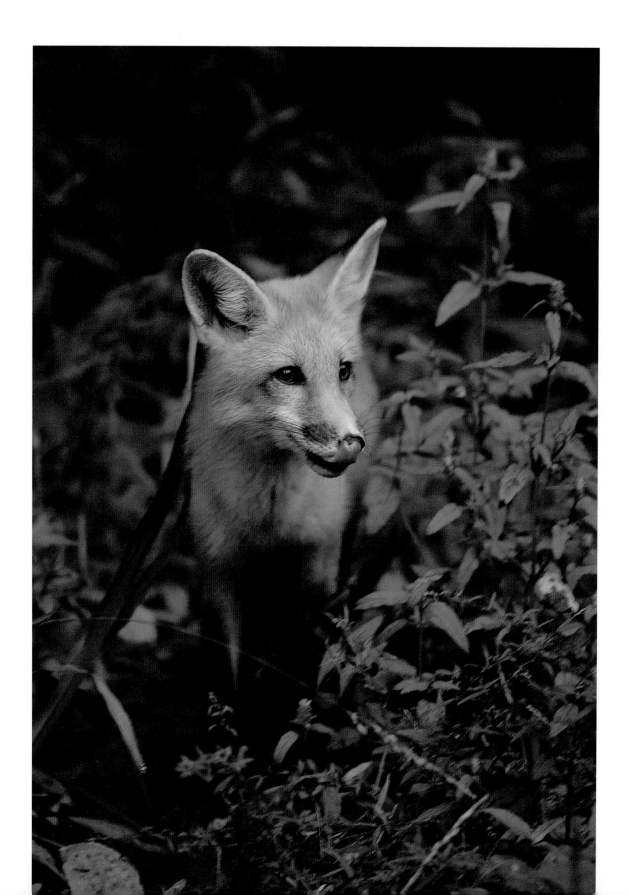

OPPOSITE Red fox | GREAT SMOKY MOUNTAINS, NORTH CAROLINA

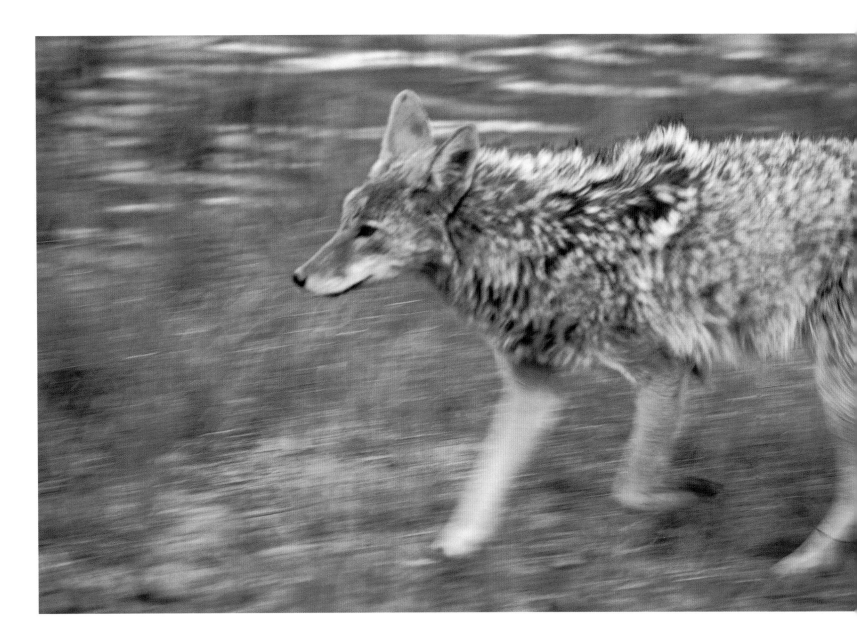

Coyote | YELLOWSTONE NATIONAL PARK, WYOMING

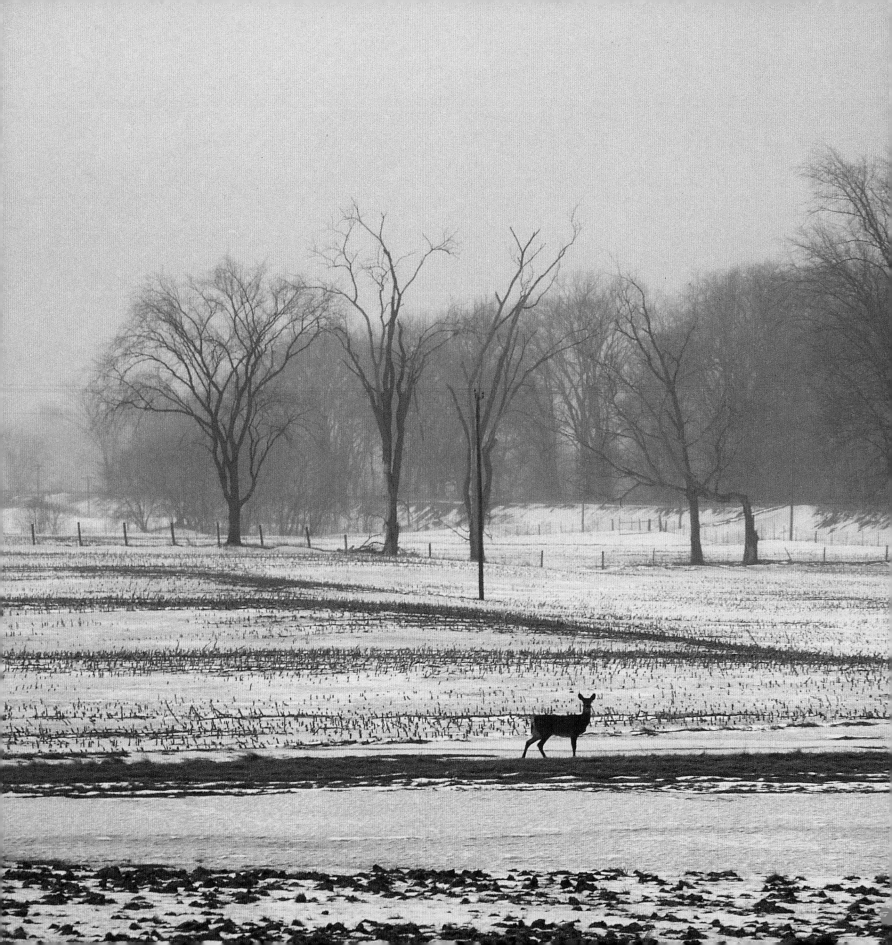

White-tailed deer in early spring
BOLTON, VERMONT

175

White-tailed deer on a rock wall,
Canyonlands National Park | MOAB, UTAH

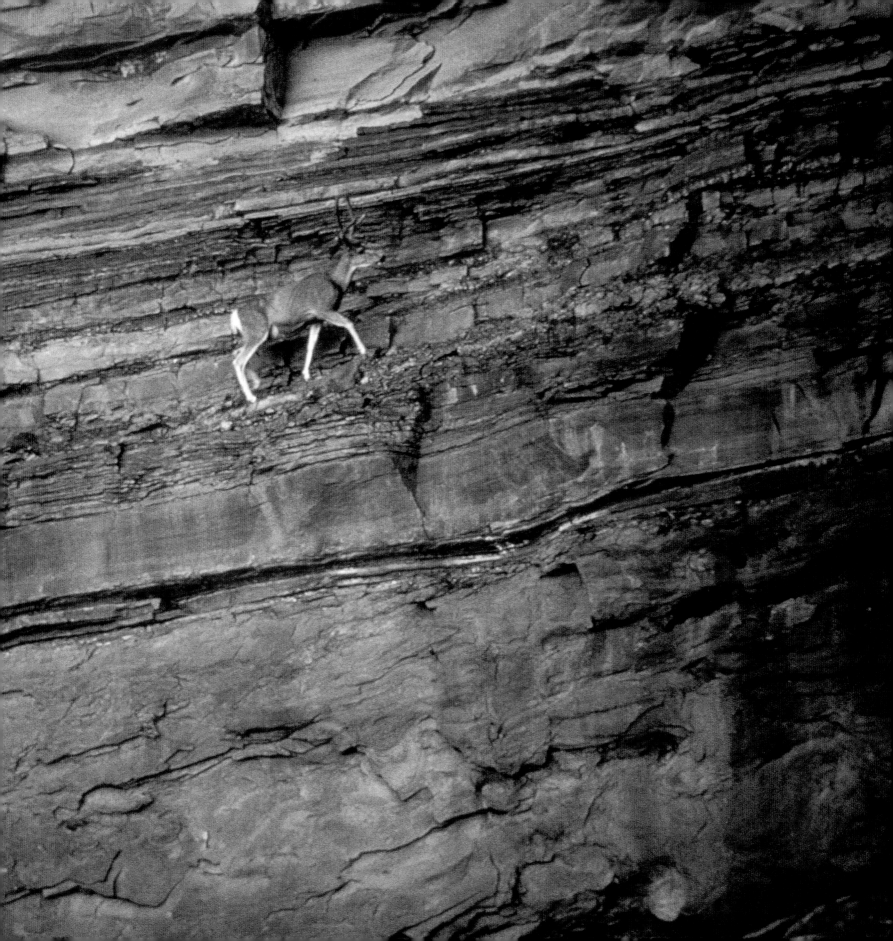

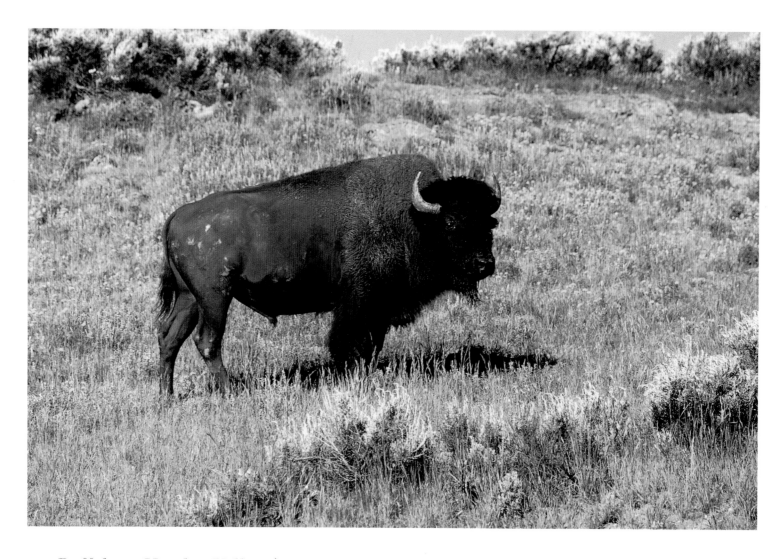

Buffalo in Hayden Valley | YELLOWSTONE NATIONAL PARK, WYOMING

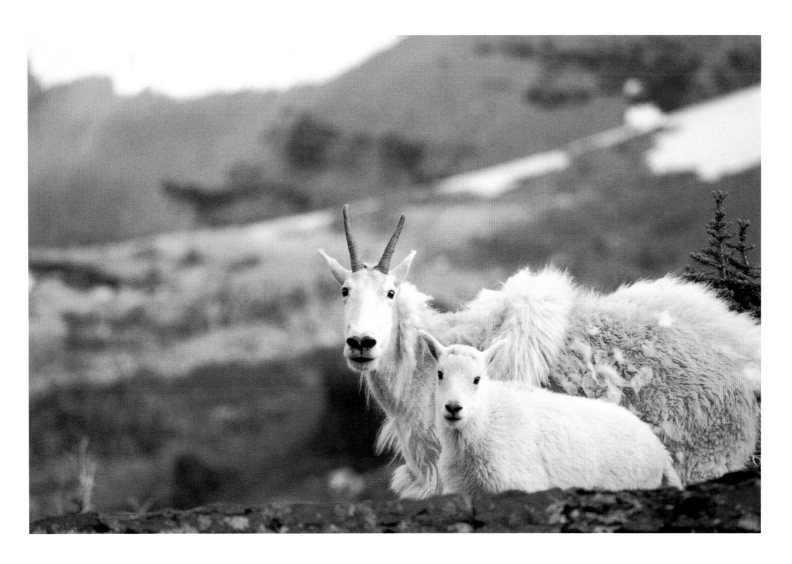

Mountain goats, Logan Pass | GLACIER NATIONAL PARK, MONTANA

Chipmunk | RHODE ISLAND

Prairie dog | TUCSON, ARIZONA

Goldfinches on thistles | GREAT SMOKY MOUNTAINS, TENNESSEE

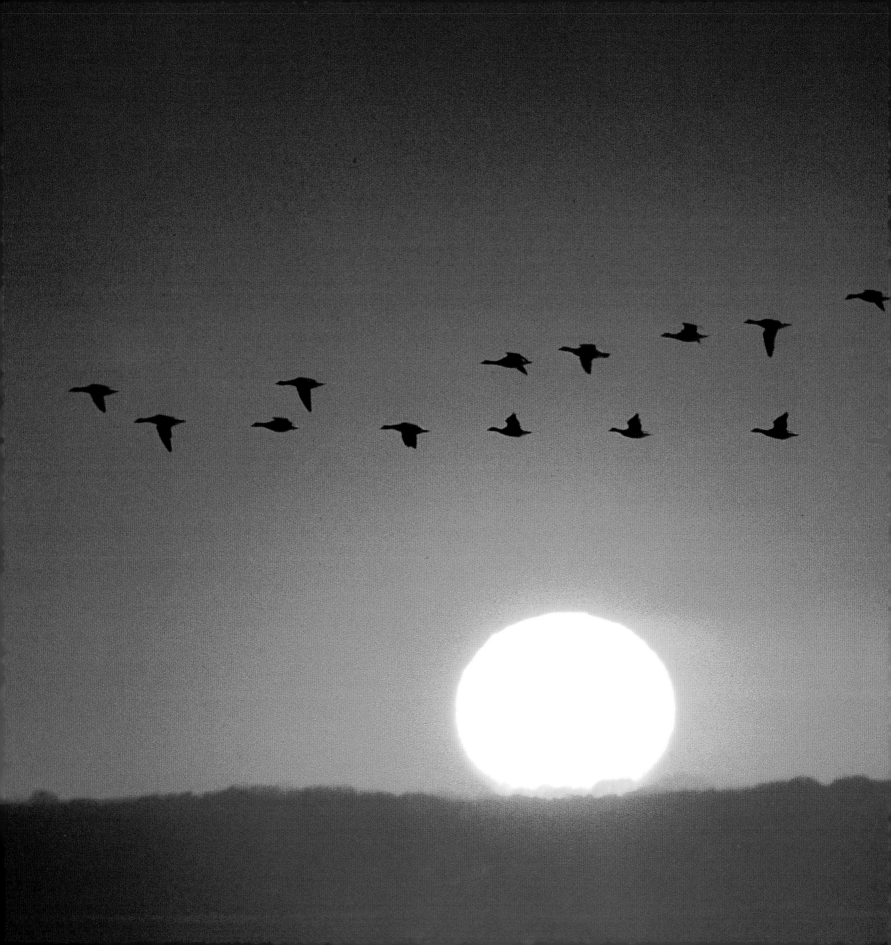

Migrating snow geese | BRIGANTINE,
NEW JERSEY

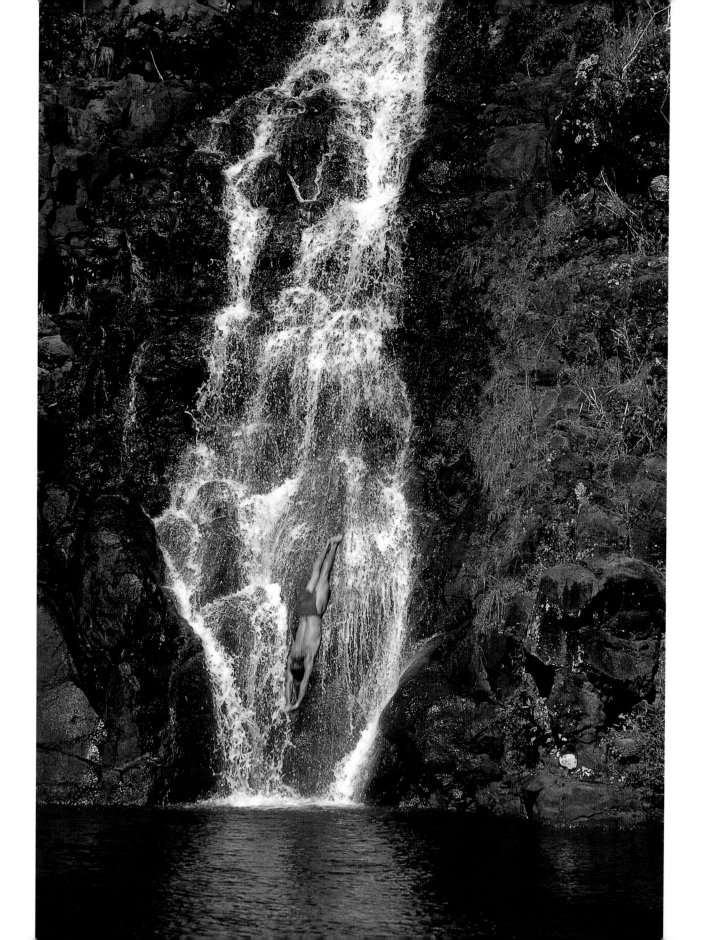

Alaska and Hawaii

THE FORTY-EIGHT-STATE LAND MASS HAS ITS OWN VISUAL IDENTITY. BUT ALASKA AND HAWAII ARE ALSO America. In this breathtaking coda Bullaty and Lomeo explore these recent frontiers. Their primary focus is elemental: the vast ice domain of Alaska; the fiery realm of Hawaii with its emerging islands being forged in a volcanic smithy. But, as in their other work, they are taking us to the heart of a place and a reality as well. And their elation shows. These are photographs that seem to tremble with their own excitement, their sense of discovery.

Something of that elation shows in their almost erotic photograph of the red-suited diver plunging into Waimea Falls at Oahu on Hawaii (opposite). We see it again in the equally uncanny miracle of the two diving whales set against the immense expanse of Glacier Bay (page 188). An instant, yes, but it is time enough for their two not quite symmetrical fins to bring into our vision the sundry peaks of the opposite coastline.

The photograph of Resurrection Bay on Kenai Peninsula is, by contrast, a study in atmosphere, a thin ripple of silver light on the water setting off a wind-swirling, now-you-see-it, now-you-don't, pine-clad mysteriousness.

Against such breathtaking rapidity the Prince William Sound photograph looks peacefully majestic. But those tiny icebergs floating about

OPPOSITE Diver at Waimea Falls | OAHU, HAWAII

ABOVE Totem | HAINES, ALASKA

are only the latest broken-off fragments of a fully visible glacier.

From this view of a working glacier we ascend for two views of the Mendenhall Glacier. A river of ice with a tiny helicopter above it is seen from another helicopter. But the image of subtly colored folds that seems hardly that of our own planet was taken while walking across and around some very spooky crevasses. These glacier photographs lead, in turn, to a full-scale one honoring our continent's tallest mountain, Mount McKinley, and a beautifully composed photograph that might be out of a Japanese scroll of the town of Haines surrounded in fog and cloud-swirled mountain eminences.

Alaska then concludes with an overhead shot of a whole family rapidly working in an unbelievably restricted space to clean the day's catch, and two persuasive images of popular art, a raven totem (the one black creature in a white world) and a salmon sign.

Hawaii opens with a Douanier Rousseau-like evocation of a tropical rain forest paradise—complete with waterfall—on the Big Island. The varied textures prepare us for the play of contrasting patterns, light, and texture in the facing study of palm tree leaves in a Maui garden. From there we ascend to a West Maui mountain panorama: the textures of the strong foreground grasses setting off the utterly bare mountain shapes of the cloud-tormented highlands.

There follow two matching coastal views, of men in racing canoes, and palms on the Hana coast, and we return to the volcanoes of Hawaii Volcanoes National Park, focusing on photographs of black Pahoehoe lava formations: an extensive view of lava swirled into brush-stroke configurations, a close-up with a lone pioneer fern claiming the foreground, and an eerie driftwood skeleton atop a lava floor. The next volcanic subject is swirling clouds, lava fires, a land coming into being. The chapter concludes with two photographs of the same volcano: pouring out red-hot lava, and black lava flowing against a background of billowing steam vents—a new bit of America rising out of the Pacific.

Fireweed | KENAI PENINSULA, ALASKA

Whales | GLACIER BAY NATIONAL PARK AND PRESERVE, ALASKA

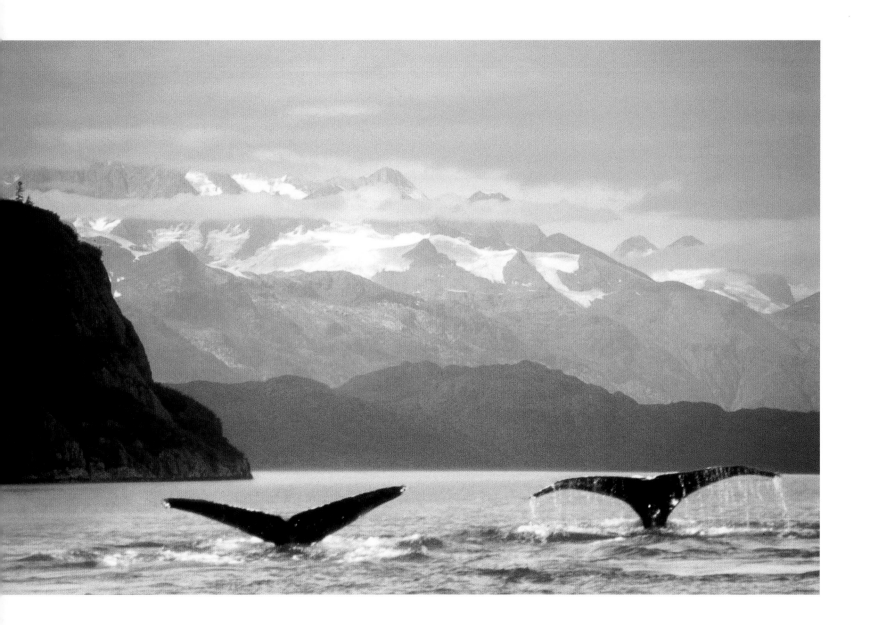

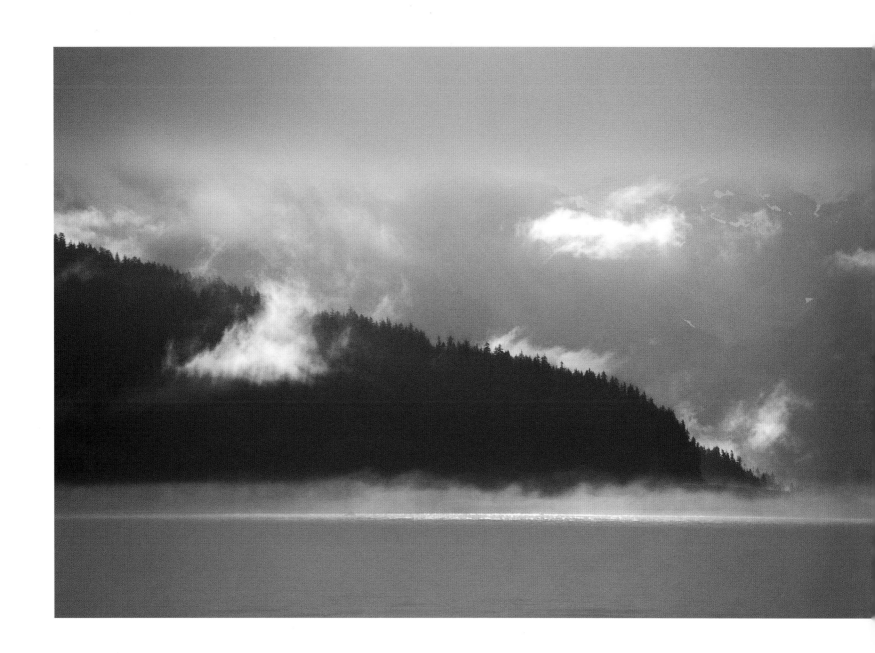

Resurrection Bay | KENAI PENINSULA, ALASKA

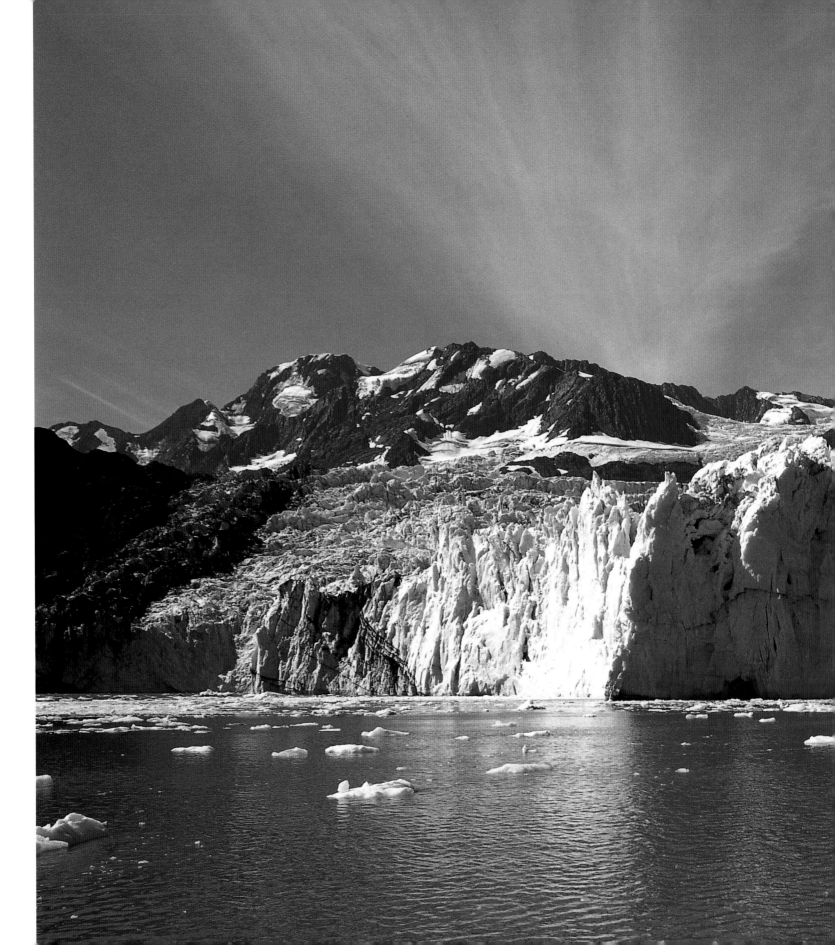

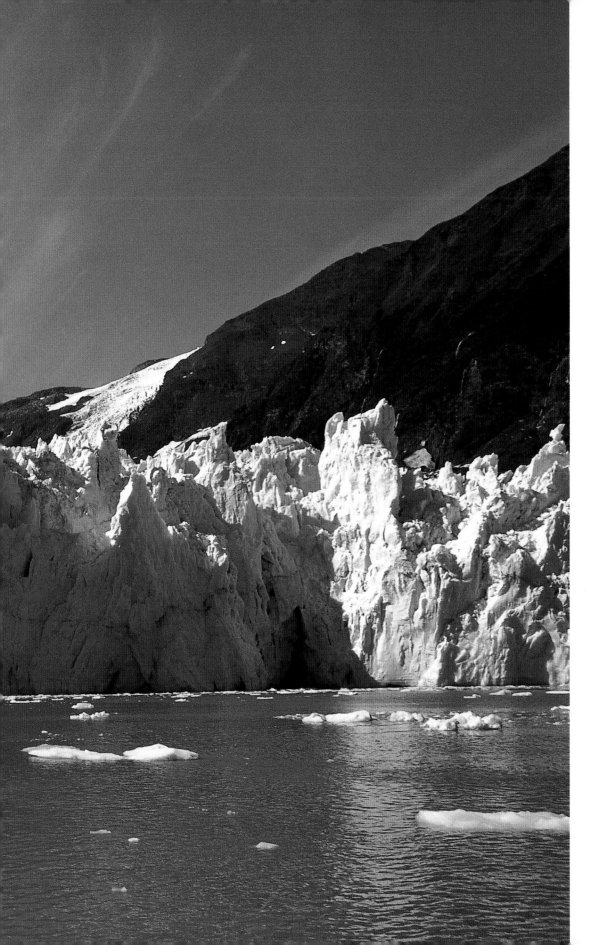

Glaciers at Prince
William Sound | ALASKA

Mendenhall Glacier from a helicopter | ALASKA

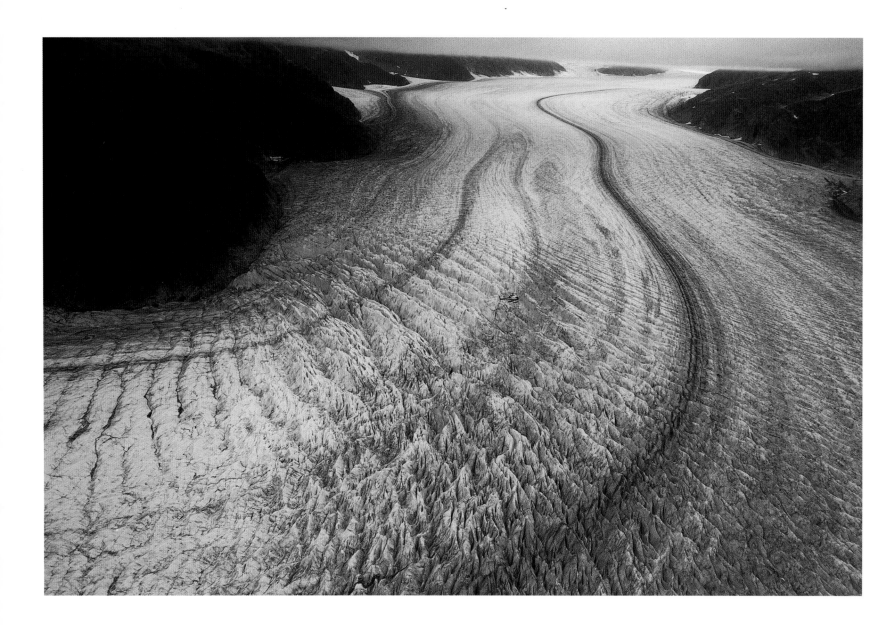

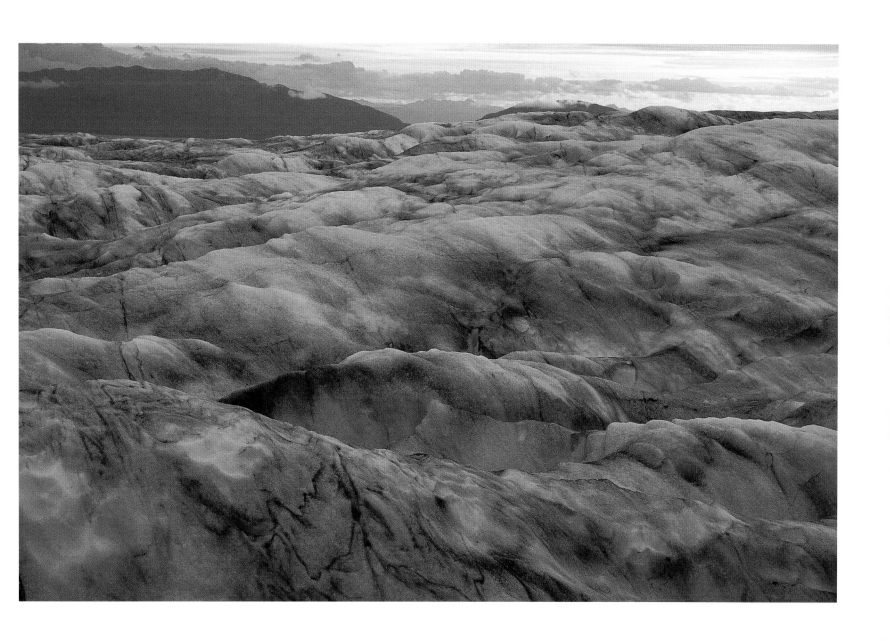

Crevasses on Mendenhall Glacier | ALASKA

FOLLOWING PAGES Mt. McKinley | DENALI NATIONAL PARK AND PRESERVE, ALASKA

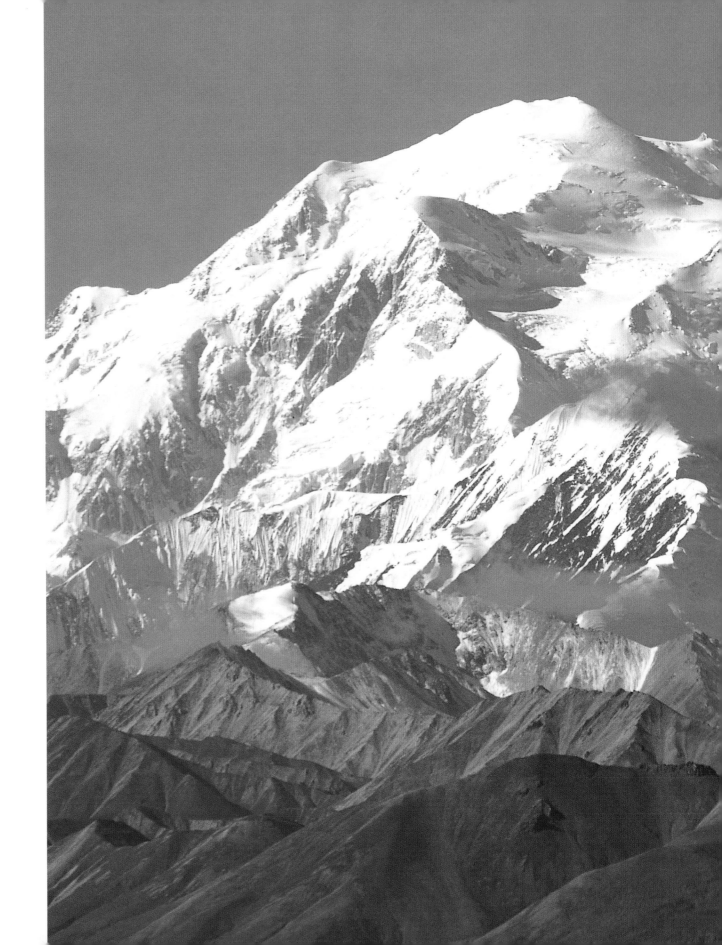

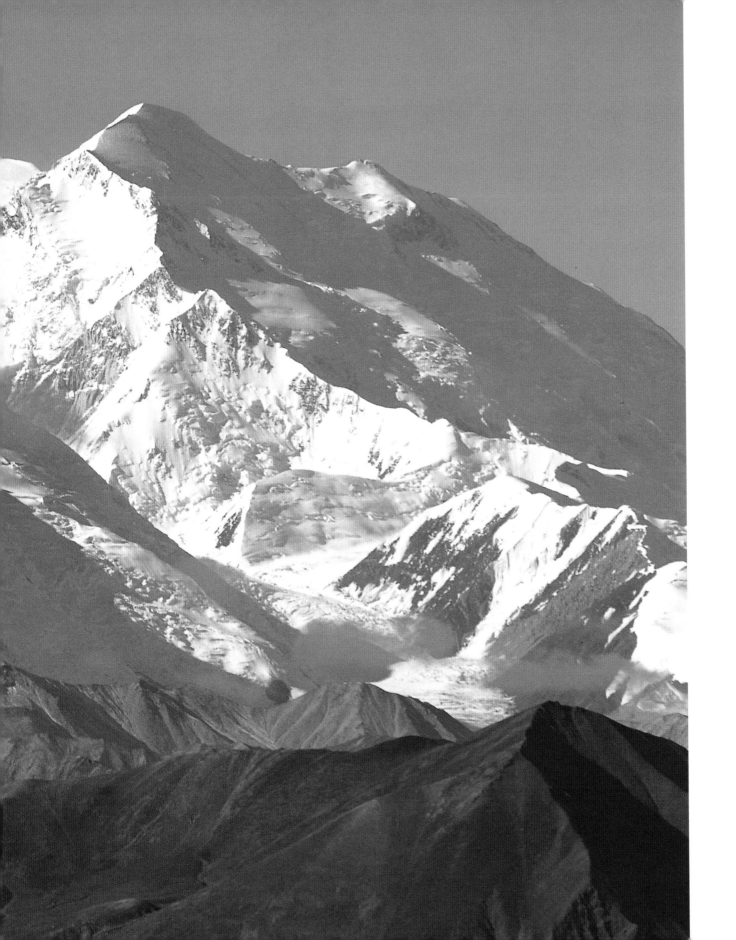

Portage Cove | HAINES, ALASKA

Cleaning the catch | GLACIER BAY NATIONAL PARK AND PRESERVE, ALASKA

Raven totem, Cultural Arts Center
JUNEAU, ALASKA

Salmon sign | VALDEZ, ALASKA

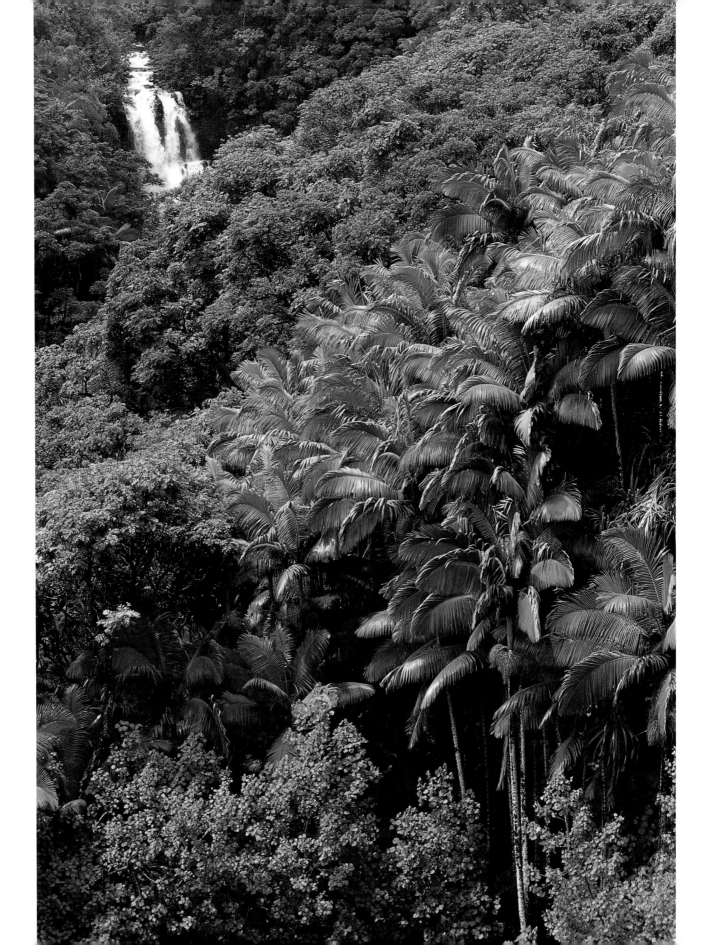

OPPOSITE Tropical rain forest | BIG ISLAND, HAWAII

Palms in a tropical garden | MAUI, HAWAII

West Maui Mountains | MAUI, HAWAII

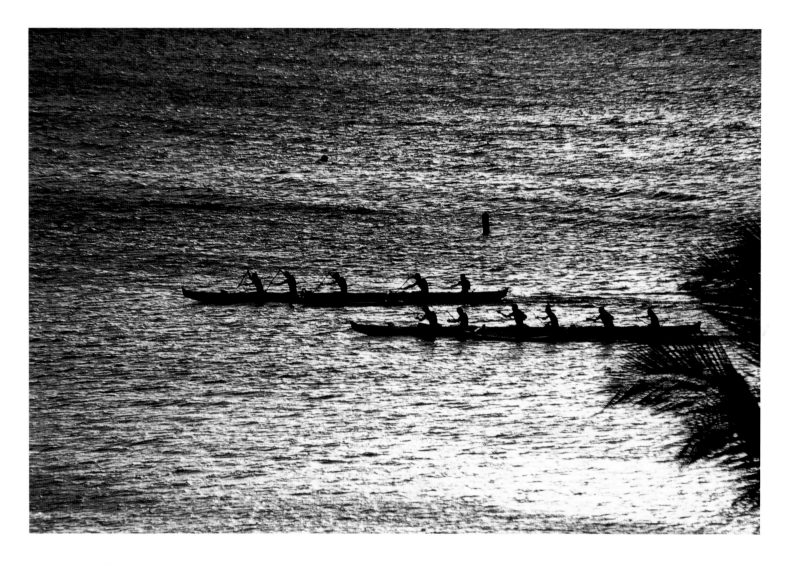

View from the coast | MAUI, HAWAII

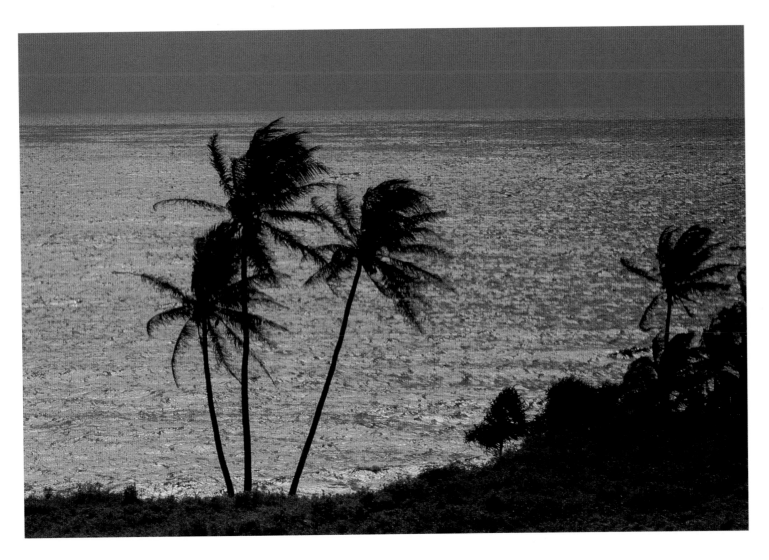

Palms on the Hana coast | MAUI, HAWAII

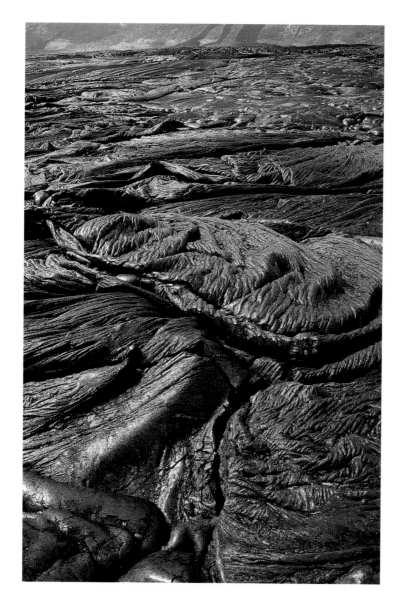

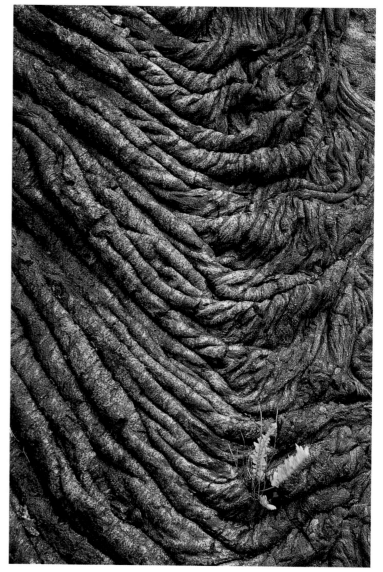

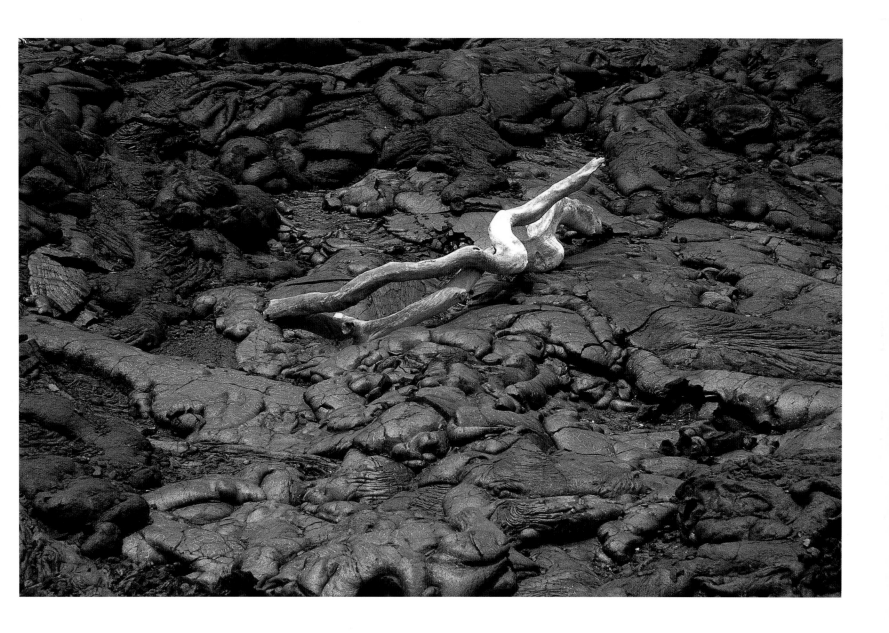

Sea of lava on volcanoes,
Hawaii Volcanoes National Park
BIG ISLAND, HAWAII

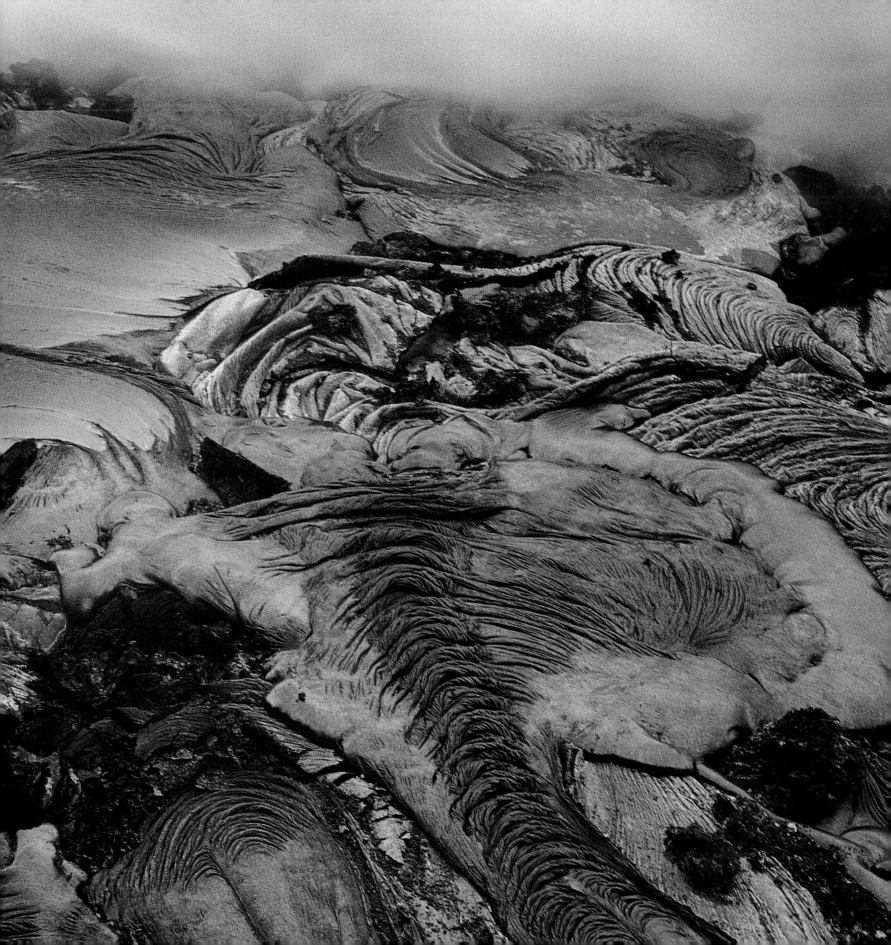

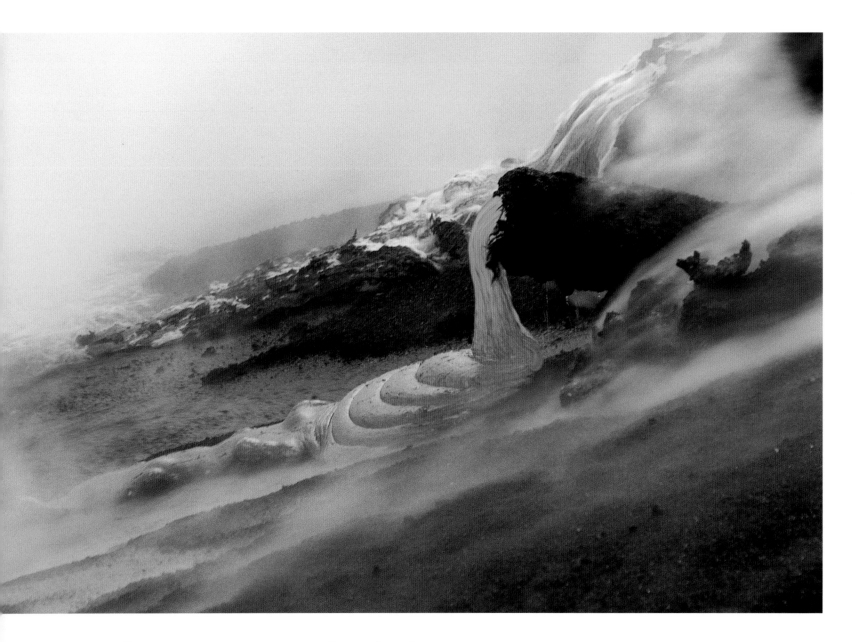

Lava pouring out to sea through tubes,
Hawaii Volcanoes National Park | BIG ISLAND, HAWAII

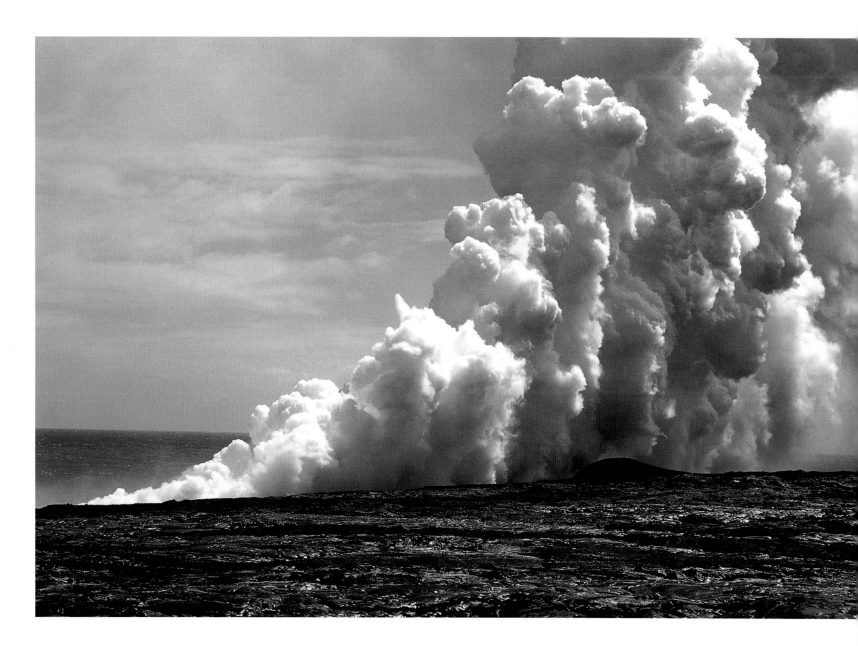

Newly formed land from lava and active steam vent,
Hawaii Volcanoes National Park | BIG ISLAND, HAWAII

Ice cream cone and cloud | SANTA ROSA, NEW MEXICO

ACKNOWLEDGMENTS

TO SAY THANK YOU IS TO REMEMBER . . .

. . . Our parents, Pasquale and Josephine Lomeo, whose lives were so very difficult due to circumstances, and Robert and Gretl Bullaty, whose lives were tragically cut short by inhumanity. They would have been happy to know that we are able to celebrate life. Perhaps we photograph for them and for those we care about. Perhaps that is why we try to capture the magic and the absurdities of the world around us.

My (Sonja's) thank you goes way back to my childhood and Máni Hochmutová, who in the Czech woods pointed out the wonder of a flower, a berry, a birdsong; to my uncle Franta Zelenka, who taught me to look at the world with his love of fun; to Otto Schwelb, Ivo and Sonia Rublič and Ota Janeček, who inspired a great love and respect for the arts. To Bela Finkelsteinová for saving my life the one time I was ready to give up; to Alina Szapocznikow, whose strength and talent I so admired; to Ray and Rudy Pick who invited me to come to the USA.

A very special thank you will always go to Sudek for the realization that photography was a way back to life and a search for meaning. That thank you also comes from Angelo, who was lucky enough to have met Sudek and shared many a joke and much wisdom over a glass of beer.

Trying to make sense of fifty years of photography and pulling two lifetimes together for *America America* was not easy, and we thank you, friends, for your patience and support, especially to Don and Noriko Carroll for invaluable advice, patience, and a love of good pictures; to Howard and Sybille Millard for sharing photographic moments and a love of nature; to our friends at the Image Bank; to our friends at PAI; to Mike Brown of Hunter Editions; to Evelyne Daitz for exhibiting our work at her Witkin Gallery; to Ernst Haas, Jay Maisel, and Pete and Reine Turner, who were among the first to exhibit our work; to Marge Neikrug-Raskin for continuing to do so; to Olivia Gilliam of Orion magazine and to Marion G. H. Gilliam, Tina Rahr, and Laurie J. Lane-Zucker for honoring us with an award and exhibition; to Ann Guilfoyle for long years of support.

Thank you Franny Ahders and Niki Jankulov; Evelyn Angeletti; Noella Ballenger and Sunny Asch; Amnon and Katie Bar-Tur; Ben Blom; Dick and Jeanne Bole; Alessandro Contini Bonacossi; Hermann Brammer; Dick Brigham for caring and fighting for the environment; Bianca and George Brown; Cornell Capa/I.C.P.; Milly and Russell Ellis; Woody Eitel and Karen Newell;

Berry Eitel Walter, Alexandra, Reavis Eitel; Gerda and Herb Erman; Eva Fuka; Christine Gagné-Snider and family; Leonora Goldberg/ASMP NY; Nelson Gruppo; John Hagmann; Stevie and Daphne Hard; Dot, Walter, and Crosby Hard; Joel and Lori Hecker; Toni Herber; Berty and Hanka Hornung; Bill Jones; Harold and Wanda Jones; Dr. Lawrence Katz; Leon Kowner; Grace, Ira, Lucy, and Peter Krupenye; Annie Larralde; Sigi Laufer and Eve Rubenstein and Abigail and Tom Ferguson; Dianne and Mark Maas; Kathryn Marx; Barbara and Arthur Michaels; Mario Modestini; Jan Osers; Ernst Otto; Bob Persky; Ralph and Susan Rosenthal; Rina and Vev Rotholz, David and Kathy, Ruthy and Turild, Susie and Eliot, and families; Jim, Elizabeth, and Alexandra Sage; Andrea and Ken Stein; LouAnn and Bill Tracy; Elena Bonafonte Vidotto; Steve Werner/Outdoor Photographer. Thank you in Alaska to Mary Barber, Kate Stastny, Ken Morris in Anchorage, Diane Dunham, J. R. "Trapper" Irwin in Juneau, Larry West in Haines, Steve Halloran in Skagway. Thank you in Hawaii to Rick and Linda Herzog, to Barbara-Ann and Gary Andersen of Historical Shipman House, to Donovan DeLa Cruz of McNeil Wilson Communications.

Thank you to all whose pictures are in this book. We truly regret not having all the names and are listing those we know: Preservation Hall Jazz Band Live! musicians Lester Caliste, Shannon Powell, Greg Stafford, Walter Payton, Ralph Johnson, Jeannette Kimball, and John Chaffe in Louisana; Kevin, Arlene, Alison, and Corey Walsh—Easter Parade, New York; Lutitia Fink and Sally Aplin in Alabama; Jim and Alice Forrest in Iowa; Galeyn Remington in New York; Dallas and Pat ("Wheatie") Lawrence in Kansas; the Gagné boys—André, Bernard, Adrien, Harvey, Leonard, Father Simeon, and Uncle Elzear. Thank you also to the very many Americans we met on our journeys, for help and a bit of insight on what this country is about.

Photographers need tools—cameras and film— and we have gratefully used everything from Kodak Baby Brownies to 8/10 and 11/14 Eastman view cameras; Rolleiflex, Leica, Miranda, Nikon, and Canon, and digital cameras may be in our future. But right now we cannot imagine life without the great variety of Kodak and Fuji films that we used to capture the light and color in this book.

To Robin Magowan, a major gratitude for taking the time and real interest in looking at our photos and writing with such perception and poetry.

To Abbeville Press and all who worked on this book: Bob Abrams, Mark Magowan, Susan Costello, Celia Fuller, Patty Fabricant, Louise Kurtz, Dorothy Gutterman, Marike Gauthier, deep thanks for believing in us and getting the book into the hands of many.

And love and gratitude to each other for a wonderful life in photography.

INDEX